Botswana
Kenya
Tanzania
South Africa
Namibia
Zambia
Egypt
Israel
Jordan
Italy
Luxemburg
Czech Republic
Switzerland
Spain
Greece
England
Germany
Portugal
Turkey
Scotland
Ireland
Wales
Russia
France
China
Hong Kong
Japan
India
Burma
Cambodia
Thailand
Viet Nam
Bali
Nepal
Papua New Guinea
New Zealand
Australia
Peru
Chile
Bolivia
Ecuador
Argentina
Bonaire
Brazil
Venezuela
Bahamas
Cuba
Cayman Islands
Costa Rica
Belize
Mexico
Canada
United States
Honduras
Panama
Ghana
Morocco
Madagascar
Bhutan
Falkland Islands
South Georgia Island
Antarctica

Graphic Design by Michal Janicki

Printed in China by Everbest Printing Co. through
Four Colour Imports, Ltd., Louisville, Kentucky.

ISBN-13: 978-0-9790072-1-7

This book is dedicated to my mother, Beatrice Friedberg Lewis.

The expanded edition is dedicated to the late Eli Segal, founding CEO of both Americorps and the Welfare to Work Partnership. He profoundly influenced the lives of hundreds of thousands of people. He is an inspiration to those of us who can only touch the lives of a few.

Preface to the Expanded Edition

The publication of One World, A View of Fifty Countries, has been most gratifying. The book seems to have struck a deep chord in many people. It is distributed nationally and has sold through the first edition. This expanded edition now includes photographs from sixty countries and all seven continents.

I have discovered that one of the best things about publishing a book is the people one meets in the book world. Without exception everyone has been knowledgeable and patient, while also going out of their way to be helpful.

Amy Martin of Four Colour Imports Ltd, gave me valuable advice on publishing a book.

The principle clients of the Chicago Distribution Center are prestigious university presses. Don Collins, Ann Tranchita, Karen Hyzy, Jeanne Weinkle and their helpful team took an enormous leap of faith in taking me as a client. This allowed my book to be carried in bookstores and on websites.

I was told that the bookstores in the Chicago area where every prominent author in the country does book signings are *The Book Stall at Chestnut Court* in Winnetka and *Barnes and Noble Old Orchard* in Skokie. I approached Roberta Rubin, owner of the *Book Stall*, and Mary Ann Diehl, director of Community Relations at *Barnes and Noble Old Orchard*. Both professionals told this first time, unknown author that they loved the book. Each bought numerous copies for their store, and both gave me a forum to speak and have a book signing.

Bess Winokur and Alice Acheson gave invaluable advice on how to promote the book.

Mike Campbell, Sam Bosch and the supportive staff at Graphic Arts Center Publishing Company were willing to distribute the book nationally and encouraged me to produce this expanded edition.

Steve Bennett, founder of Authorbytes.com, has designed my website, oneworldthebook.com. He is remarkably creative and a continual source of ideas on how to expand the scope of the book.

In addition, he has put me in contact with best-selling author, Jacqueline Mitchard. As a result, we are collaborating on a children's book. Steve has become a treasured friend.

Carol Kanter reviewed the manuscript and made many helpful suggestions.

Numerous people have commented on the elegant design elements of the book. Fortunately, Michal Janicki's expertise is once again evident in this expanded edition.

Introduction

"The world will never starve for wonders, but only for want of wonder."

– *G. K. Chesterton*

"The world is new to us every morning."
"Being human is a surprise, not a foregone conclusion."
"A person has a capacity to create events."

– *Abraham Joshua Heschel*

For the photographer and traveler, there is a new world to discover around every corner. Unlimited possibility and beauty beckon. In this era of specialization—which greatly benefits my profession of orthopedic surgery—when photographing I prefer to be a generalist, capturing images for the sheer joy of it. As a physician it is a great privilege to share intimate moments in people's lives; as a photographer it is an honor that people from all parts of the world have allowed me to gain their trust.

It is an exciting time to be capturing images. Recent technological advances—the transition from film to digital, and from darkroom chemicals to computer software—are revolutionary. Yet for me the technique of making a picture must be subordinate to what Henri Matisse called "expressing the emotion within you—the feeling awakened." When I look at my photographs the themes of harmony, serenity and intimacy seem to emerge. I often feel as if I am participating in a sacred moment. Especially today, with much of the world in chaos, I truly hope that some of these feelings will resonate with others.

Marcel Proust stated, "The real voyage of discovery is not in seeing new lands but in having new eyes." Because the quality of an experience is much more important than the quantity, I never planned to travel to a set number of places and was surprised to find I have photographs from over fifty countries.

This is still a small percentage of the over three hundred countries in the world. These photographs are not intended to be representative of the places visited, but are, simply, scenes, animals or people that caught one person's attention.

Quotations have always given me delight and inspiration, and it was a great joy finding ones to accompany these photographs. I hope these images will speak for themselves, and the sayings will add another dimension to them.

Acknowledgments

I was recently in the Amazonian rain forest, where one gains an appreciation of the remarkable diversity of life and, at the same time, the interdependence of life. While touched by the beauty I have seen, I am at the same time aware of the significant need of so many people in the places I have visited. How does one decide whom and how to help? My friend Geoffrey Tabin, M.D., through the Himalayan Cataract Project, has accepted this challenge. He performs surgery and teaches local practitioners how to accomplish cataract surgery. Together, during the past decade, they have restored sight to over two hundred thousand people. One measure of the value of an organization is how much progress is generated by a contribution. To restore sight to someone for less than forty dollars is a remarkable achievement. Therefore my intention is that proceeds from the sale of this book will be contributed to this organization.

I would like to thank several people who have been mentors, especially the widely respected photographers John Paul Caponigro, Jay Maisel and Leslie Alsheimer. Art Shay, another world-renowned photographer, has been a good friend and a great inspiration by telling me that I have a "good eye," but that I need to use it more diligently for my images.

Michal Janicki has created my web site, designed this book, and patiently spent countless hours guiding me through the minefields of Adobe Photoshop in the digital darkroom.

Laurel Feldman was most encouraging by exposing my photographs to the public in a one-man exhibition in her gallery. Billy Oberman helped to crystallize ideas for the book and contributed significant additions to it. My daughter Melanie Lewis typed the manuscript and made many helpful suggestions. I was fortunate that Marsha Goldsmith, my editor, contributed her professional expertise to refining the manuscript.

I am grateful for the moral and aesthetic support from many people including: Bobbi and Mel Adess, Christine and John Bakalar, Sarah Barnes, Abel Berland, Sonia and Ted Bloch, Steve Brodsky, Sandy and John Callaway, Karen Erickson, Cindy Falstad, Arthur Feldman, Aaron Feldman, Sandra and Ted Friedberg, Lena and Alex Golbin, Satish Gulati, Rita and Tom Herskovits, Jim Friedberg and Sherry Levin, Carol and Arnie Kanter, Anita Kaplan, Dolores and Morry Kaplan, Ira and Michael Kornblatt, Elliott Krick, Joan and Jordan Krimstein, Lynne Lamberg, Judy Lavin, Debi Lee, Beatrice Lewis, Hadley Lewis, Margo and Michael Oberman, Lisa Oberman, Sam Parnass, Harold Reuter, Karen and David Sager, Vanessa L. Sanchez, Susan and Oren Scheff, Gloria and Harry Schuman, Florence Shay, Richard Simon, Bill Smith, Doug Solway, Johanna and Julius Tabin, Jean and Geoff Tabin, Evelyn Waldman, June Waldman, Karen and Ken Waldman, Sharon and Alan Waldman, Becky Wanta, Frank Warren, Alyssa Webb, Lynn Webb, Jim Wright, Rollyn Wyatt, Barbara and Eldee Young.

Finally, I would like to thank my wife, Valerie Dewar Searle Lewis, my severest critic and greatest inspiration, who has greatly enhanced the entire text.

*Expanded Edition
Addendum*

Africa

Lion at Sunset

"You are a fragment of God himself.
Do not be ignorant of your high birth."
– Epictetus

Of the big cats, lions are the only social animals, and typically live in prides of two to fifteen. Males protect the pride and females are the hunters. Lions sleep much of the day and hunt at night. They seem to suffer from the heat just as much as humans do. Lions may mate hundreds of times during the three or four days when a female is in heat, sometimes as often as every fifteen minutes. The surprisingly short gestation period of three months is dictated by the females' role as primary food providers.

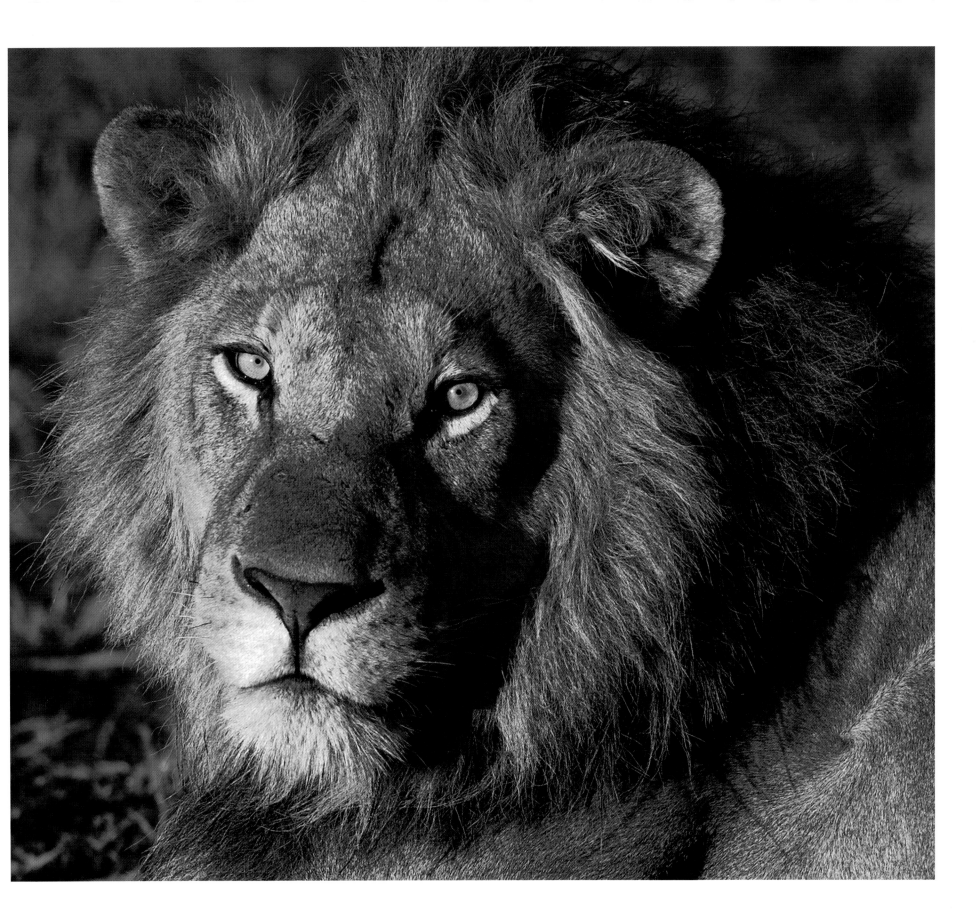

Brother and Sister

"The supreme happiness of life is the conviction that we
are loved."
– Victor Hugo

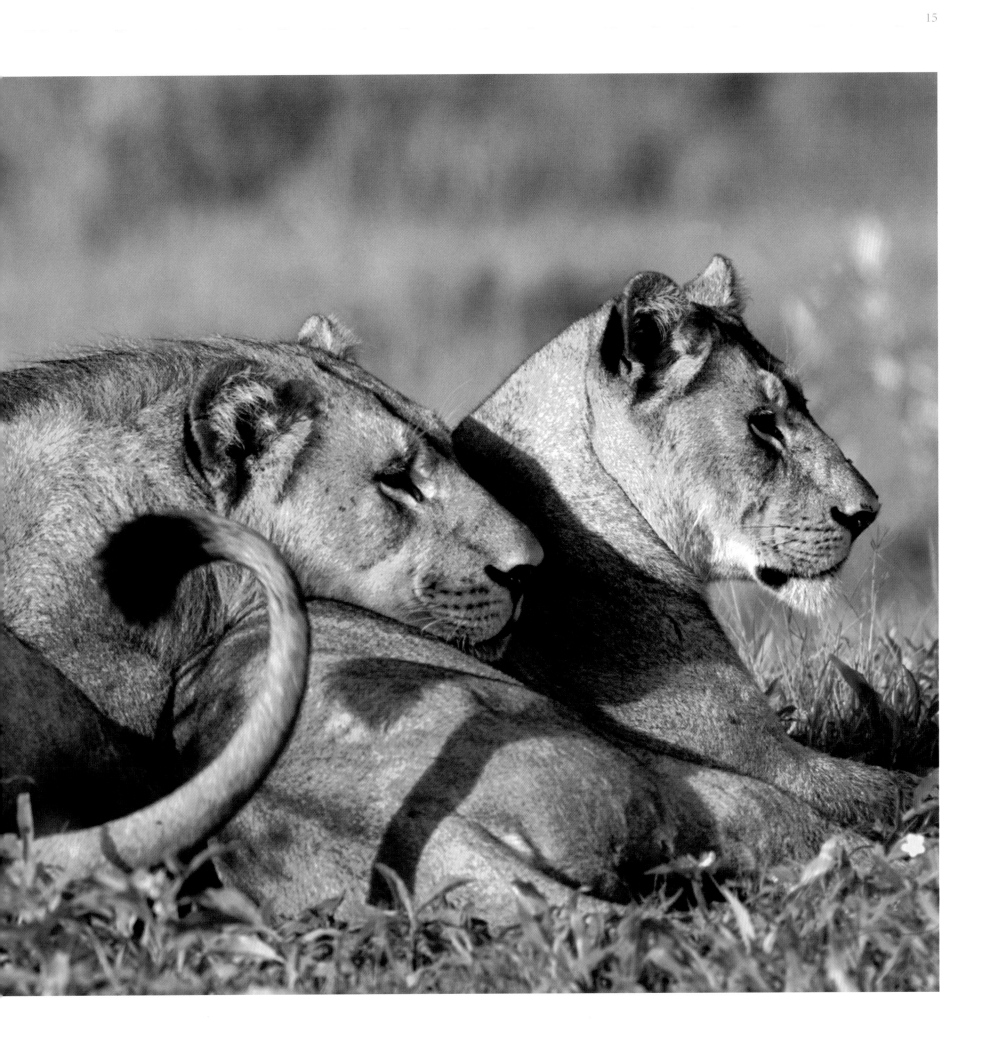

Lion Drinking

"The less effort, the faster and more powerful you will be."
– Bruce Lee

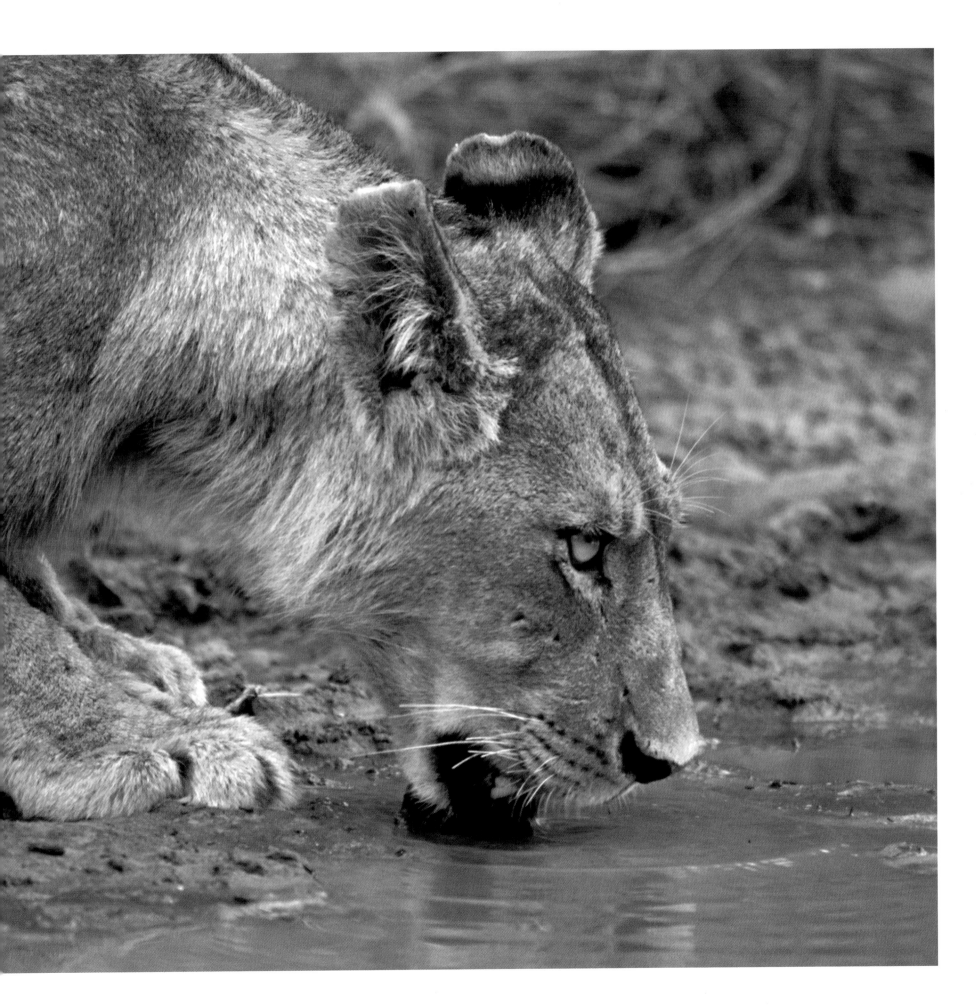

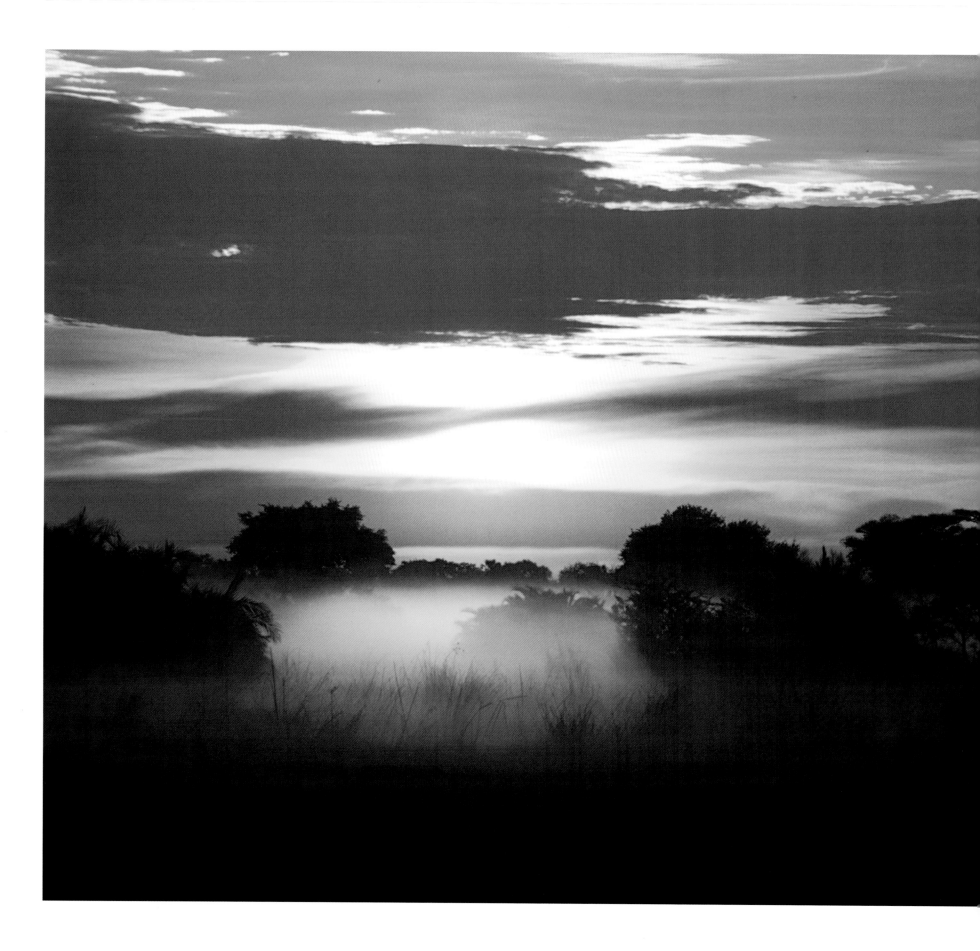

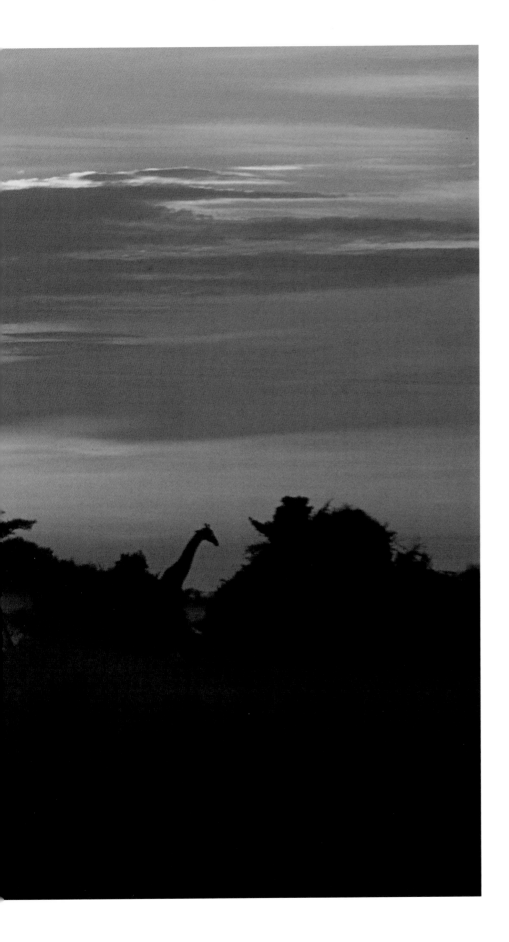

Sunrise with Giraffe

"Every place in the world is magical if you are there at the right time."
— John Shaw

While I was photographing this sunrise, a giraffe obligingly appeared on the horizon.

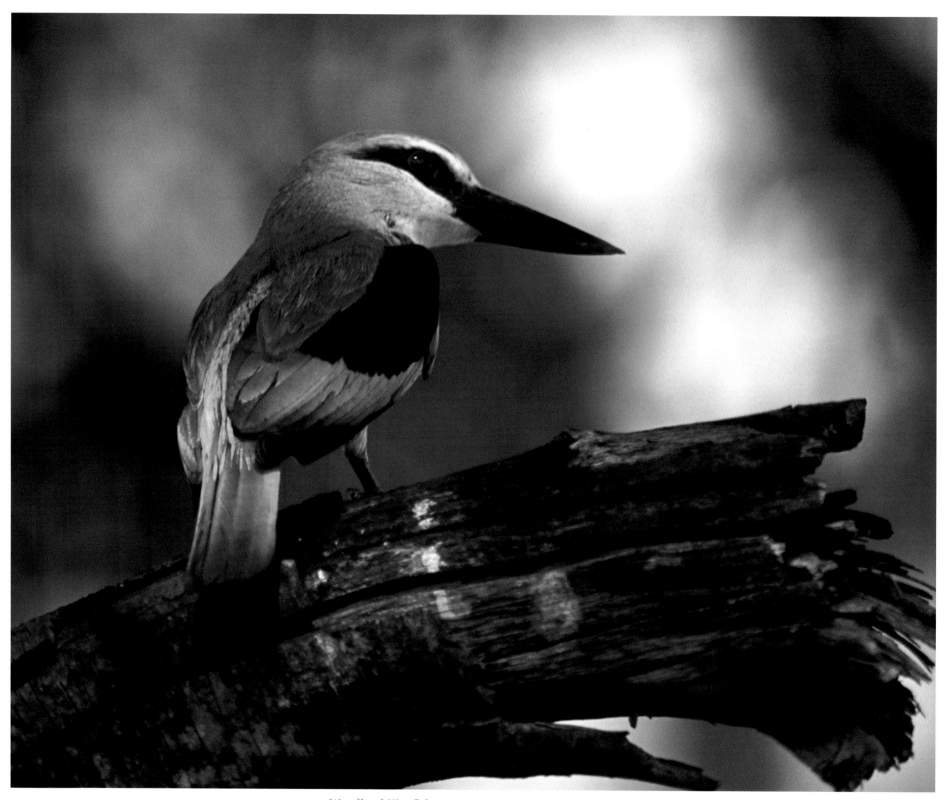

Woodland Kingfisher

*"Spirit of Beauty, that dost consecrate with thine own
hues all thou dost shine upon."*
– Percy Bysshe Shelley

A woodland kingfisher perches motionless until
a large insect or small lizard appears. It then dives
on its prey and takes it back to its perch, where
it pounds it repeatedly to remove the legs or wings
before swallowing it.

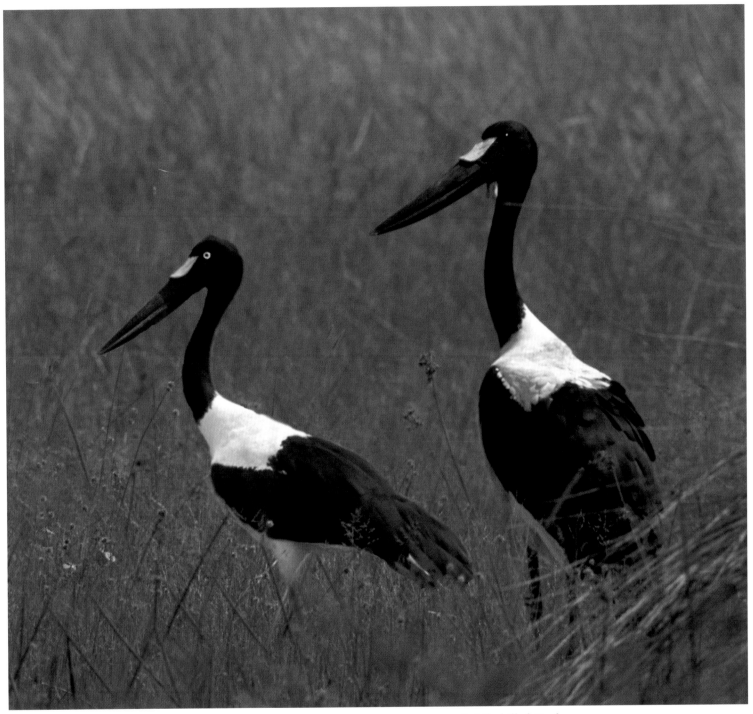

Saddle-billed Storks

*"Every generation laughs at the old fashions, but follows
religiously the new."*
– Henry David Thoreau

The unusually large bills of these storks make them
adept at attacking small animals such as frogs, fish and
rodents. Note that the male and female have different
eye coloring.

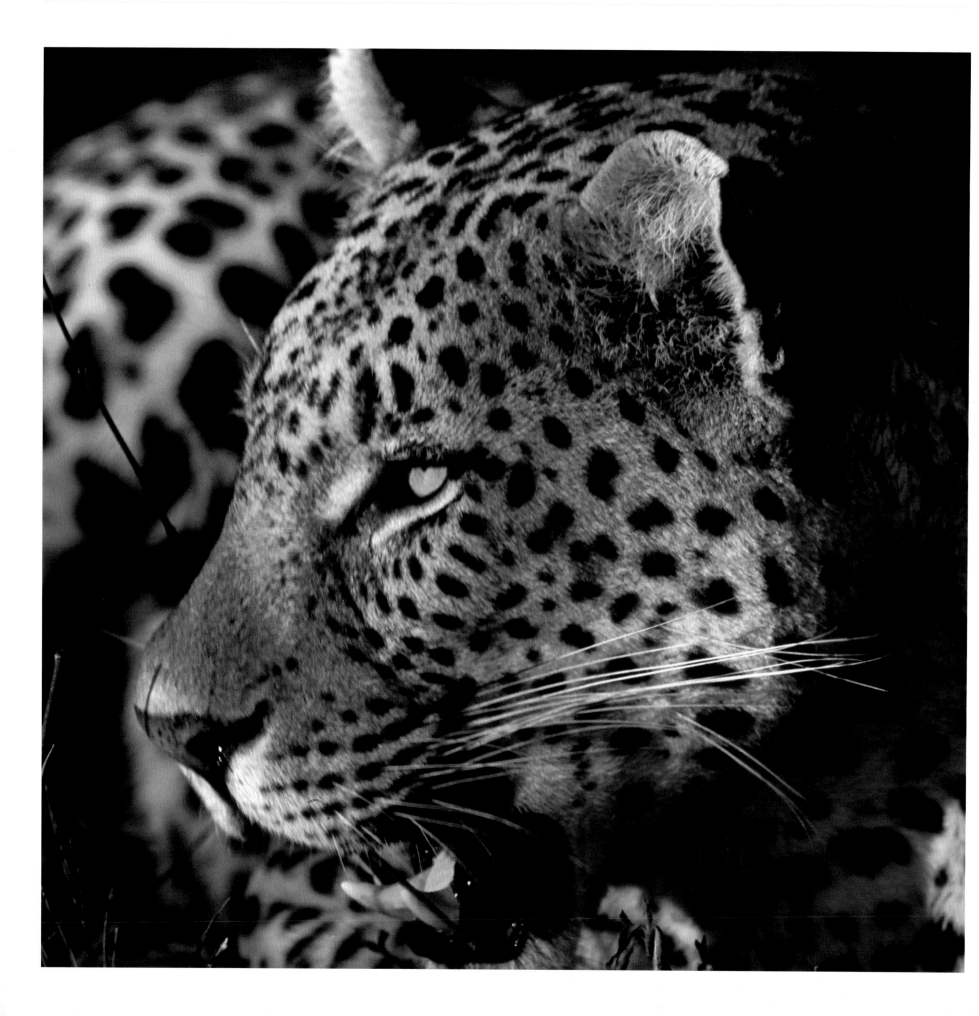

Leopard (previous page)

"Nature, red in tooth and claw."
– Alfred, Lord Tennyson

Leopards are equally good at running, jumping, tree-climbing and swimming across rivers. Using patience and stealth, they creep up to within five yards of their quarry before pouncing. Generally leopards are shy, but this elegant specimen calmly walked by an open Land Rover that I was sitting in, well within the parameters of the five-yard pouncing distance.

African Fish Eagle

"Elegance is a state of mind."
– Oleg Cassini

The African fish eagle is closely related to the North American bald eagle. Both catch fish by swooping down with extended legs to grasp prey with their talons. Fish eagles are so successful at fishing that they can spend ninety percent of the day resting or preening.

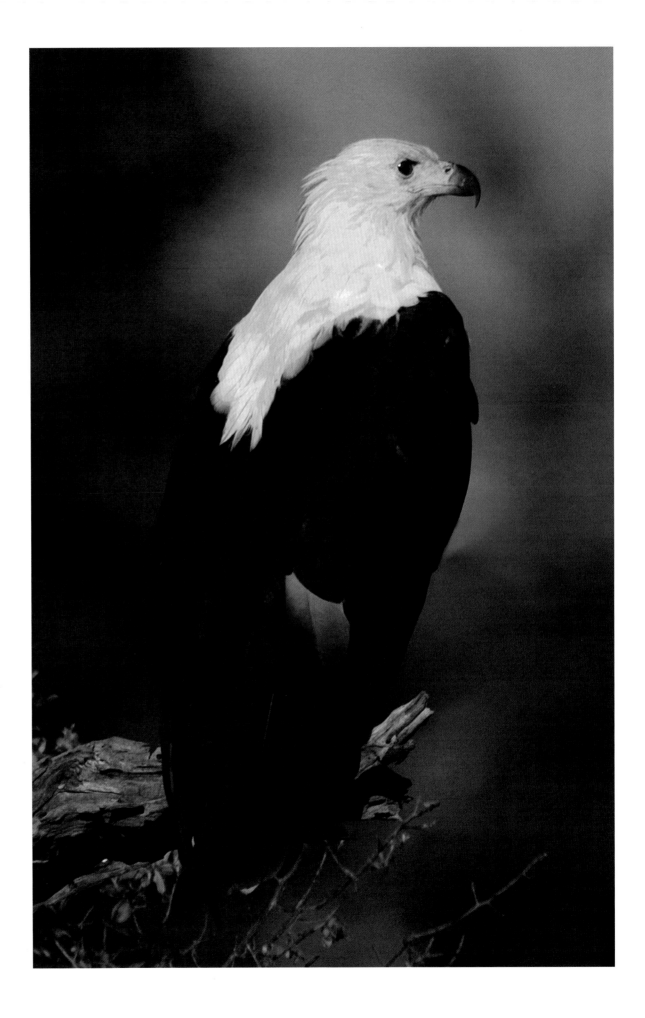

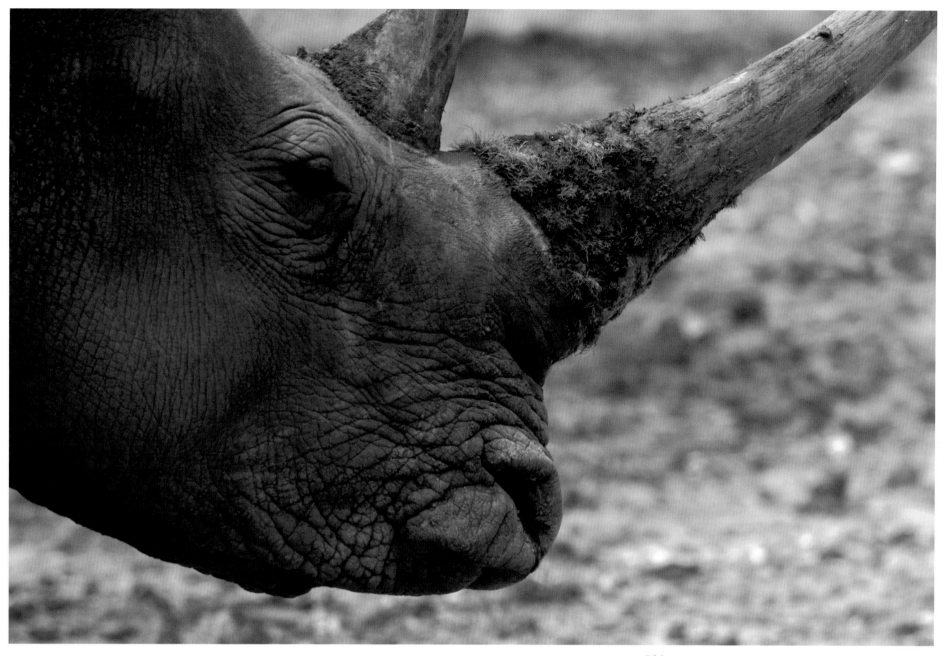

Rhinoceros

"The Lord prefers common looking people. That's why he made so many of them."
– Abraham Lincoln

Rhinoceroses spend most of their time eating. Because their horns, made of keratin like human fingernails, are thought by some to be an aphrodisiac, and also are prized in Yemen as dagger handles, rhinoceroses have been hunted almost to extinction.

Hippopotamus

"When you have eliminated the impossible, whatever remains, however improbable, must be the truth."
– Sir Arthur Conan Doyle

These animals weigh from four thousand to seven thousand pounds. They are found in the water during the day in herds of ten to fifty. They come on shore at night to graze, when it is cooler. Although they are not meat eaters, they kill more humans than any other animal in Africa. Fatalities occur when people get between hippos and their path to the water, or when a hippo upends a boat. Their powerful jaws can bite a ten-foot-long crocodile in two.

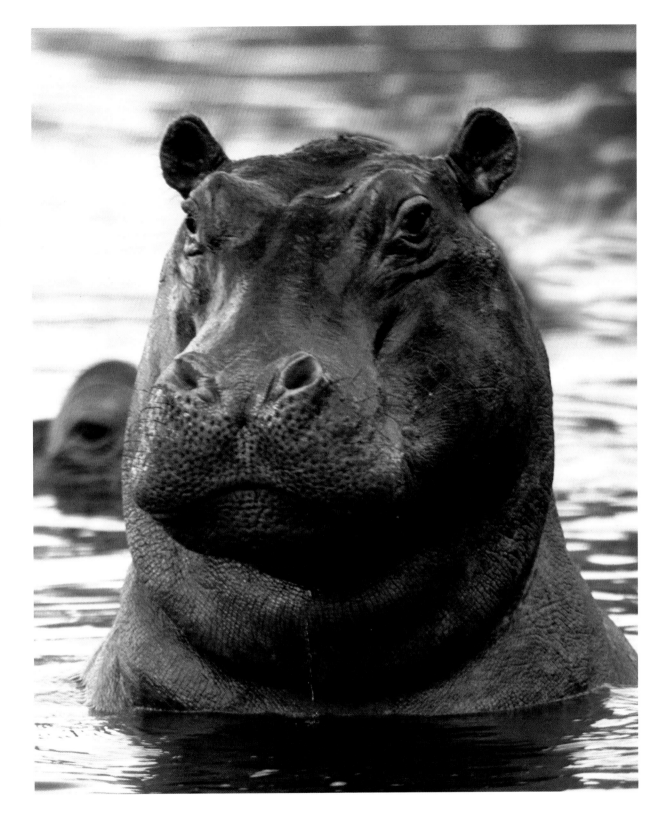

Impala

"Now, here, you can see, it takes all the running you can do, to keep in the same place. If you want to get somewhere else, you must run at least twice as fast."
– Louis Carroll

Impalas are found in large herds. It is thought that their high leaps into the air demonstrate to a predator that they are healthy animals. Females in a herd synchronize giving birth to within a couple of weeks of each other. This is known as predator swamping—the production of so many young that predators are unable to catch them all.

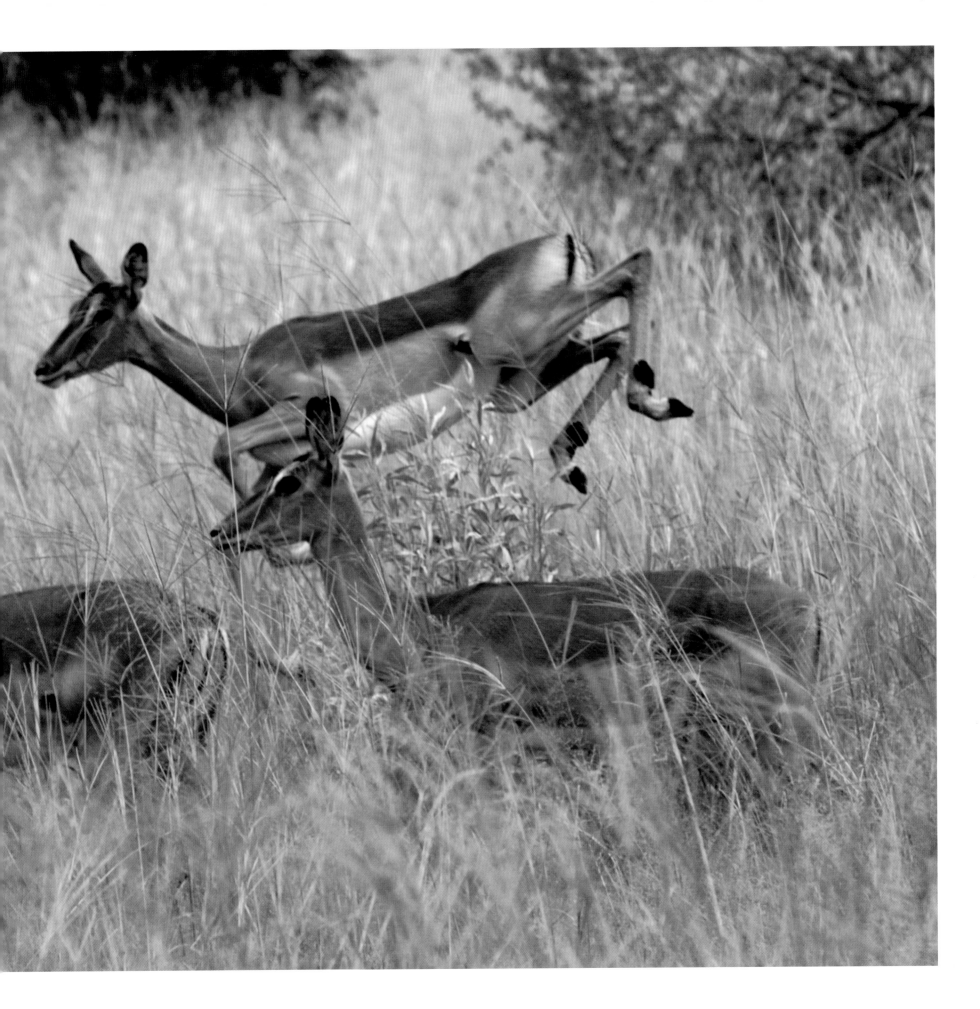

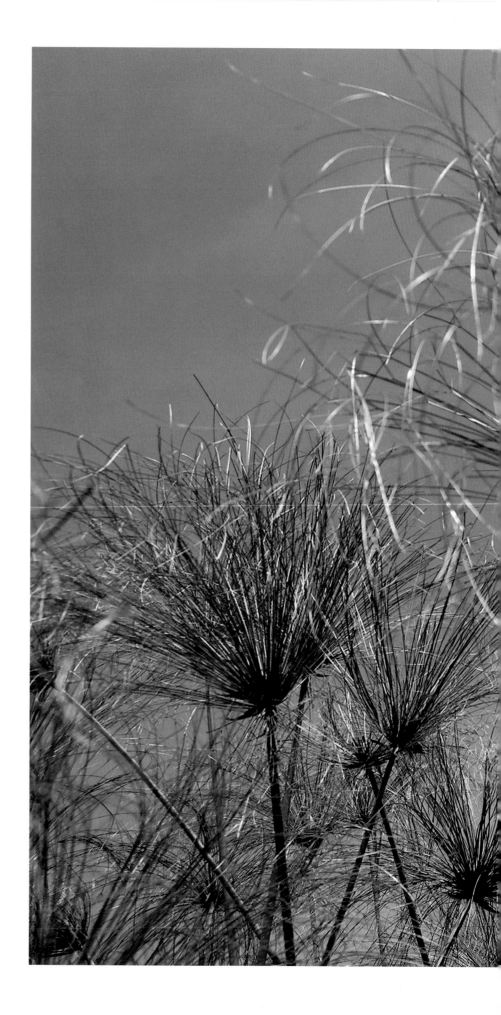

Papyrus Reeds

"A poet could not but be gay,
In such a jocund company."
– William Wordsworth

In the middle of the vast expanse of the Kalahari Desert lies an oasis that is wet, fertile and filled with life: the Okavango River Delta of Botswana, the largest inland delta in the world. Much of it is filled year round with water from central Africa. Tall papyrus reeds line the waterways, trapping nutrients and adding to the fertility. In other parts of the Okavango, where streams have changed course, sweet grasslands provide food and shelter for the abundance of wildlife.

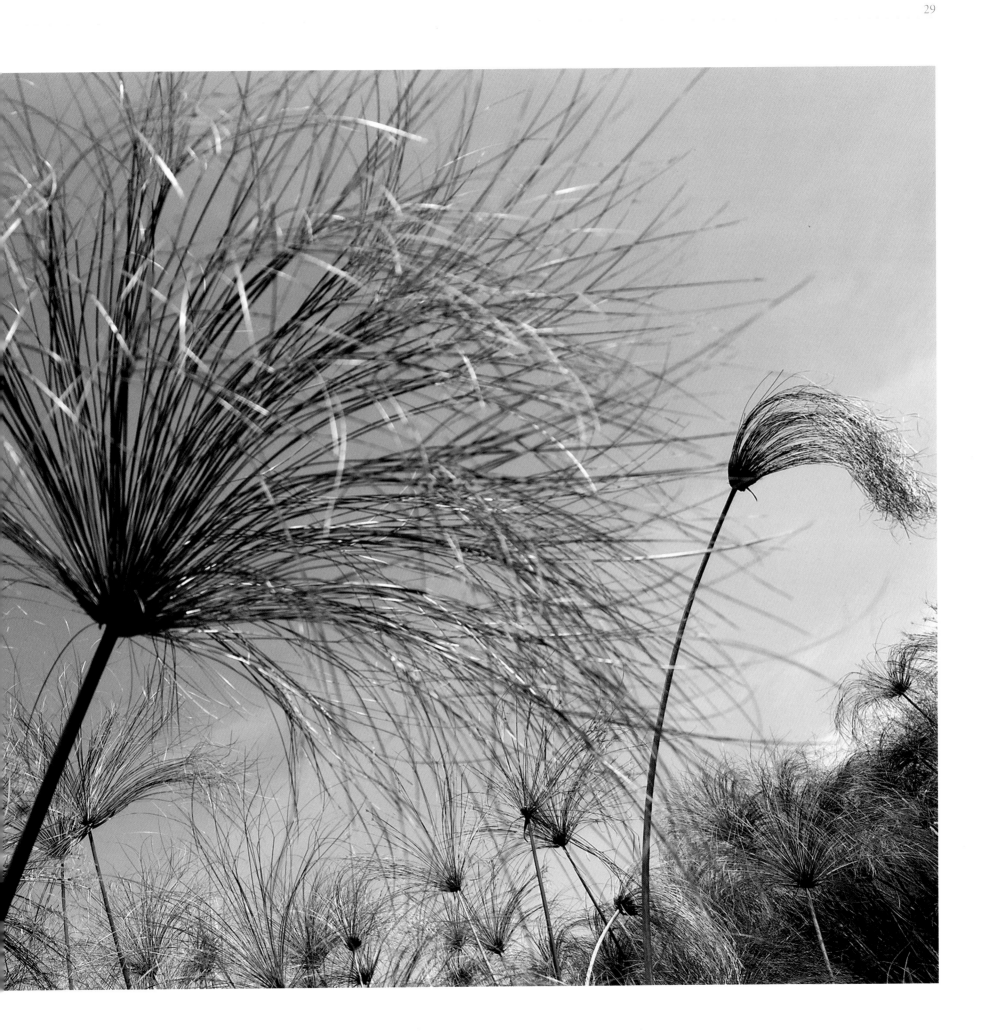

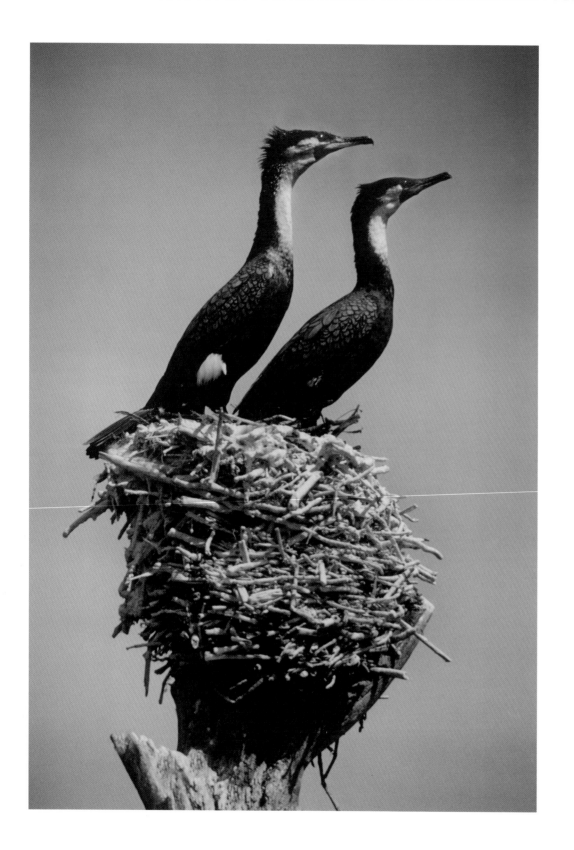

"In the spring, a young man's fancy lightly turns to thoughts of love."
– Alfred, Lord Tennyson

Cormorants are skillful divers, catching most of their food under water where the chase may last for up to a minute.

*"I'll get by
as long as I
have you."*
– Roy Turk

These elegant birds are the rarest cranes in Africa. They mate for life and both parents care for the offspring.

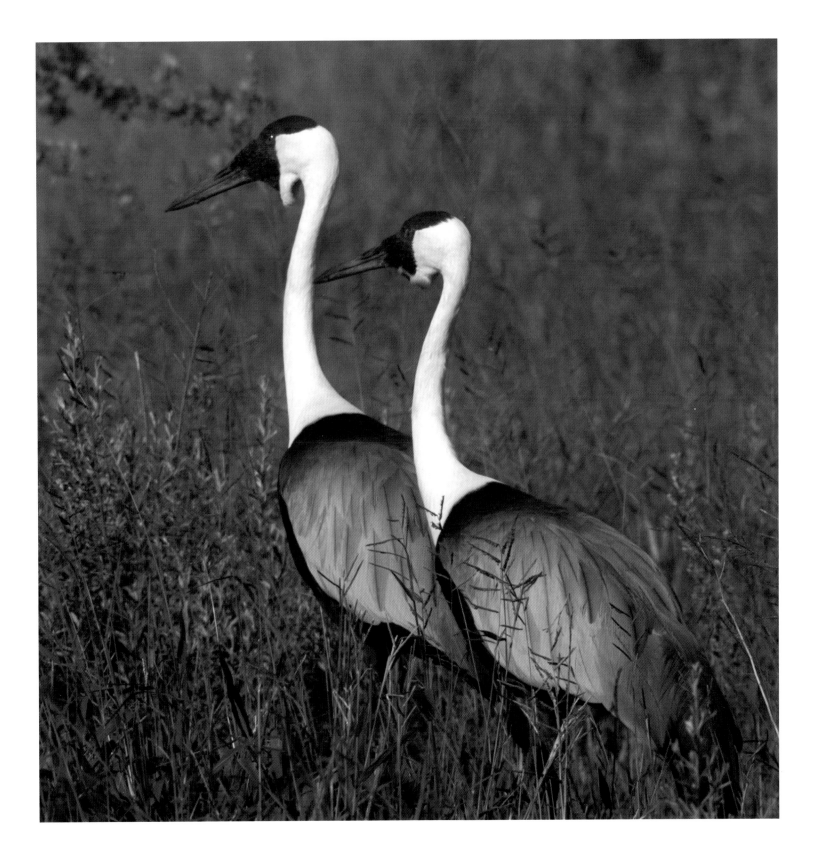

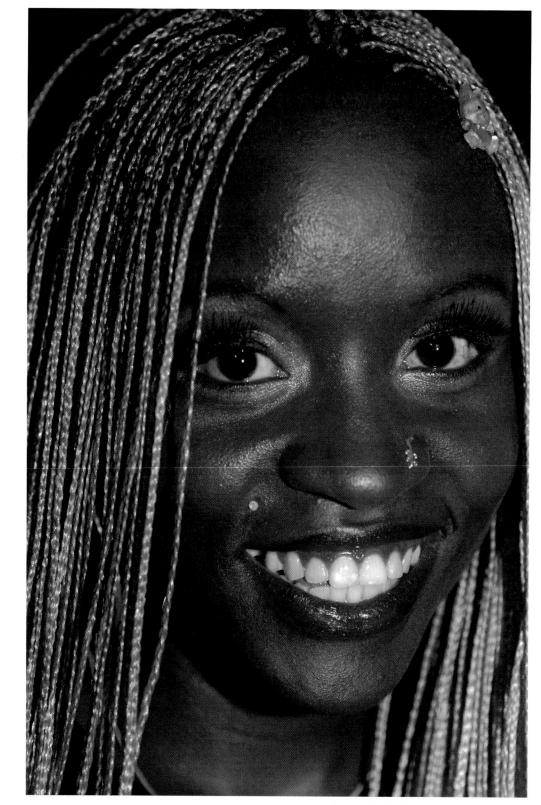

Young Girl, Windhoek

"She walks in beauty like the night..."
– Lord Byron

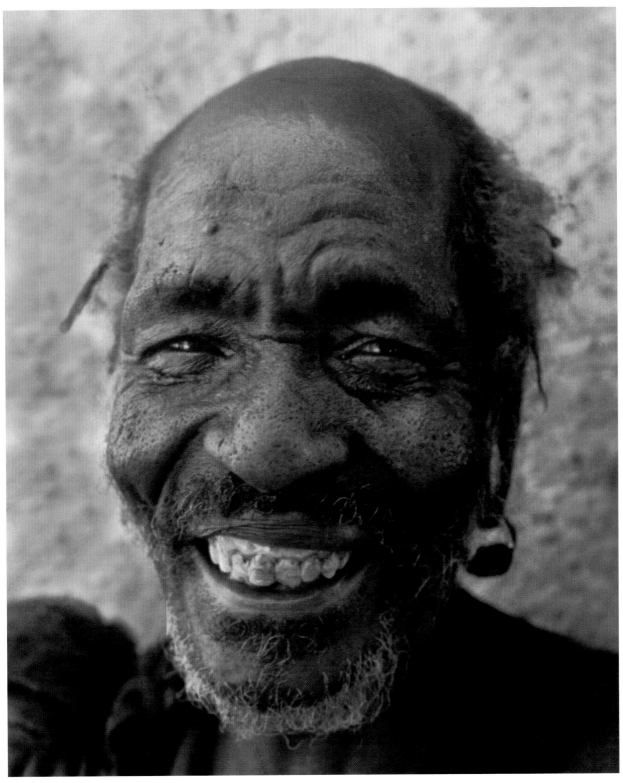

Tribal Elder

"To me old age is always ten years older than I am at the time."
– Bernard Baruch, on his eighty-fifth birthday

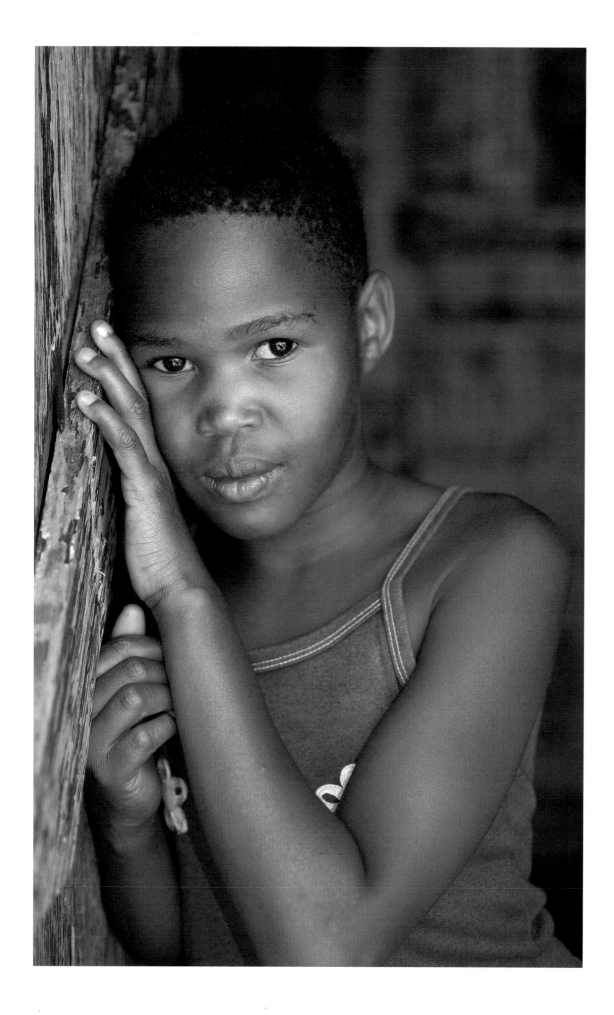

Young Girl, Soweto

"A child's mind is fresh and new and beautiful, full of wonder and excitement."
– Rachel Carson

In two successive years, I visited Kliptown, one of the poorest shantytowns near Johannesburg. My good friend, the late Eli Segal, helped to establish the South African branch of City Year, an organization of volunteers that works in Kliptown and similar communities and has dramatically improved the lives of the inhabitants.

Children and Dog, Soweto (facing page)

"A child is not a vase to be filled, but a fire to be lit."
– Francois Rabelais

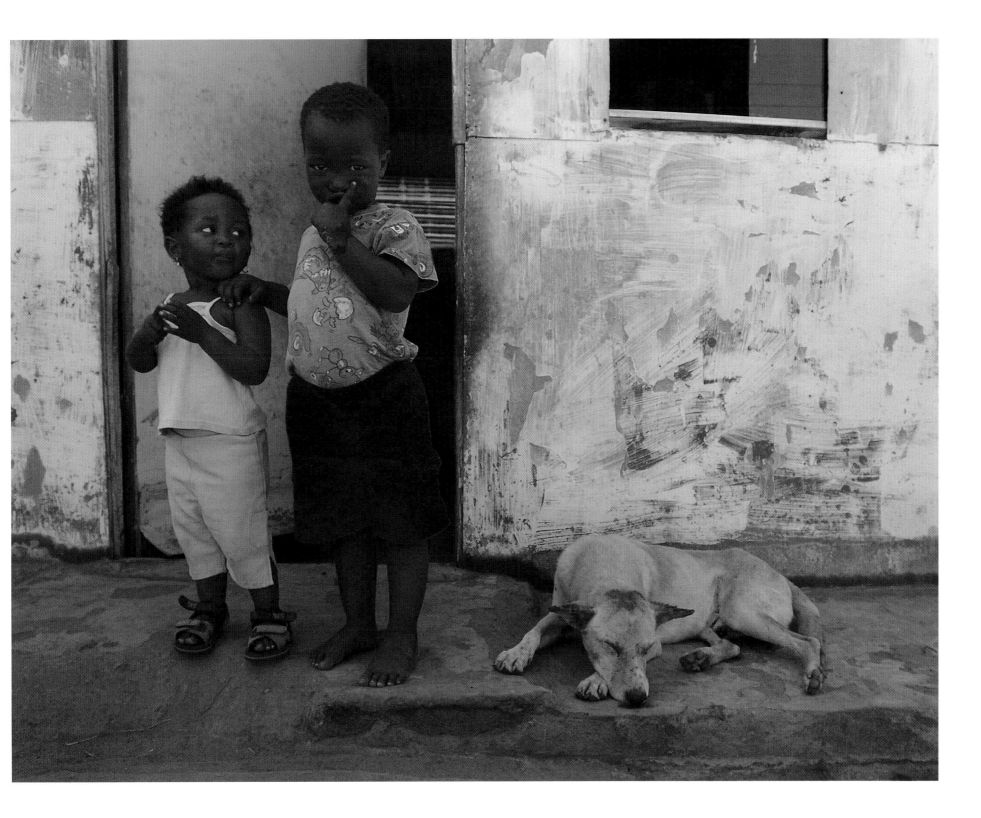

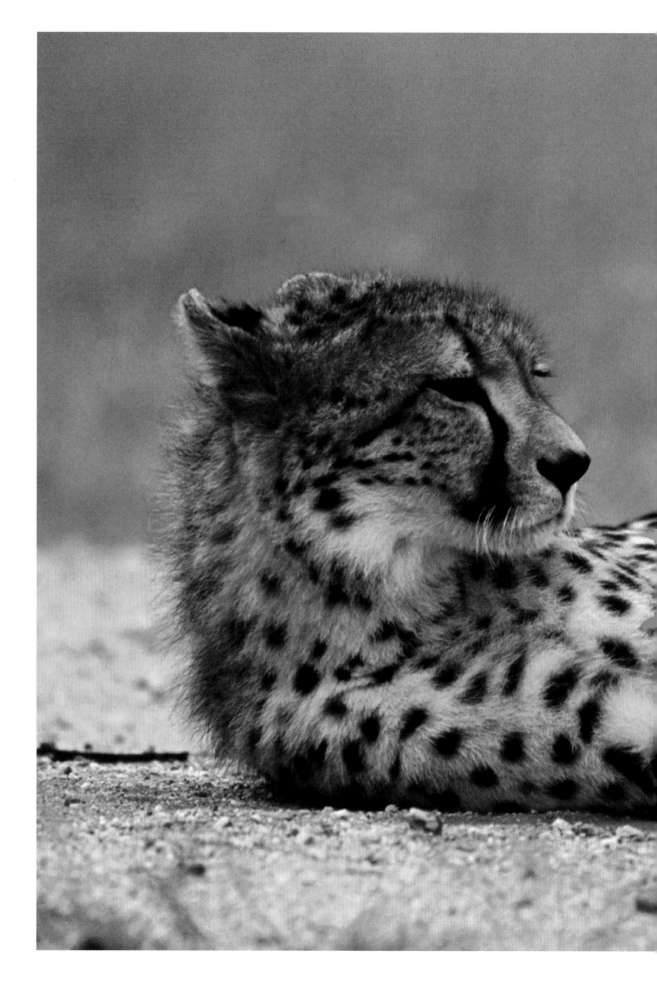

Mother and Daughter Cheetahs

"The most ferocious animals are disarmed by caresses to their young."
– Victor Hugo

Cheetahs are the fastest animals on earth. From a standing position, they can reach seventy miles per hour in just a few seconds. They hunt in open grassland where speed is to their advantage and where they can protect themselves best from their enemies. Unlike most predators, they hunt during the day. The black lines down their faces perform the same function as eye-black for baseball players, protecting their eyes from the glare of the sun. Of the big cats, cheetahs are the most endangered species. Most cheetah cubs do not survive adolescence; many are eaten by lions.

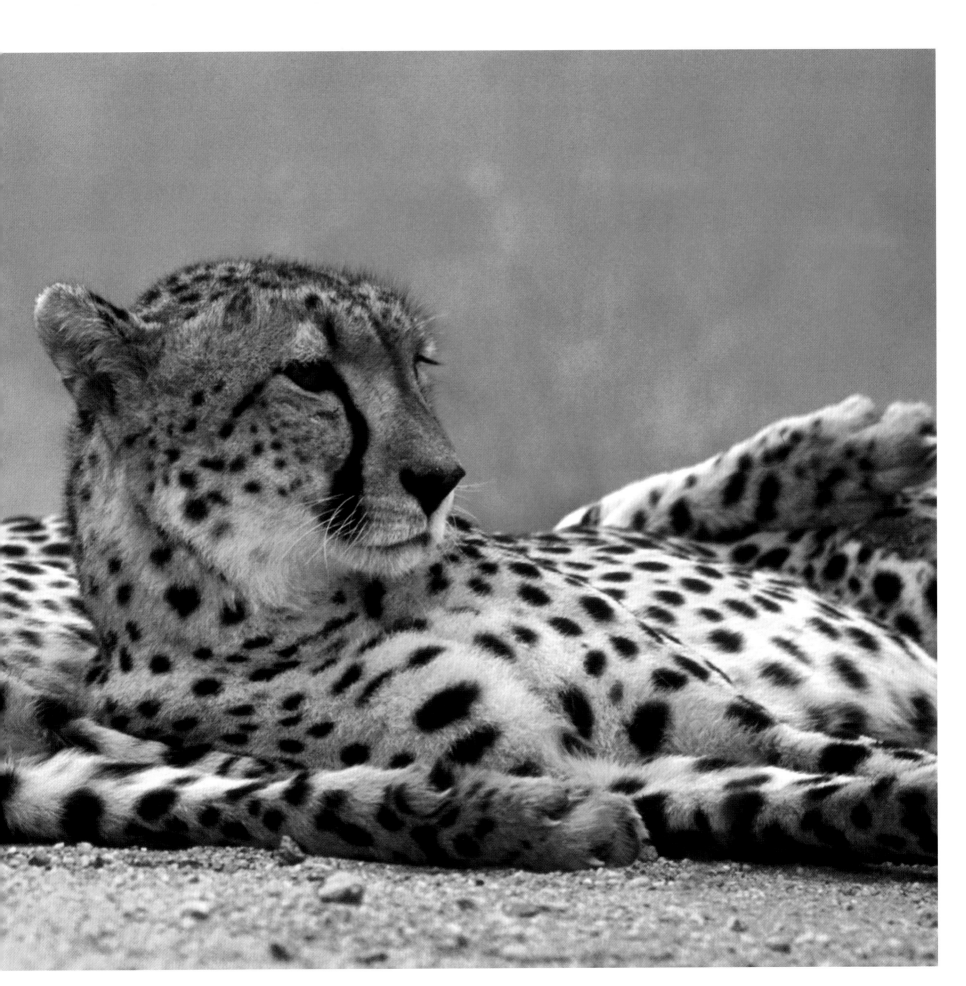

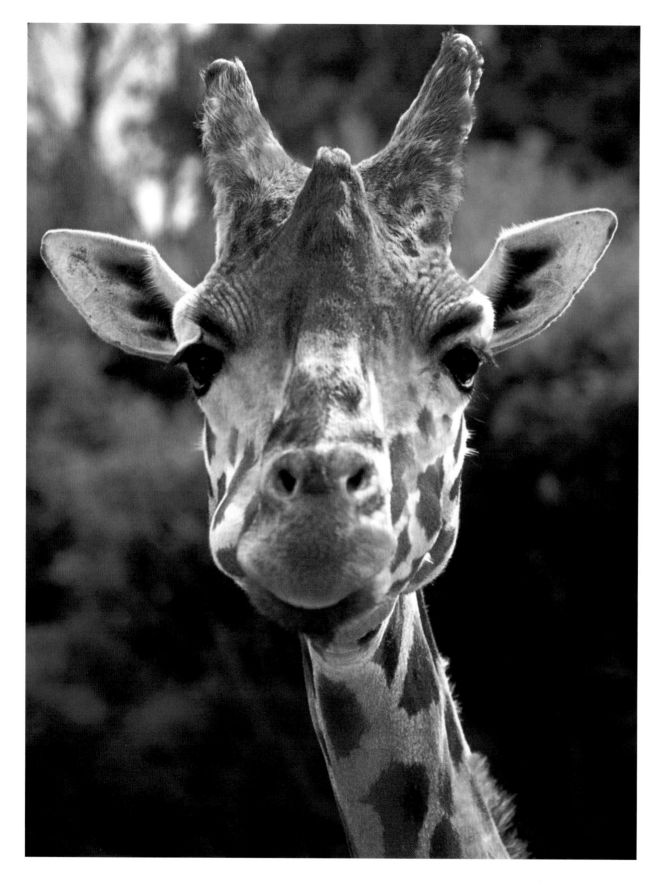

Giraffe

"He was fresh and full of faith that 'something would turn up'."
– Benjamin Disraeli

The tallest land animal, the giraffe is able to browse on acacia leaves, its main food, nineteen feet above the ground. The animal's massive twenty-five pound heart pumps blood against gravity all the way up to its head. An adult giraffe is strong enough to kill a lion with one kick.

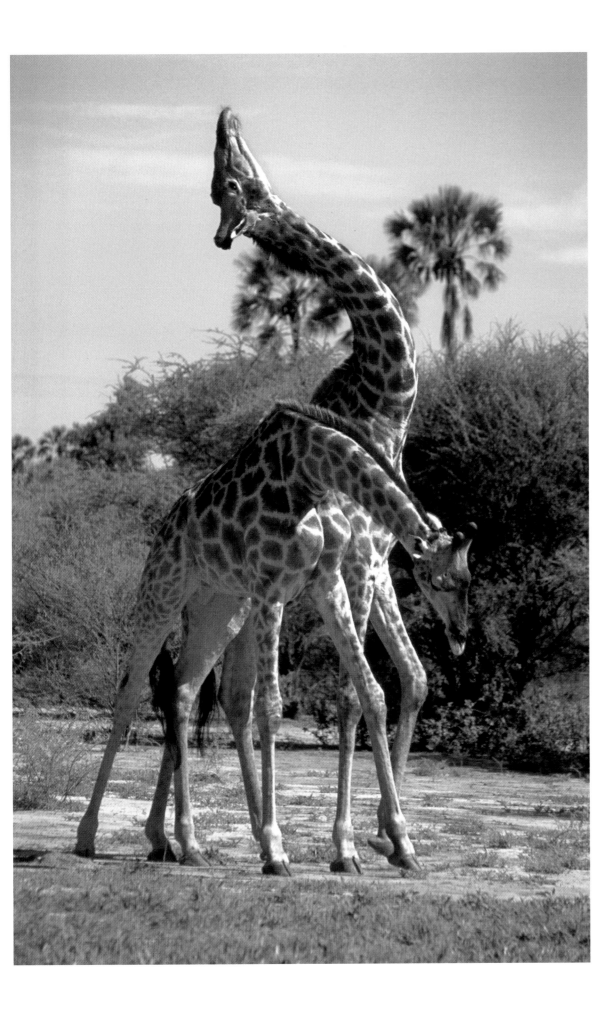

Giraffes Necking

"Most sorts of diversion in man, children and other animals, are an imitation of fighting."
– Jonathan Swift

One male giraffe establishes dominance over another by standing next to him, swinging his neck back and forth and striking his opponent. The two hit each other with their necks until one gives up. Usually no harm is done, but one giraffe is capable of breaking the neck of another.

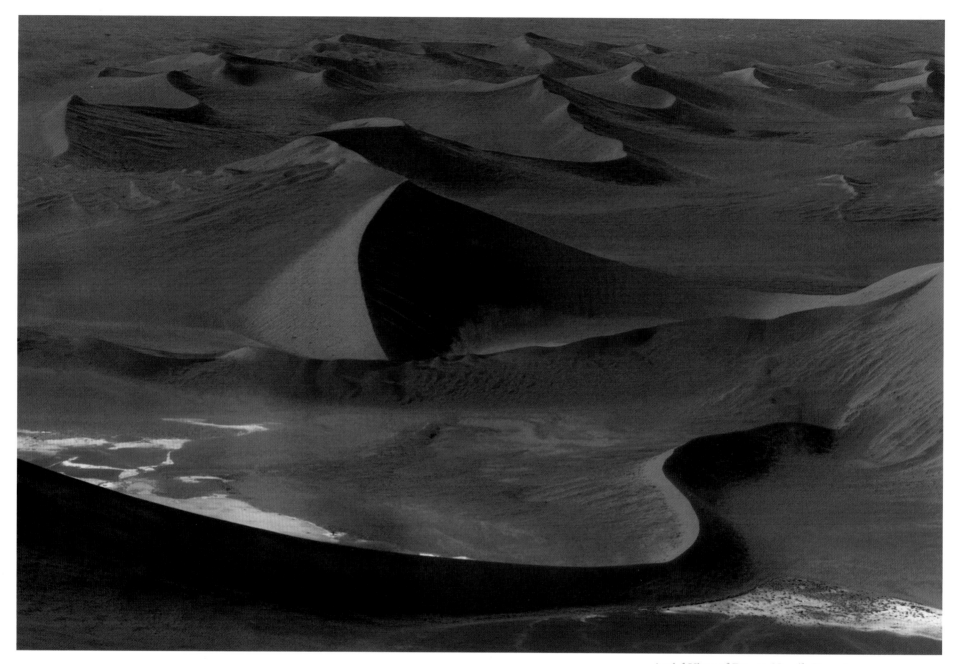

Aerial View of Dunes, Namib Desert

"But at my back I always hear
Time's winged chariot hurrying near:
And yonder all before us lie
Deserts of vast eternity."
– Andrew Marvell

The Namib desert stretches for fourteen hundred miles along the coast of southwest Africa and for about one hundred miles inland. Scientists say that it has existed for eighty million years, making it the oldest desert in the world.

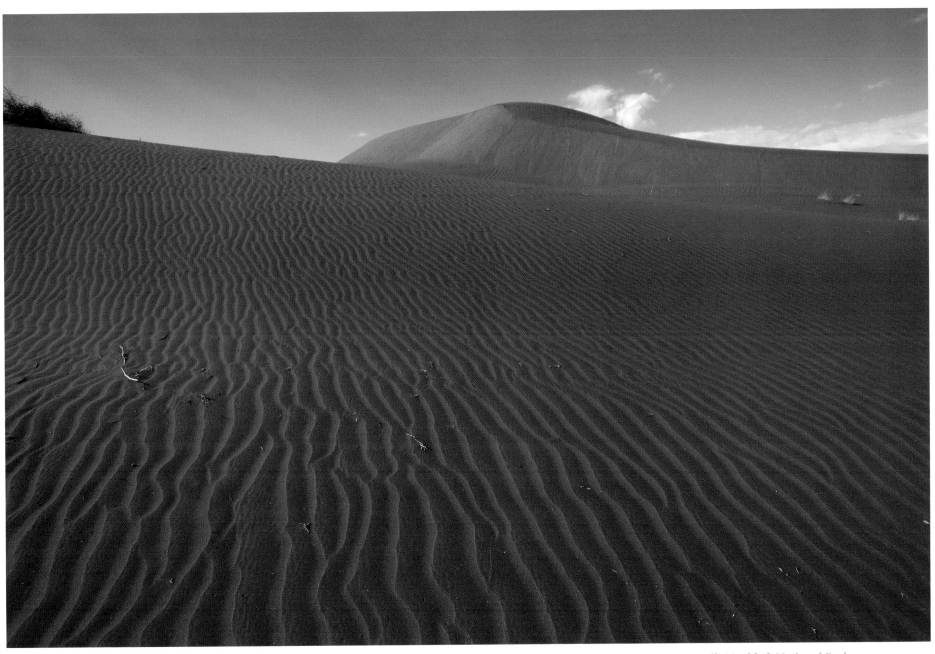

Dunes, Namib-Naukluft National Park

"I believe a leaf of grass is no less than the journeywork
of the stars."
– Walt Whitman

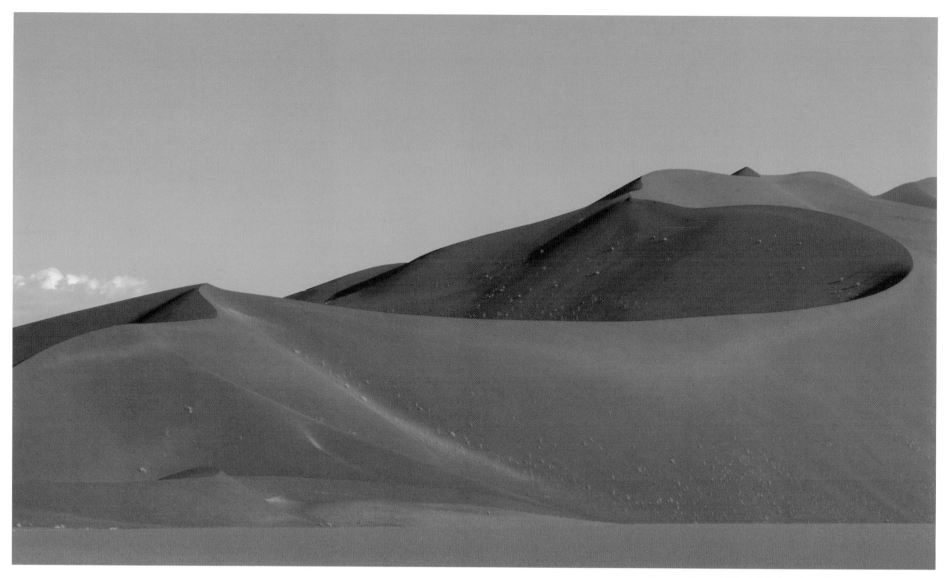

Dunes, Namib-Naukluft National Park

*"To say nothing is out here is incorrect; to say the
desert is stingy with everything except space and light,
stone and earth is closer to the truth."*
– William Least Heat-Moon

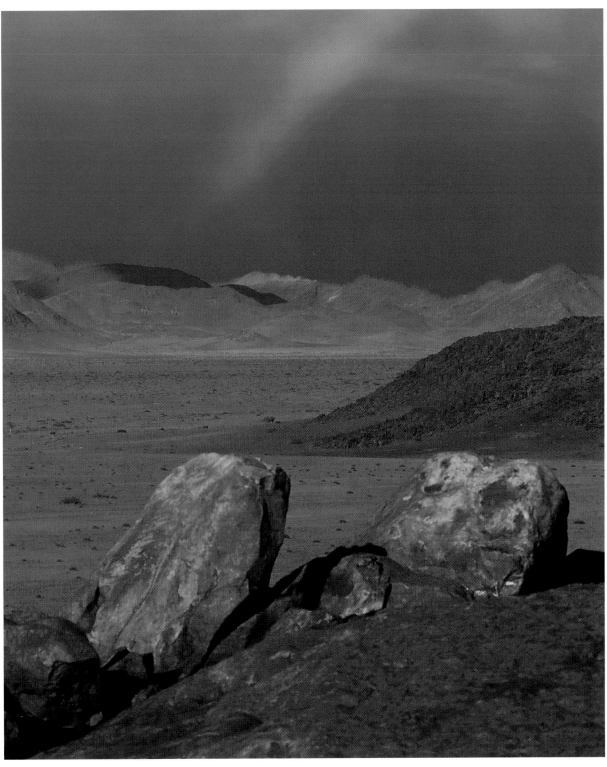

Namib Desert with Rainbow, Sossusvlei

*"All any man can hope to do is add his fragment
to the whole.
What he leaves is stones for others to step on or
stones to avoid."*
– Robert Henri

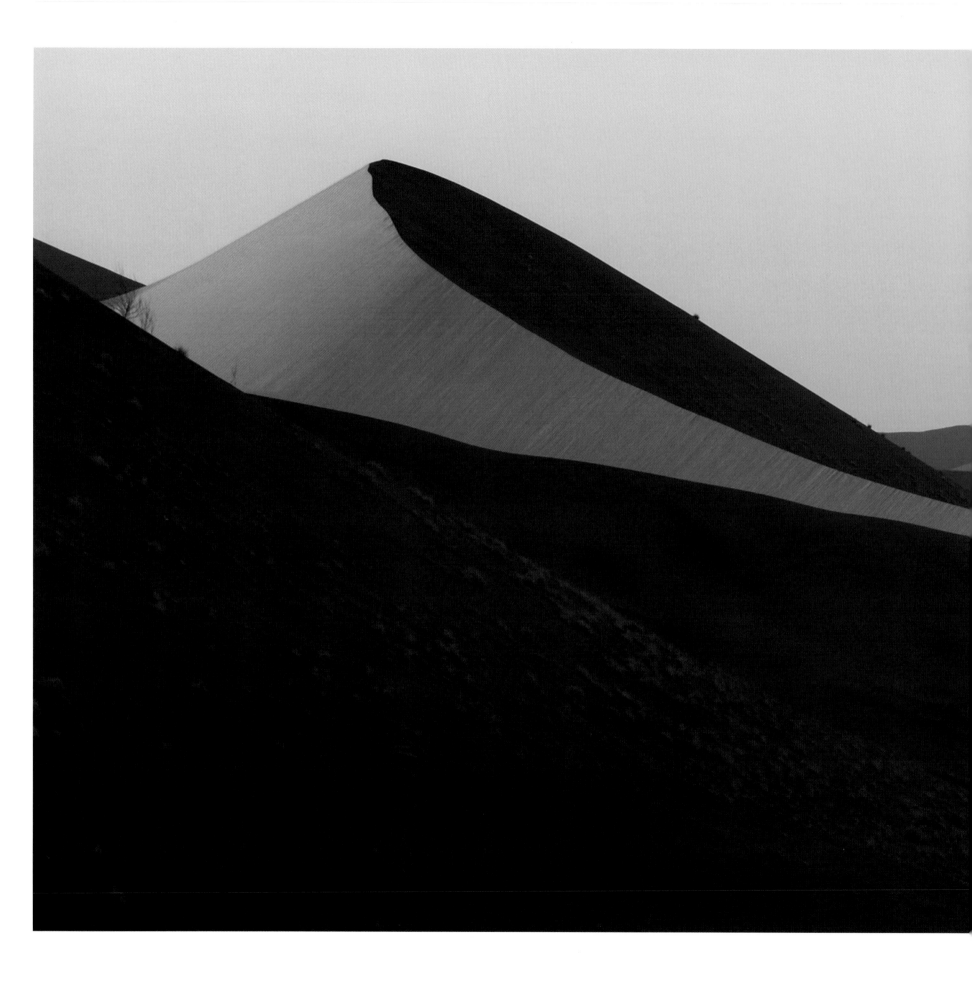

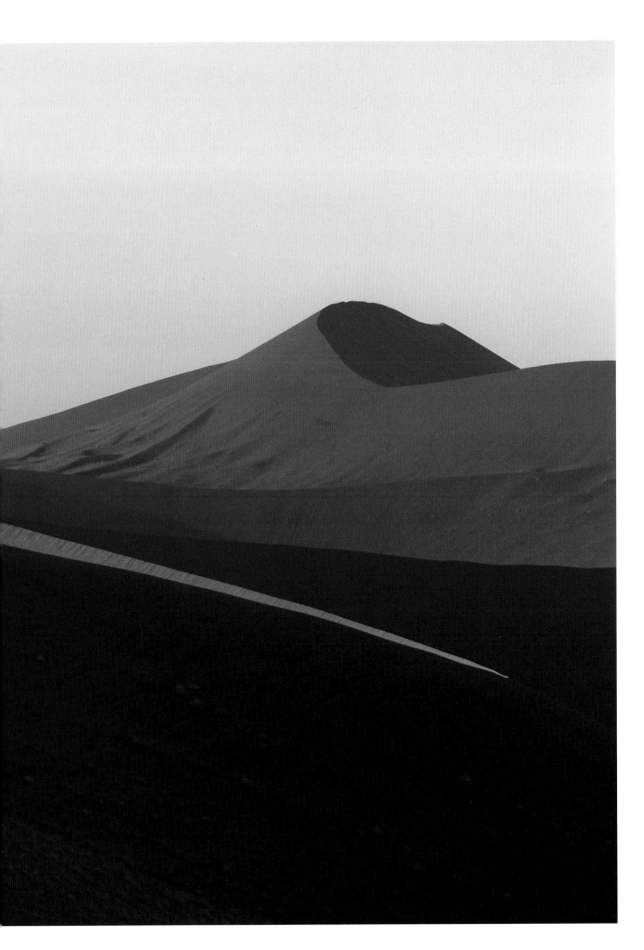

Dunes at Daybreak, Namib-Naukluft National Park

"Don't overdo it, don't underdo it, do it just on the line."
– Andrew Wyeth

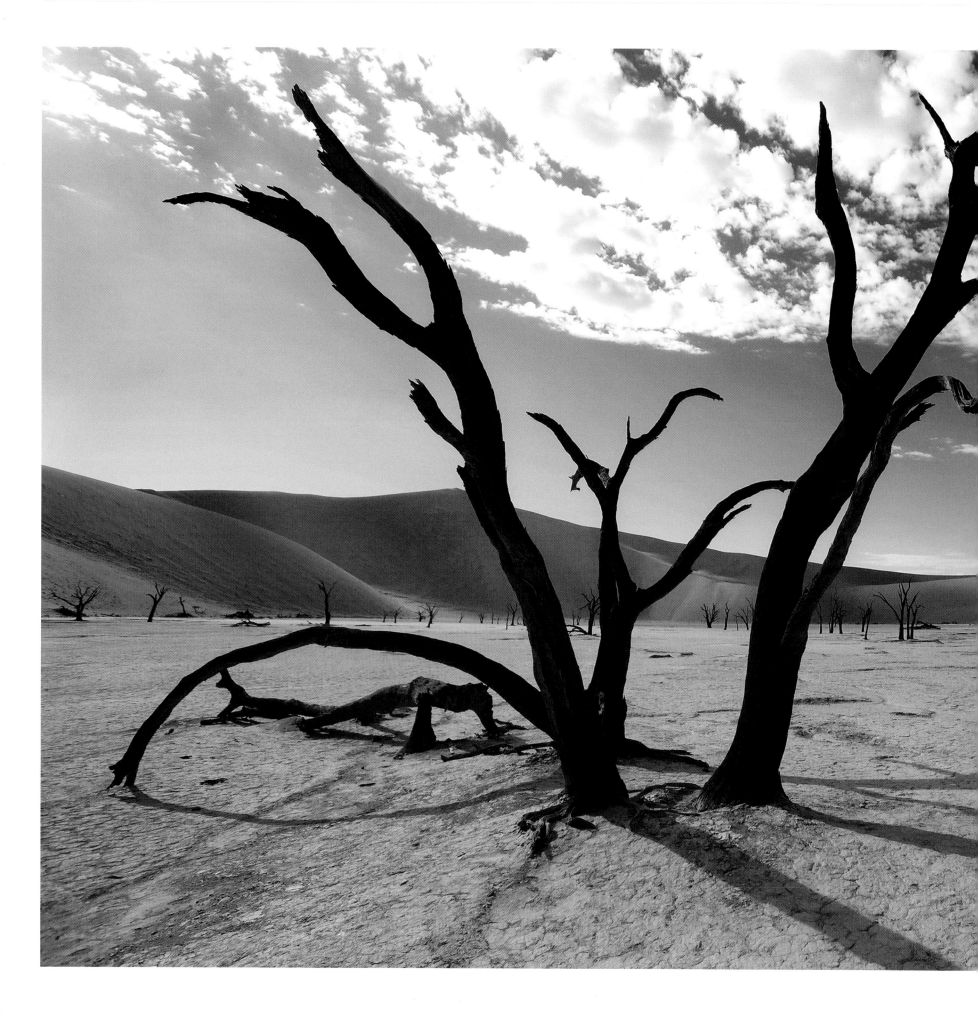

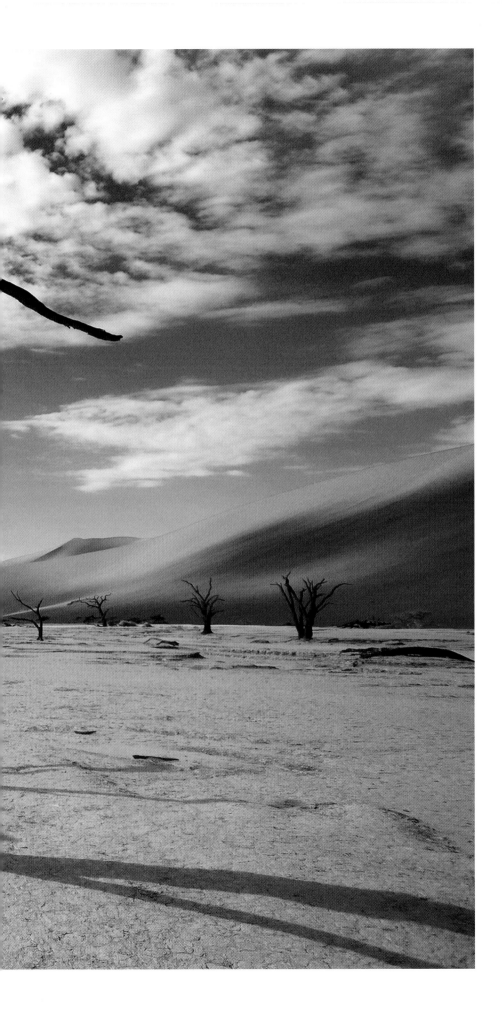

Dead Lake, Namib-Naukluft National Park

"The poetry of earth is never dead."
– John Keats

This shallow lake dried up over eight hundred years ago, but the trees have not decayed because the land is so arid.

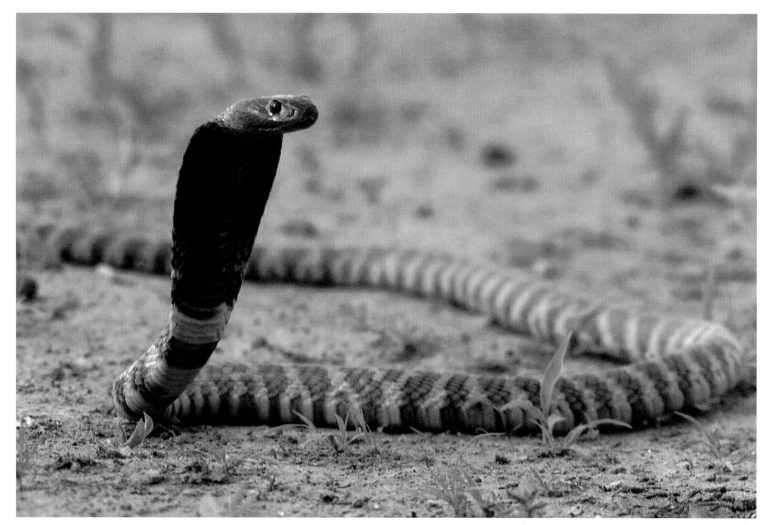

Spitting Cobra, Ongava Reserve, Northern Namibia

"There is no forgiveness in nature."
– Ugo Betti

I was three feet away from this snake when I took
this photograph. The snake had been captured in the
camp by my guide, a former snake handler. He
told me that these cobras can spit their venom into a
victim's eyes with great accuracy from as much as
ten feet away, causing temporary blindness. Their bite
can be fatal and there is no antidote. The guide
said, however, that this snake had probably exhausted
its venom during its capture, and I am glad that he
was right. He himself had lost a finger when bitten by a
puff adder. He likened the pain to holding your finger
in a candle flame and not being able to remove it.

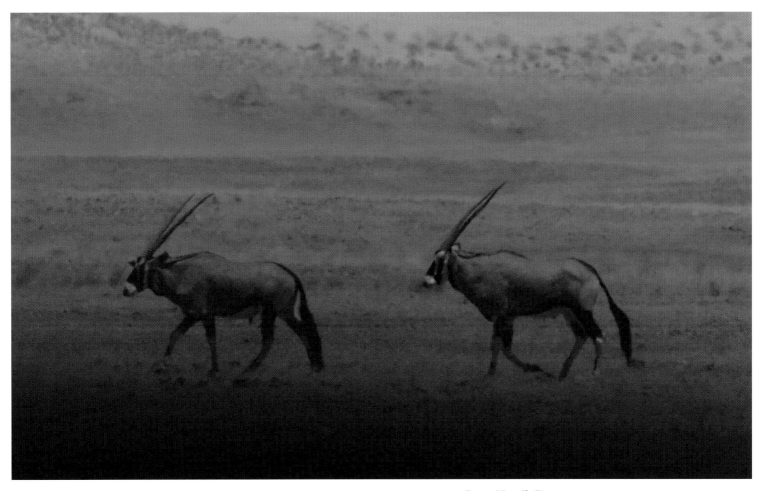

Oryx, Namib Desert

*"A man travels the world in search of what he needs
and returns home to find it."*
– George Moore

To survive in the severe heat and aridity, these large
animals have a cooling system in their sinuses
that lowers the temperature of the blood going to their
brains. They can live without drinking for a long
time, obtaining water from the succulents they eat and
feeding at night when plants have the greatest
water content.

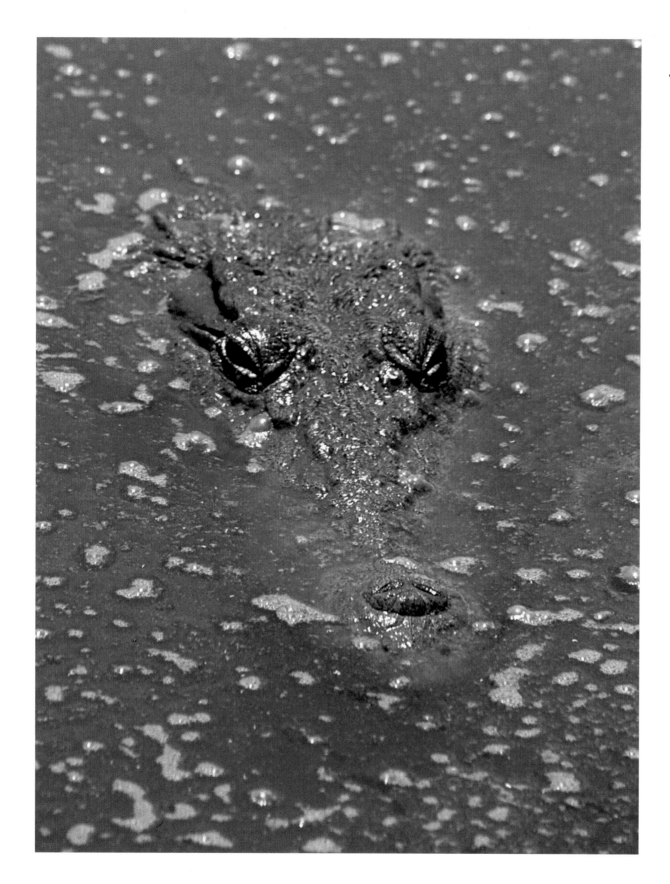

Crocodile

"A number of the bigger crocodiles are perversely unable to see the special nature of the human animal, and absent-mindedly eat him from time to time."
– Archie Carr

Crocodiles often live for over one hundred years. They can survive without food for twelve months, and can walk fifty miles on land in one day. They are virtually invisible when submerged, and are surprisingly swift when lunging at a victim. Propelled by their massive tails, they drag their prey underwater and drown it. Crocodiles may eat frogs and fish, but any animal is fair game. They have been known to eat antelopes, lions, zebras, wildebeests and domestic livestock. Crocodiles in Africa are also responsible for hundreds of human deaths each year.

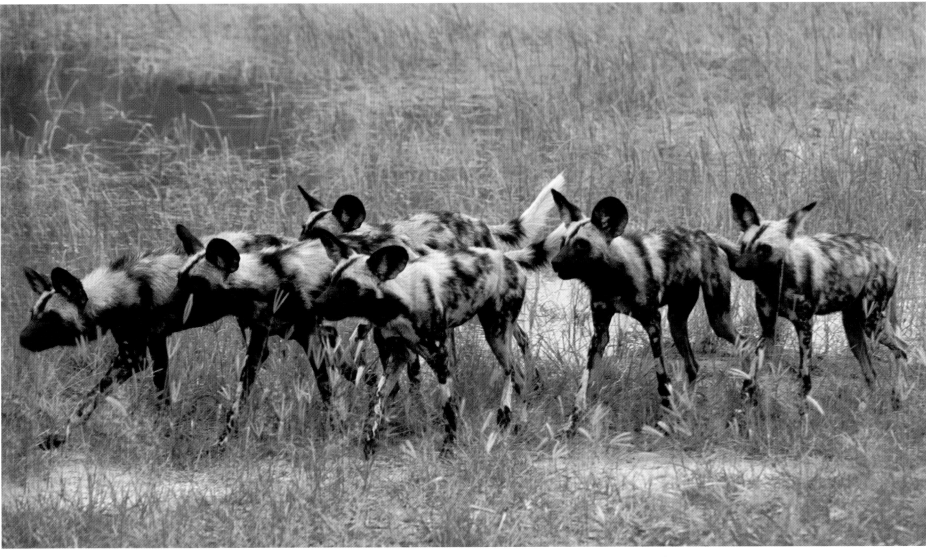

Wild Dogs

*"The strength of the pack is the wolf, and the strength
of the wolf is the pack."*
– Rudyard Kipling

Wild dogs are highly social and nomadic, their range
extending over hundreds of miles. A pack averages
twelve to twenty animals and revolves around an
alpha male and female, the sole breeding pair in the
group. Others in the pack help raise the puppies.
In this typical pack preparing for a hunt, the dogs all
work together because individuals cannot survive
on their own. Extremely efficient, these hunters catch
up to eighty-five percent of the animals they pursue.
I watched them hunt down and kill a warthog.
Tragically, with only five thousand wild dogs in exis-
tence, they are in serious danger of extinction.

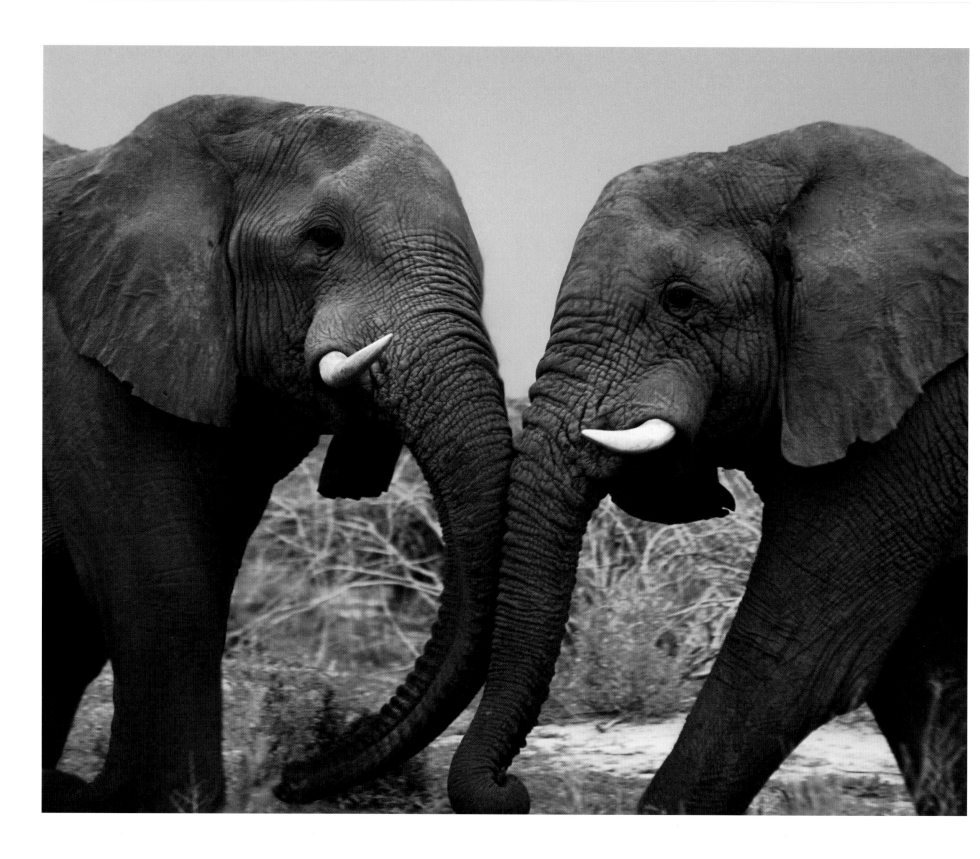

Elephants (previous page)

"An ancient life force, delicate and mighty, awesome and enchanted, commanding the silence ordinarily reserved for mountain peaks, great fires, and the sea."
– Peter Matthiessen

Elephants sometimes spend sixteen hours a day in search of food, often covering over thirty miles at a comfortable walking pace. In the course of twenty-four hours, they consume five percent of their body weight; thus, an eleven-thousand-pound elephant needs to eat five hundred fifty pounds of vegetation. The trunk of an elephant, which contains roughly one hundred thousand muscles, is used for such diverse functions as drinking, noise-making, smelling, showering with water or dust to cool off and chase away insects, and lifting everything from a leaf to a tree trunk.

Human beings and elephants have striking similarities. Their life spans are almost identical, and they have strong family ties. Humans are right- or left-handed; elephants are right- or left-tusked. The children of both species learn life skills from their mothers and fathers. After puberty--between the ages of ten and fifteen years--elephant teenagers leave their parents, but they do not mate until the age of twenty-five. Males, when they leave the fold, join bachelor societies where they spar with one another and test their strength to determine hierarchy. Females are highly selective when choosing a male. One major difference from humans: the gestation period for a female elephant is twenty-two months.

Victoria Falls

"Scenes so lovely must have been gazed upon by angels in flight."

This was a journal entry by Dr. David Livingston, after he became the first western man to see Victoria Falls in 1855. He named them after his queen.

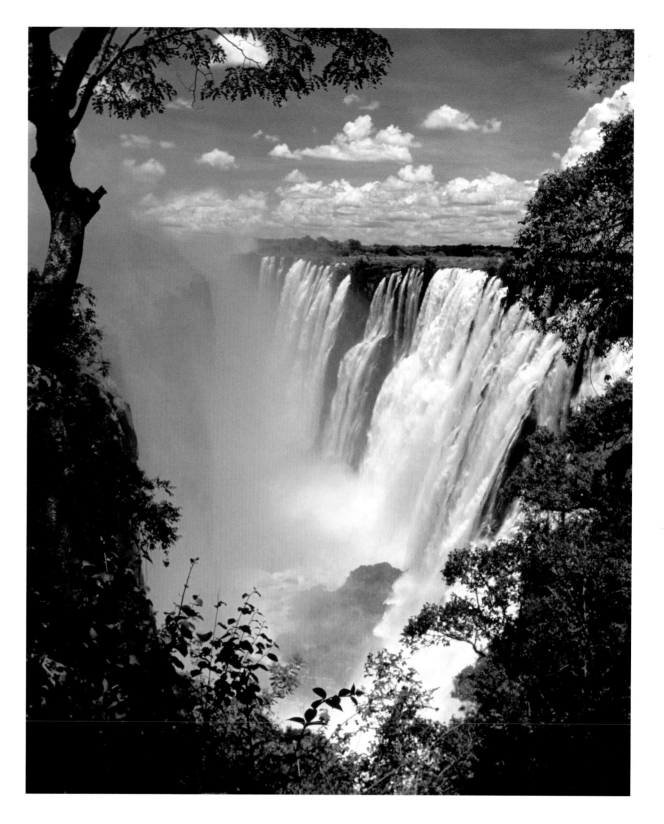

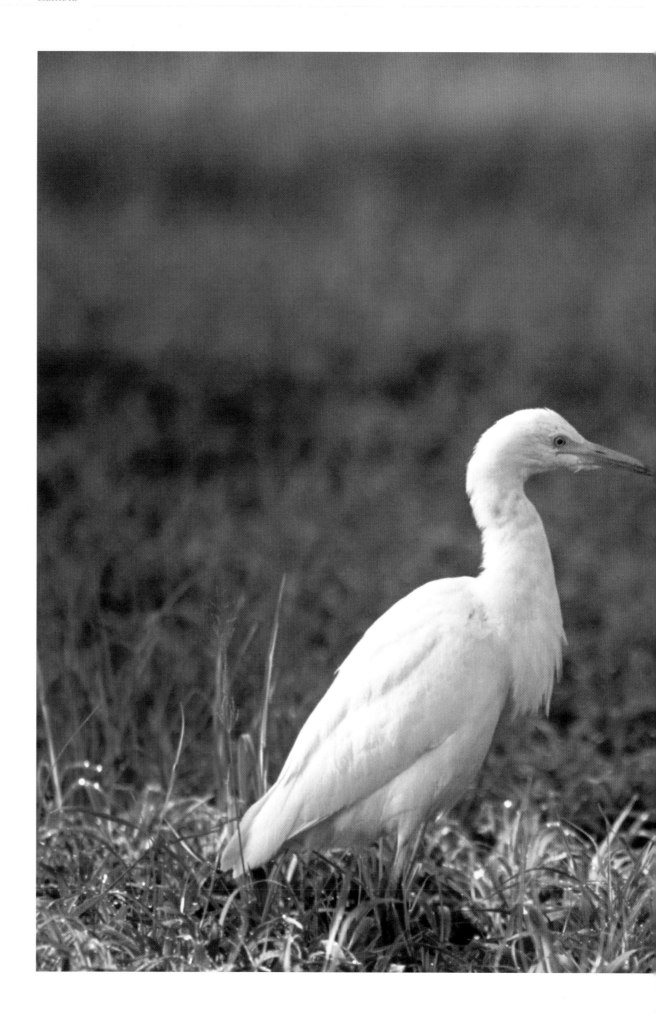

Zebra and Cattle Egret

"No man is an island, entire of itself."
– John Donne

Like fingerprints, the stripes of a zebra are unique.
In a herd, which might number one hundred
fifty animals, the mass of stripes confuses predators.
Nevertheless, zebras are still the favorite food of
lions and hyenas. Each adult stallion commands a
harem of four to ten females, which he defends
vigorously. Known for their nasty temperaments,
zebras injure more zookeepers than any other
animal. Cattle egrets follow large grazing animals,
such as zebras, using them as "beaters" to stir
up grasshoppers and other insects.

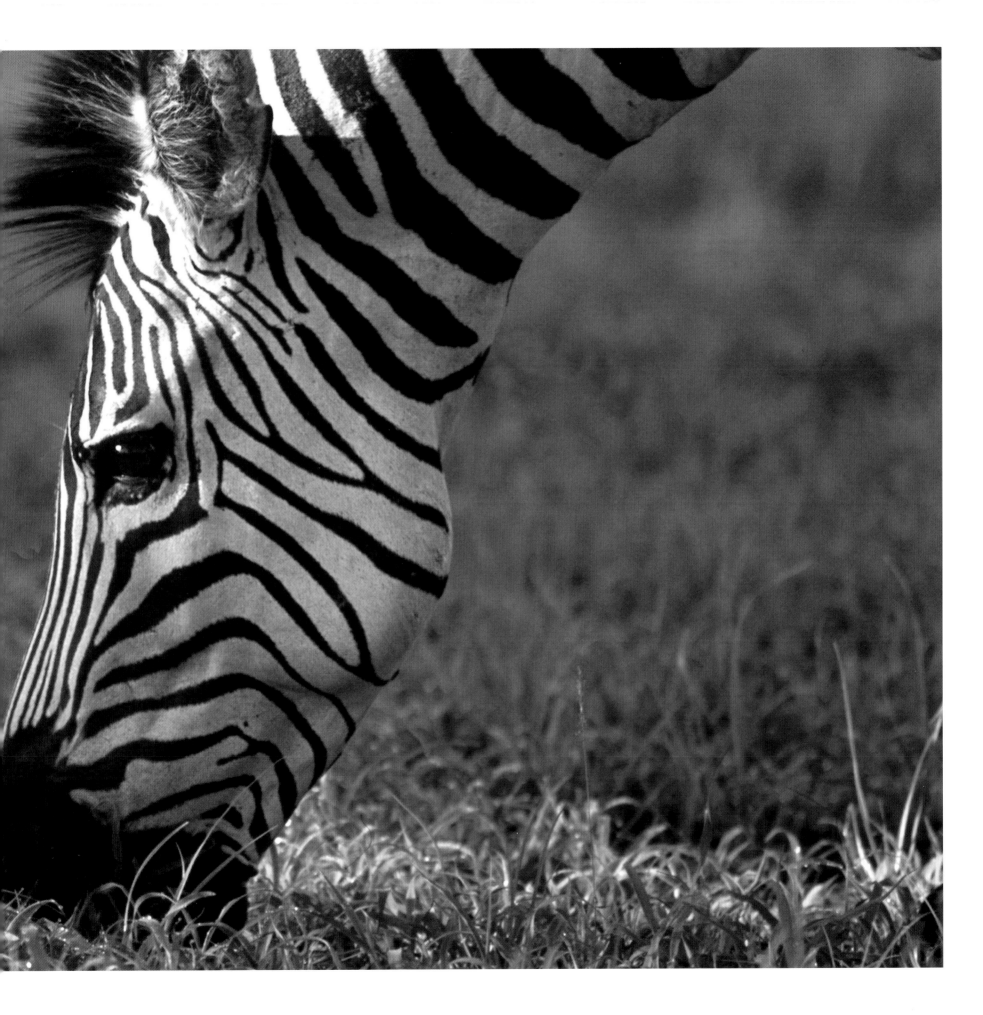

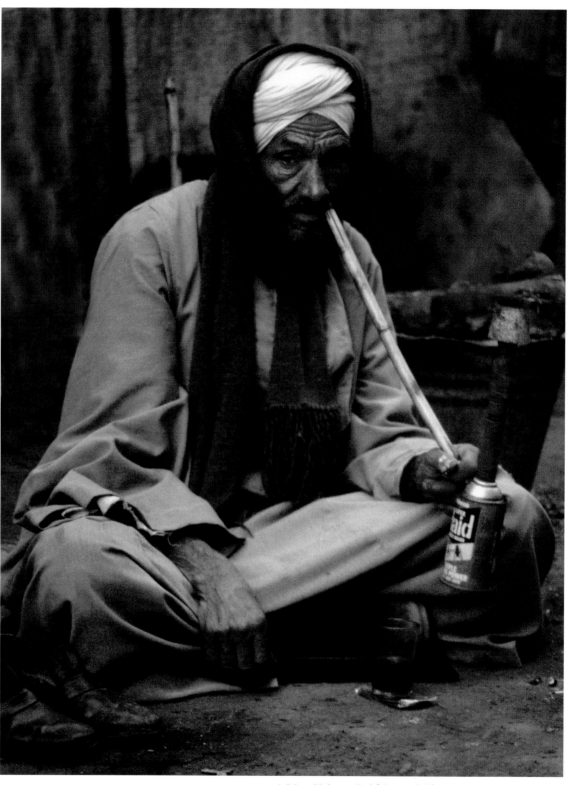

A Man Using a Raid Insecticide Can as a Water
Pipe, Cairo

*"Your old men shall dream dreams, your young men
shall see visions."*
– The Bible

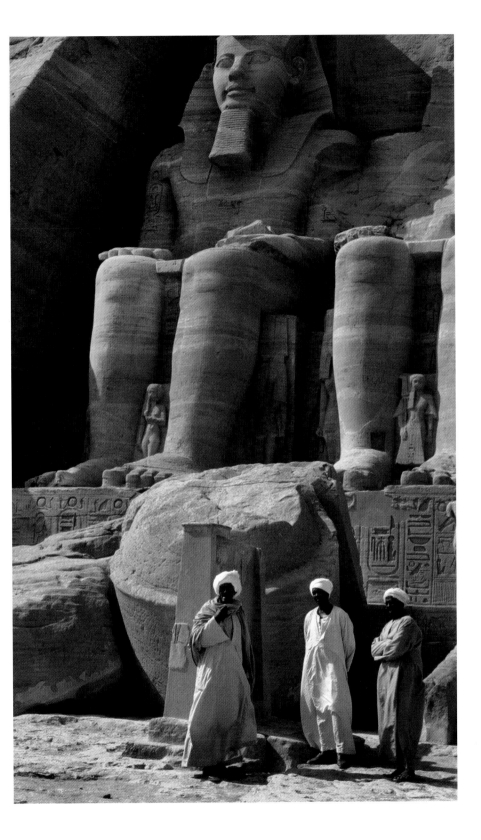

Abu Simbel

Lord Carnarvon: "Can you see anything?"
Howard Carter: "Yes, wonderful things."
– Howard Carter's comment upon first looking into
the tomb of King Tutankhamun

Hewn out of a stone cliff in the thirteenth century
B.C.E., Abu Simbel is a breathtaking sight. Built
to honor Ramses II, the statues were buried in sand for
centuries and rediscovered in 1813 by a Swiss
explorer. In 1954, Gamal Abdel Nasser, President of
Egypt, decided to build the Aswan Dam, which
meant flooding the Nile Valley in Nubia, in southern
Egypt. The huge monuments were cut into blocks
and moved two hundred ten feet further up the cliff,
to prevent them from being submerged. This
massive project involved three thousand people and
took three years to complete.

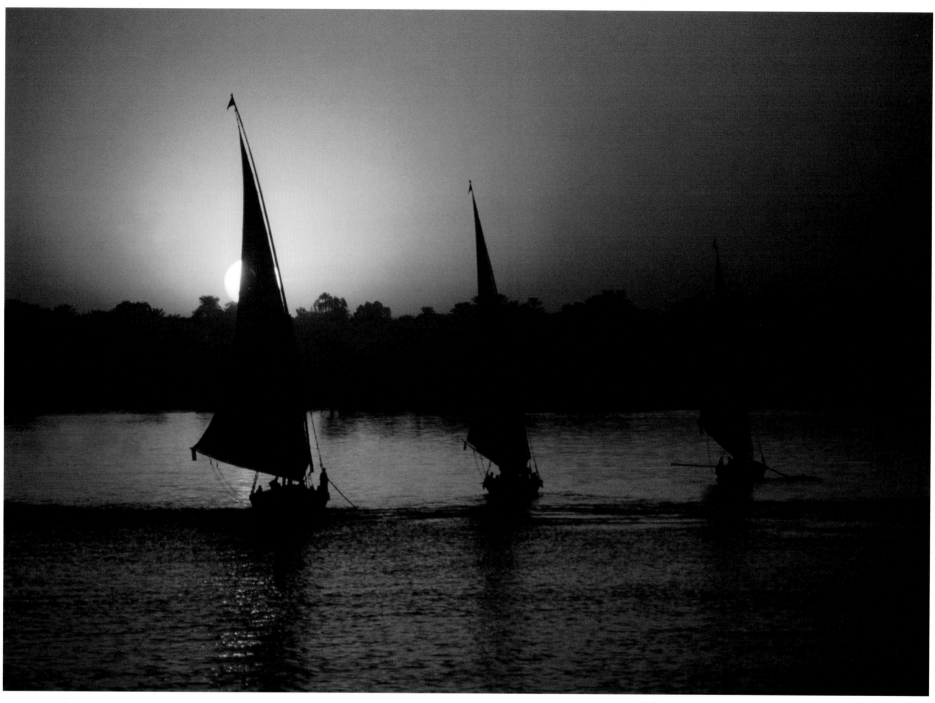

Feluccas on the Nile at Sunset

"As idle as a painted ship upon a painted ocean."
– Samuel Taylor Coleridge

Middle East

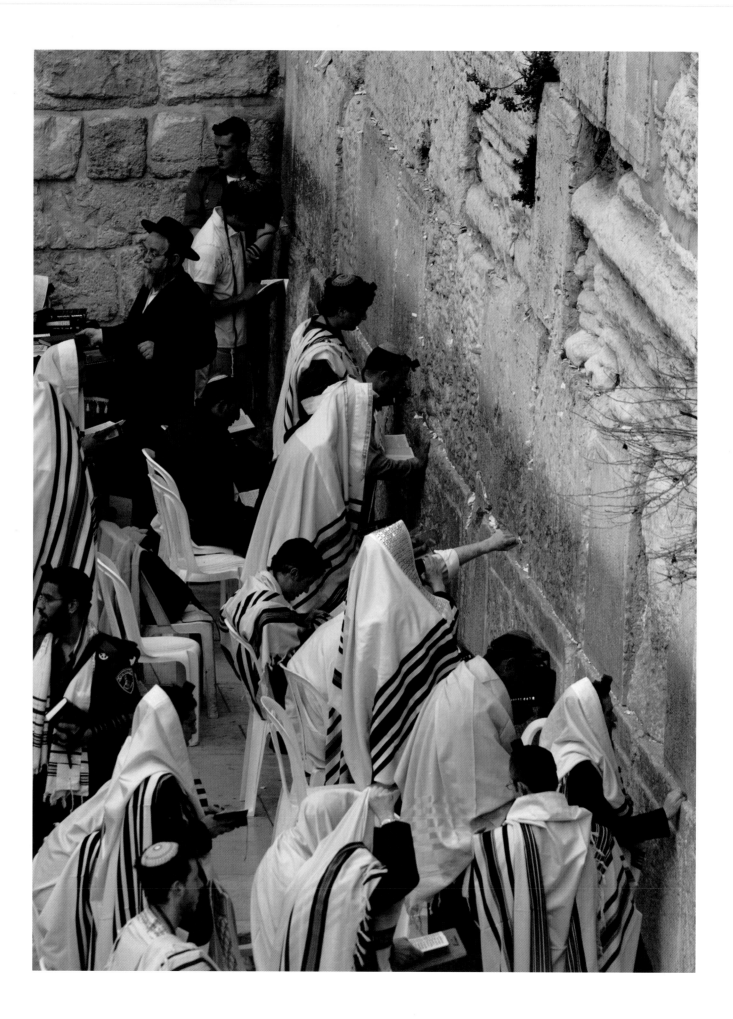

Men Praying at the Western Wall, Jerusalem
(previous page)

"This is the moment of pause,
The refilling of the empty vessel,
The renewing of the spirit."
– Jewish Prayer

The Western Wall, or Kotel, is the holiest site in Judaism. It is a remnant of the outer western wall of the Second Temple, which was built in 515 B.C.E., later destroyed, then reconstructed in 20 B.C.E. Since 1967, archeologists have discovered the complete Western Wall, buried under layers of civilizations.

Soldier Praying at Western Wall, Jerusalem

"Ten measures of beauty gave God to the world: nine to
Jerusalem and one to the remainder.
Ten measures of sorrow gave God to the world: nine to
Jerusalem and one to the remainder."
– The Talmud

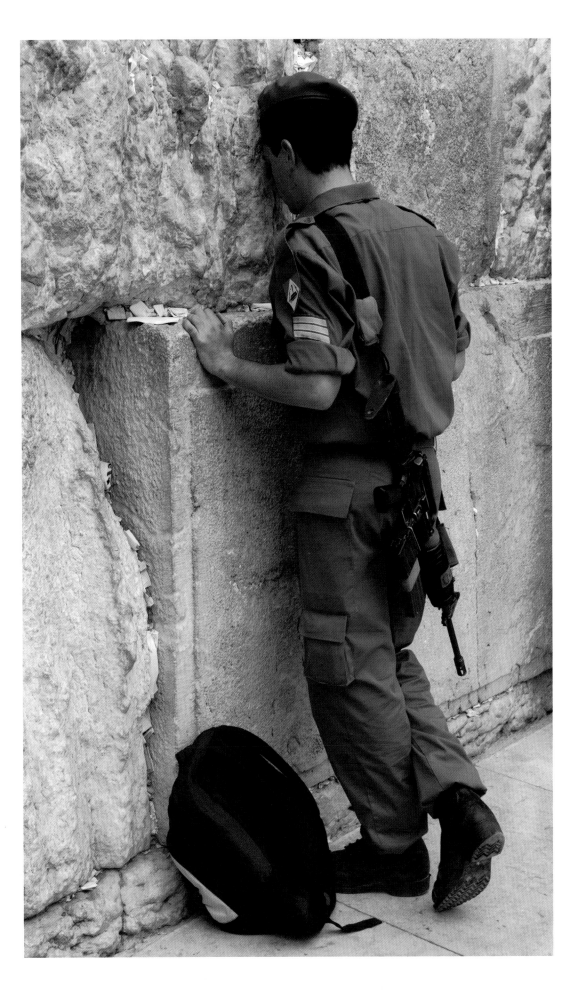

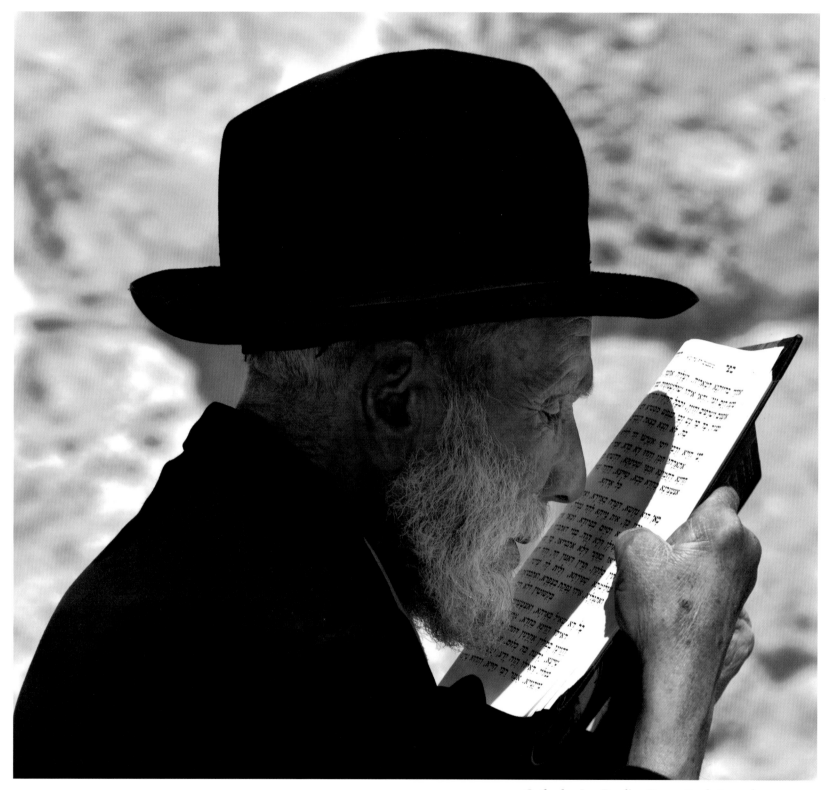

Orthodox Jew Reading Prayer Book, Jerusalem

"Every man is called upon in his own way and at his own level. God summons one man with a shout, another with a song, and a third with a whisper.
– Nahman of Bratzlav

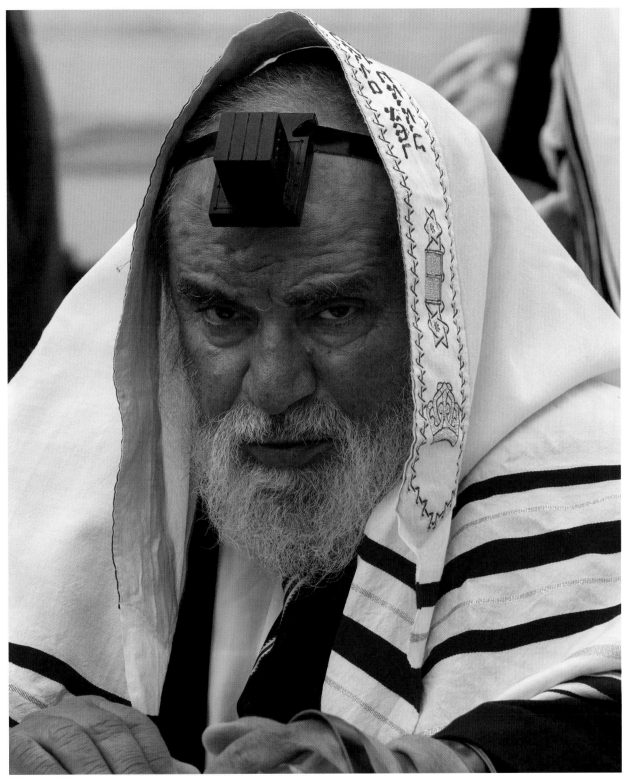

Orthodox Jew Praying, Jerusalem

*"The air over Jerusalem is saturated with prayers
and dreams."*
– Yehuda Amichai

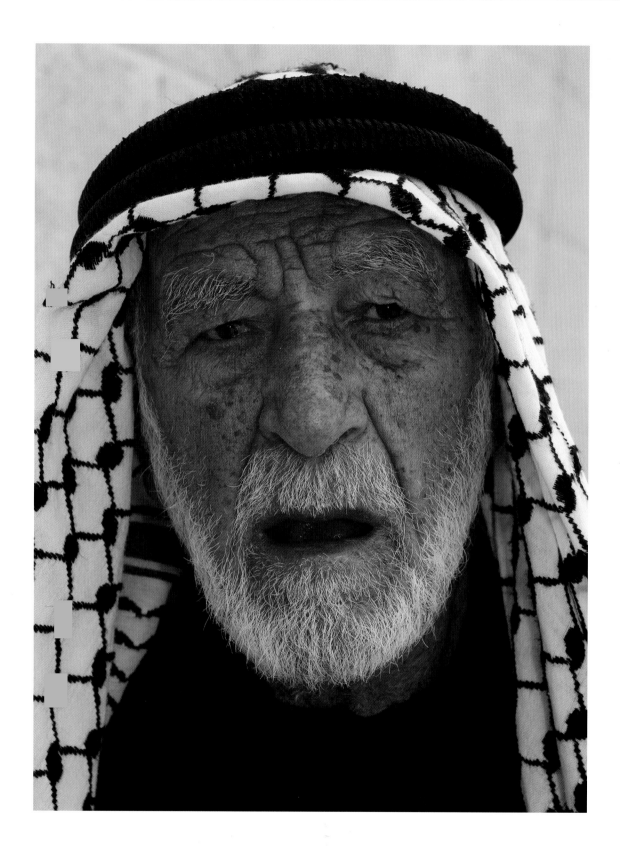

Israeli Arab, Temple Mount, Jerusalem

"Learn to listen. Learn to care. The greatest crime is to do nothing because we feel we can only do a little."
– Elie Wiesel

The Temple Mount, or Mount Moriah in the Bible, is traditionally considered the site where God asked Abraham to sacrifice his son Isaac. For Muslims it is the place where Mohammed last touched earth before God took him to heaven. The Al-Aqsa Mosque and the Dome of the Rock Mosque were built around 700 on the Temple Mount. Together, they are considered one of the holiest sites of Islam. Mecca and Medinah, the other holy sites of Islam, are the destinations of the pilgrimage that every observant Muslim is supposed to make as one of the five pillars of Islam. The other pillars are praying five times daily, giving alms, fasting during the month of Ramadan, and repeating the beginning of the call to prayer: "I swear that there is no other God but Allah. I swear that Mohammed is God's messenger."

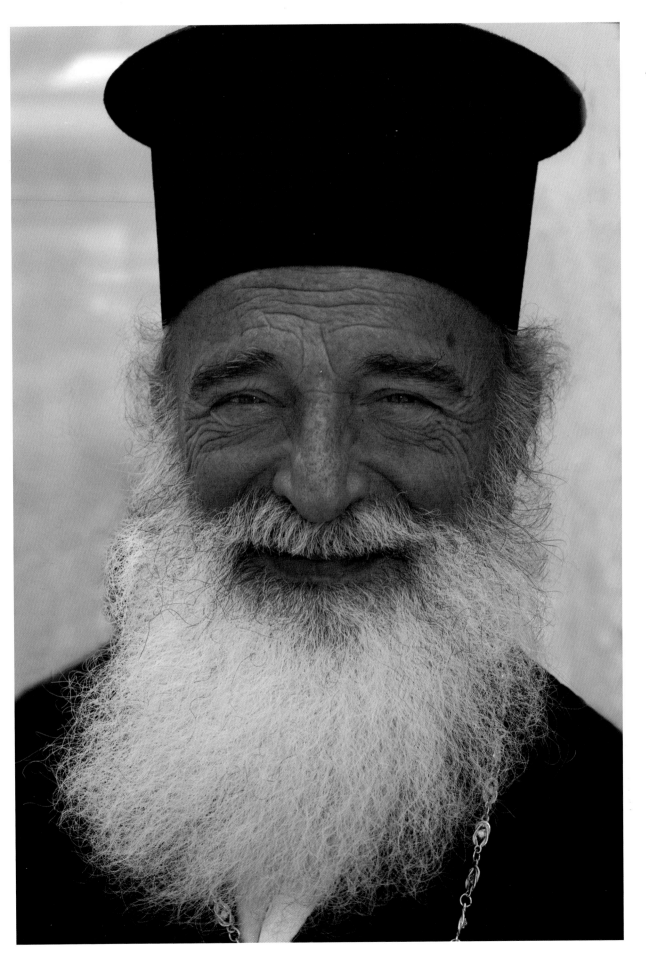

Coptic Priest, Church of the Holy Sepulchre,
Jerusalem

*"Always assume that the man sitting next to you is the
Messiah waiting for some simple human kindness."*
– Danny Siegel

According to Christian tradition, Jesus was crucified
and buried on this site. A church was first built
here in 335 by Emperor Constantine, after he declared
Christianity the official religion of the Roman Empire.
The present structure was built by the Crusaders
in 1149 and has been restored many times since.
Considered the holiest site in Christendom, it stands
within a few hundred yards of the holiest sites
of two other major religions, the Western Wall and the
Temple Mount. The Copts, a sect of Christianity
from Egypt, are one of the denominations that guard
the holy site.

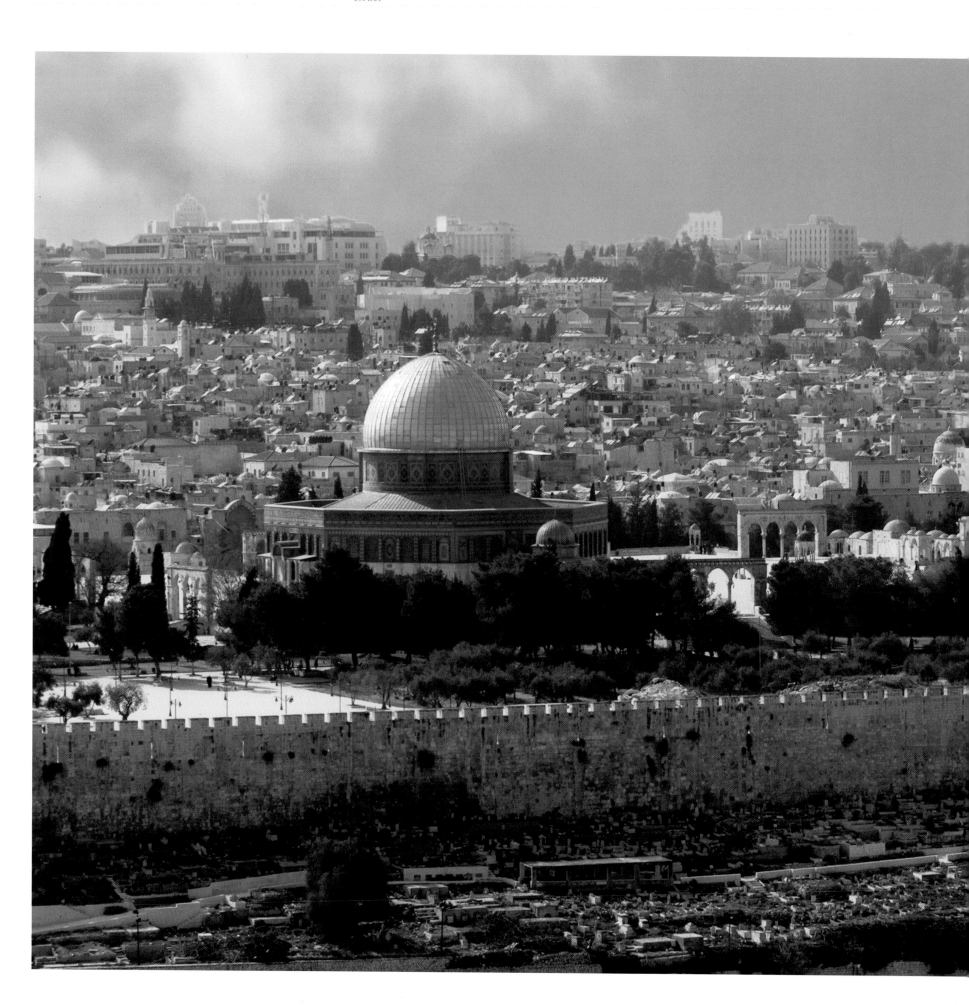

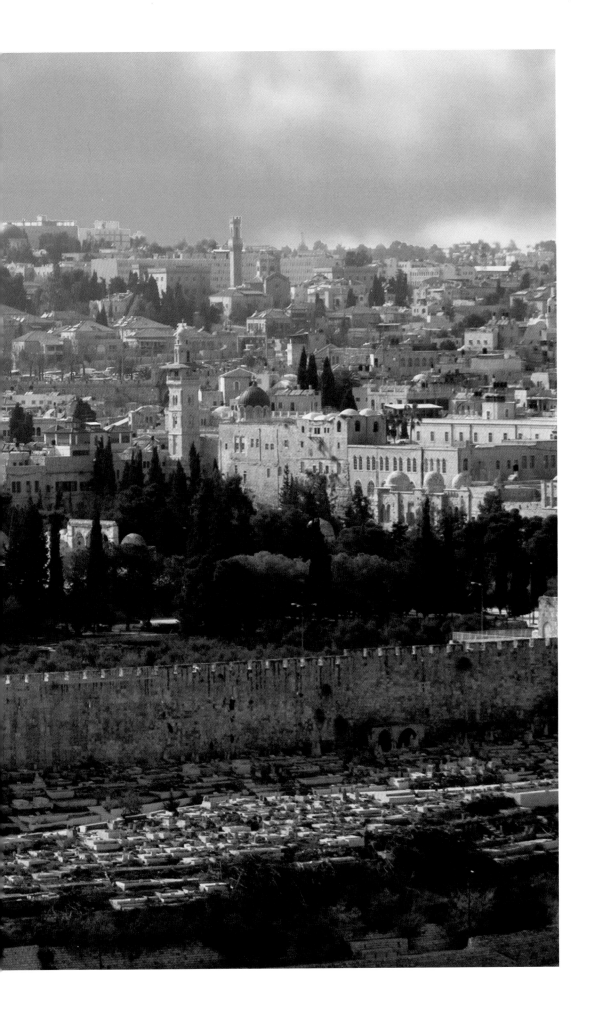

A View of the City of Jerusalem from the Mount of Olives

"Human history becomes more and more a race between education and catastrophe."
– H.G. Wells

The Arab sultan Suleiman the Magnificent built the walls of the old city in 1542. A section of those walls is in the foreground here, while along the horizon are nineteenth and twentieth century buildings. The golden Dome of the Rock is a prominent part of the skyline of the old city. Jerusalem was a Canaanite settlement before being conquered by King David in 1000 B.C.E. Solomon, his son, built the first Temple on the Mount. The city later was ruled by Babylonians, Persians, Greeks, Romans, Byzantines, Arabs, Crusaders, Ottoman Turks and, briefly, the British before Israeli Independence in 1948.

A Wall in the Old City, Jerusalem

"Our life is frittered away by detail …
simplify, simplify, simplify!"
– Henry David Thoreau

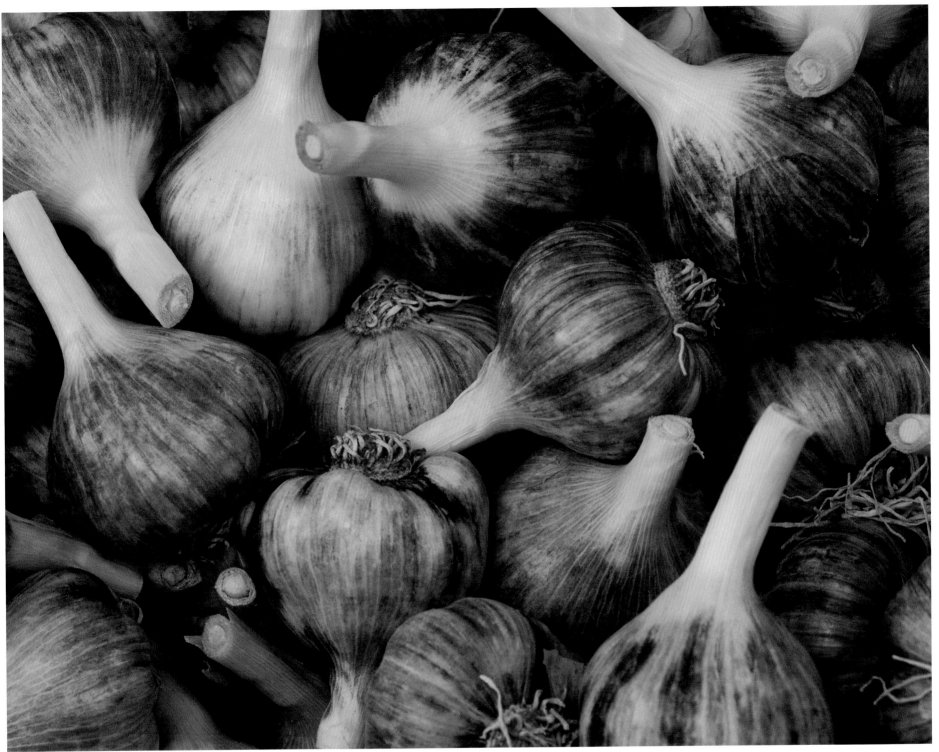

Garlic in Carmel Market, Tel Aviv

"The discovery of a new dish does more for the happiness of mankind than the discovery of a star."
– Anthelme Brillat-Savarin

This open market is in Tel Aviv, a fast-developing city of skyscrapers and tall apartment buildings. The city's impact is such that when one visitor was asked to describe Israel, his response was, "Under construction." When visiting Israel, it is easy to focus on the importance of history and religion in Jerusalem and other ancient sites, but with numerous technology firms, beautiful beaches, historic old Jaffa and a cosmopolitan atmosphere, Tel Aviv is a most exciting destination.

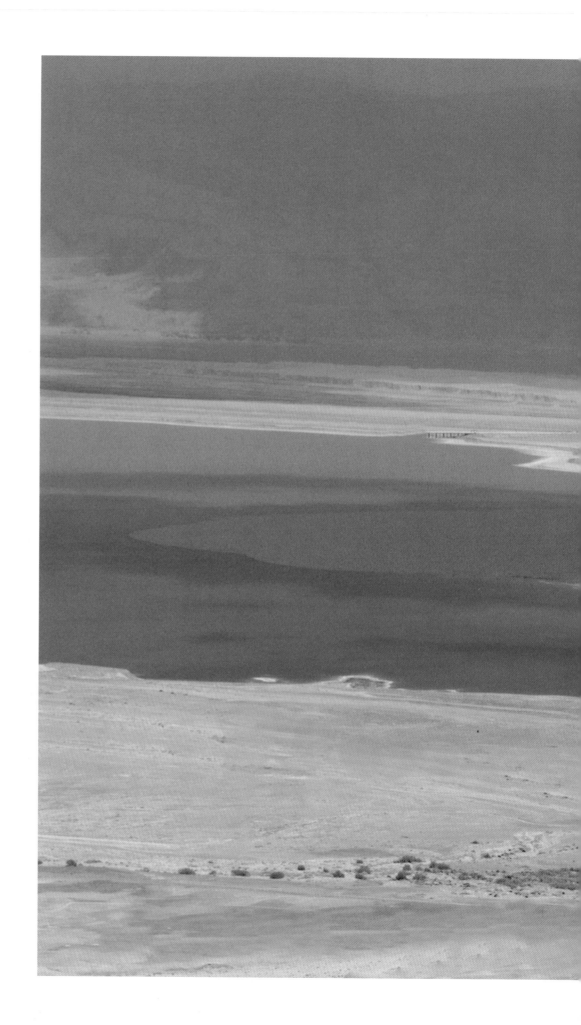

The Dead Sea

"Blue, darkly, deeply, beautifully blue."
– Robert Southey

After a flash flood, the vibrant hues of the Dead
Sea were more varied than usual. To the east of the
Dead Sea lie the Hills of Moab, where, tradition
tells us, Moses stood looking into the Promised Land.
He could see both the Dead Sea and Masada, the
famous mountain fortress. A few years ago, on top of
that extraordinary site, the son of a friend of mine
had just become a Bar Mitzvah, when a thirteen year-
old Jewish boy becomes a responsible member of
the Jewish community. The two most popular venues
for non-Israelis to celebrate this ceremony in Israel
are Masada and the Western Wall. My friend asked his
rabbi whether the Western Wall would have been
a better choice. The rabbi said, "Moses stood on those
Hills of Moab and looked in this direction. What
might he have been thinking about?" My friend replied,
"Perhaps the future of the Jewish people?" The rabbi
responded, "And so here you are four thousand
years later on the very spot that Moses was surveying
and you are continuing an ancient Jewish tradi-
tion. Now, how do you feel about your choice?"
"I guess it's not such a bad choice after all," answered
my friend.

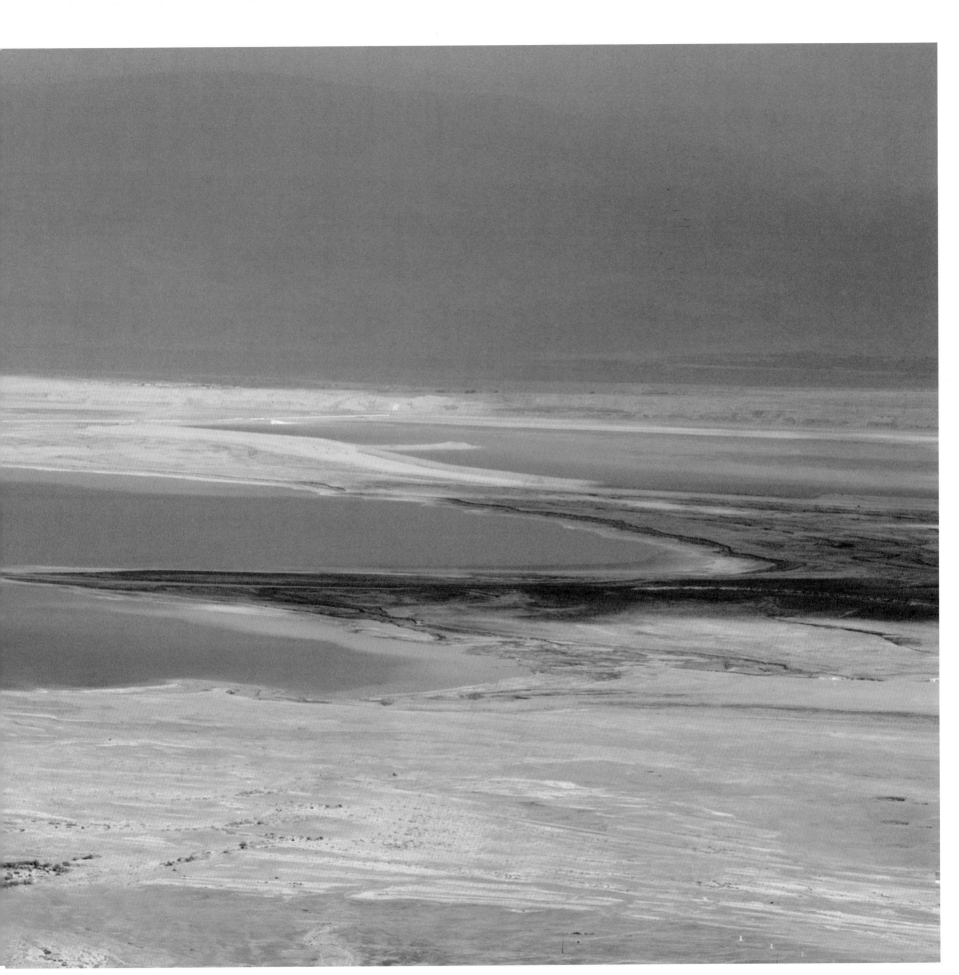

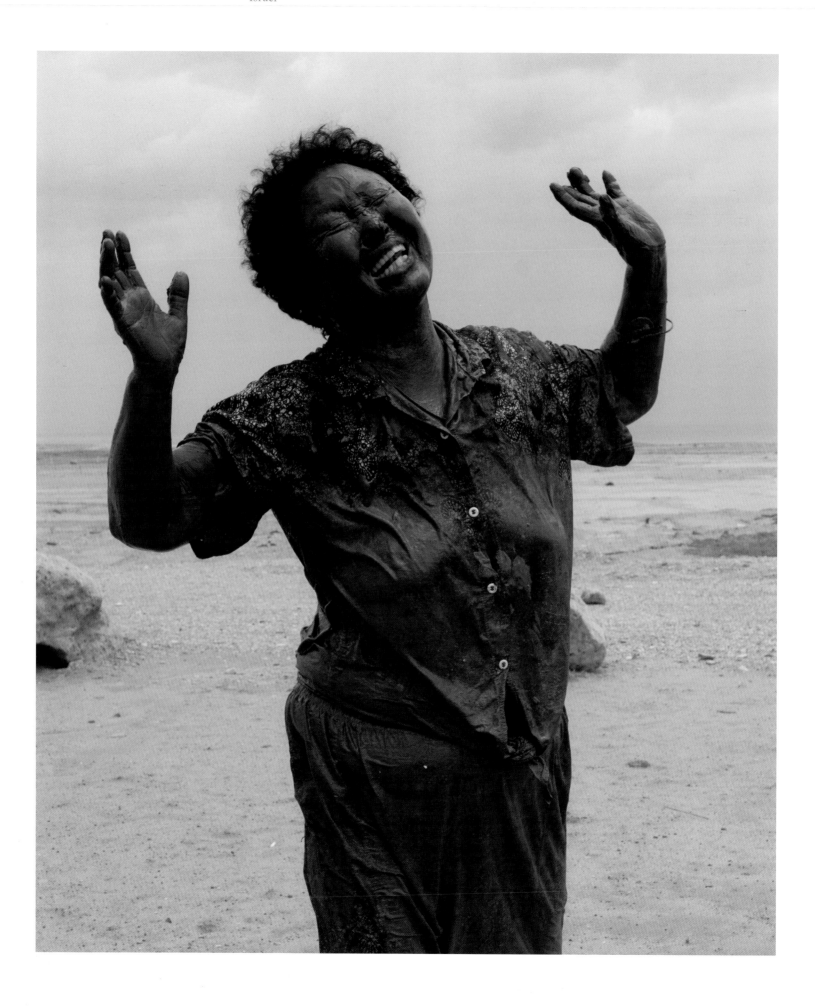

Korean Woman Enjoying a Mud Bath, Dead Sea
(previous page)

"I leap out of bed in the morning with the disposition that something perfectly wonderful is going to happen today."
– Brendan Gill

The Dead Sea is near the Negev Desert. My guide told me he had overheard a local man explaining to some visitors that some of the surrounding rocks in the Negev are a million and eight years old. He knew that because eight years previously he had listened to a geologist describing the age of the rocks as "a million years old."

My Daughters Enjoying a Mud Bath, Dead Sea

"Good humor is one of the best articles of dress one can wear in society."
– William Makepeace Thackery

The Dead Sea, at twelve hundred feet below sea level, is the lowest place on earth. Since there is more atmosphere to filter out the sun's ultraviolet rays, one can stay in the sun longer than at any other place on the planet. Therefore, visitors come from all over the world for the therapeutic benefits of the sun and the Dead Sea minerals. My family was convinced that the primary therapeutic benefit came from laughing at how silly we looked coated in mud.

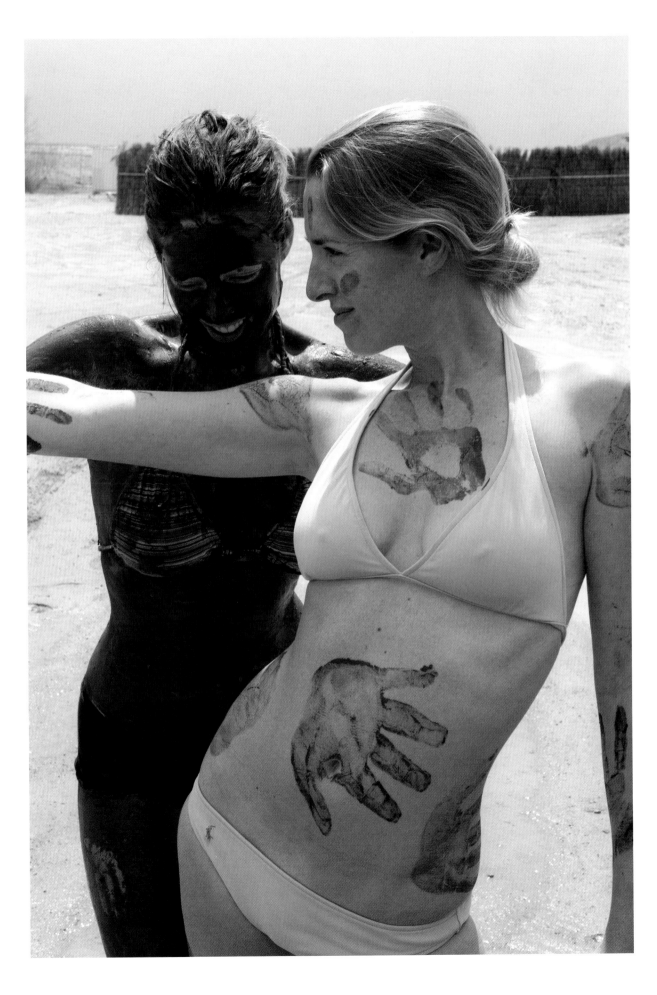

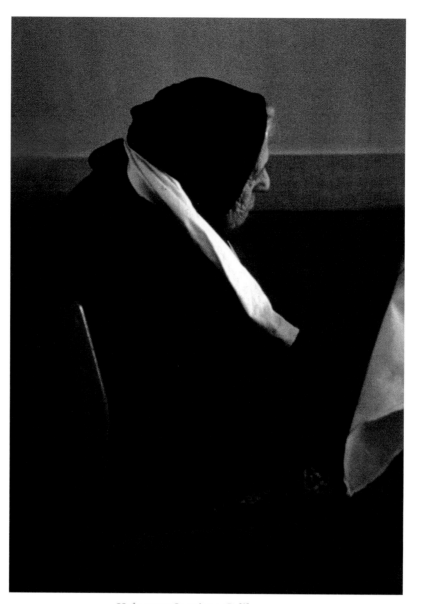

Holocaust Survivor, Galilee

*"When I was in trouble, I looked for someone who was
in worse trouble than I was, and said to myself 'What
can I do for him?' That is what kept me alive."*
– Holocaust Survivor

This woman was living in a community for Holocaust
survivors who had no living relatives. Despite the
feeling of comradeship fostered by the community, she
still sat apart.

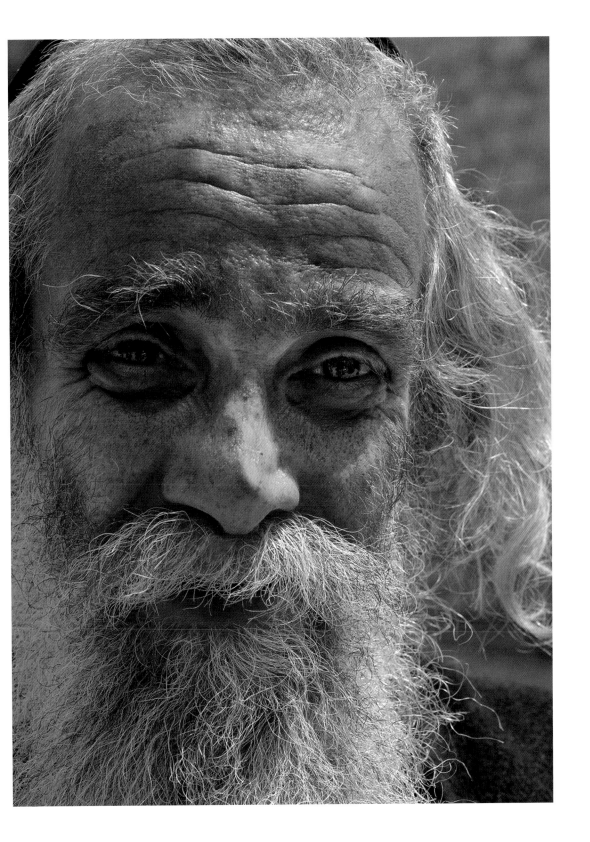

"In Israel in order to be realistic, you must believe in miracles."
– David Ben-Gurion

Safed is beautifully located, with a panoramic view of the Galilean Hills. After the Jews were expelled from Spain in 1492 many fled to Safed. Rabbi Isaac Luria, who came from Egypt in 1572, established Safed as the center of Kabbalistic mysticism. Another large influx, this time of Hasidic Jews, arrived from Poland in the late nineteenth century. A resurgence of interest in Kabbalah in the United States has made Safed a popular destination yet again.

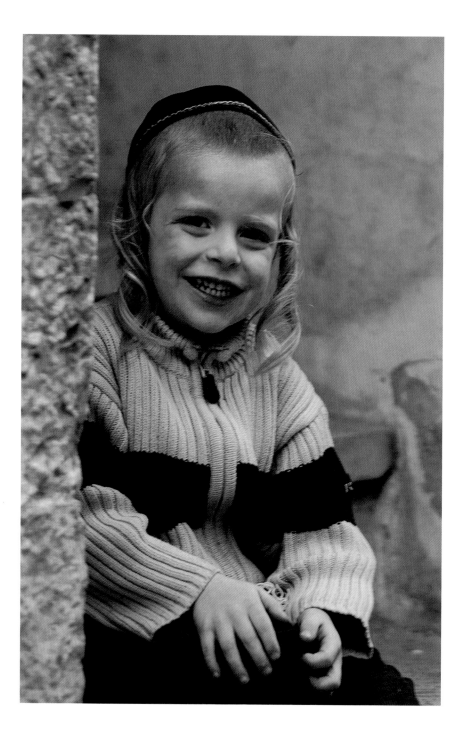

*"There are two lasting gifts we can give our
children... one is roots, the other is wings."*
– Hasidic Saying

More than half of Israeli Jews consider themselves
secular; a much smaller percentage is Orthodox
and ultra-Orthodox. Mea Shearim is a neighborhood
of several thousand ultra-Orthodox Jews.

*"I cannot keep track of all the vagaries of fashion.
Every day, so it seems, brings in a different style."*
– Ovid

The Red Sea is home to vibrant coral reefs and
a rich assortment of tropical fish. This extraordinary
looking lionfish has elongated dorsal and pectoral
fins, which are poisonous. Israel's Red Sea is but one
feature of this strikingly beautiful and geographically
varied country. In springtime, the snowy peak of
Mount Hermon provides a gleaming backdrop to the
hills of Galilee covered in brilliant wild flowers.
A major flyway, Israel in the spring and fall is host to
tens of thousands of migrating birds. The Dead
Sea is the lowest point on earth, and the Negev Desert
contains striking rock formations and the largest
crater in the world.

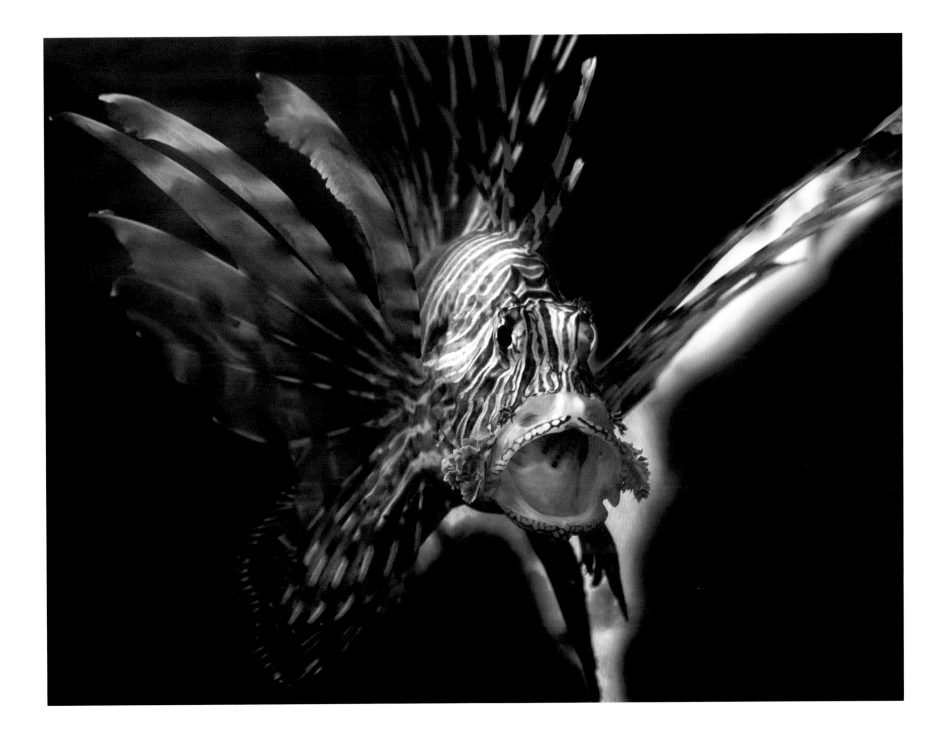

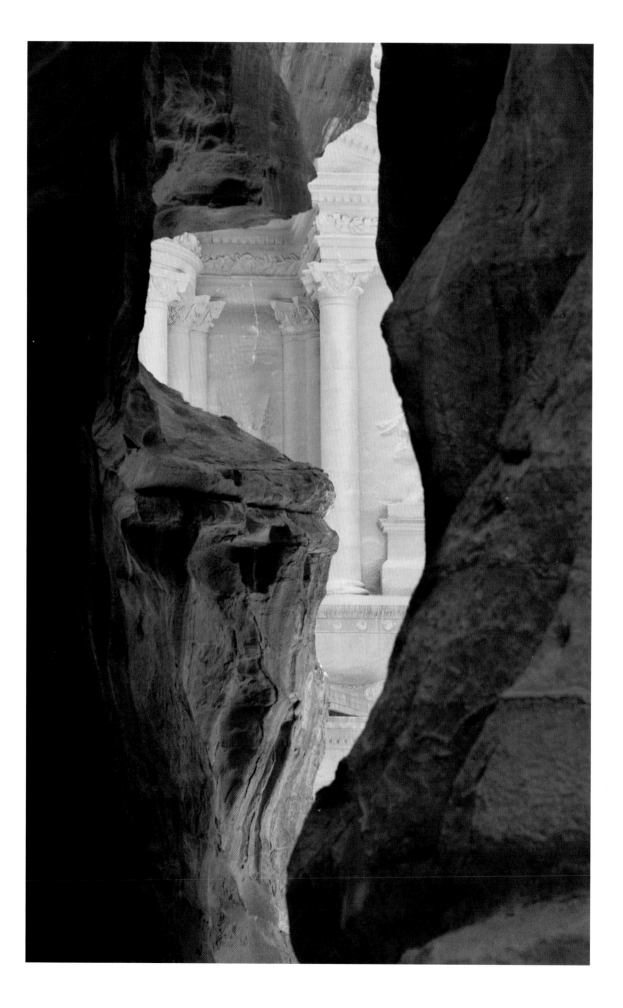

The Treasury, Petra

"*I was always conscious of another space in which the objects of my reveries evolved.*"
– Henri Matisse

A visitor's first view of the city of Petra comes at the end of a mile-long walk through a narrow canyon in the red sandstone rock. Nothing quite prepares you for the splendor of the scene.

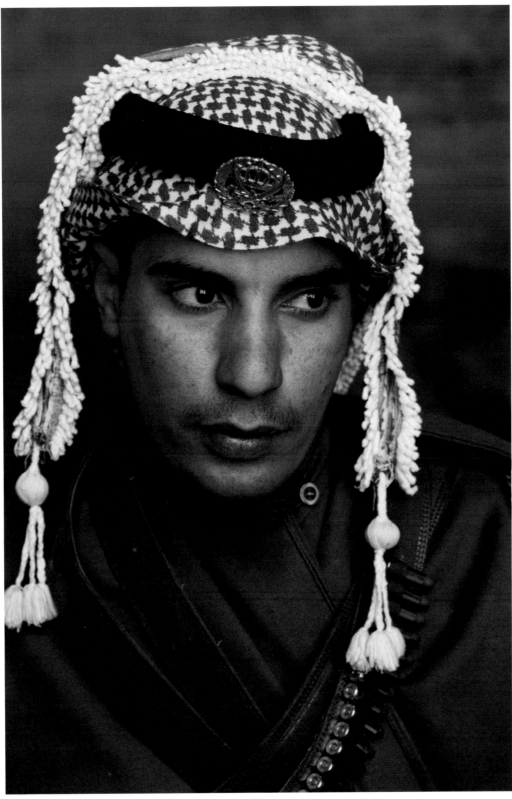

Royal Jordanian Army Guard at the Treasury, Petra

*"Believe me, every heart has its secret sorrow which
the world knows not."*
– Henry Wadsworth Longfellow

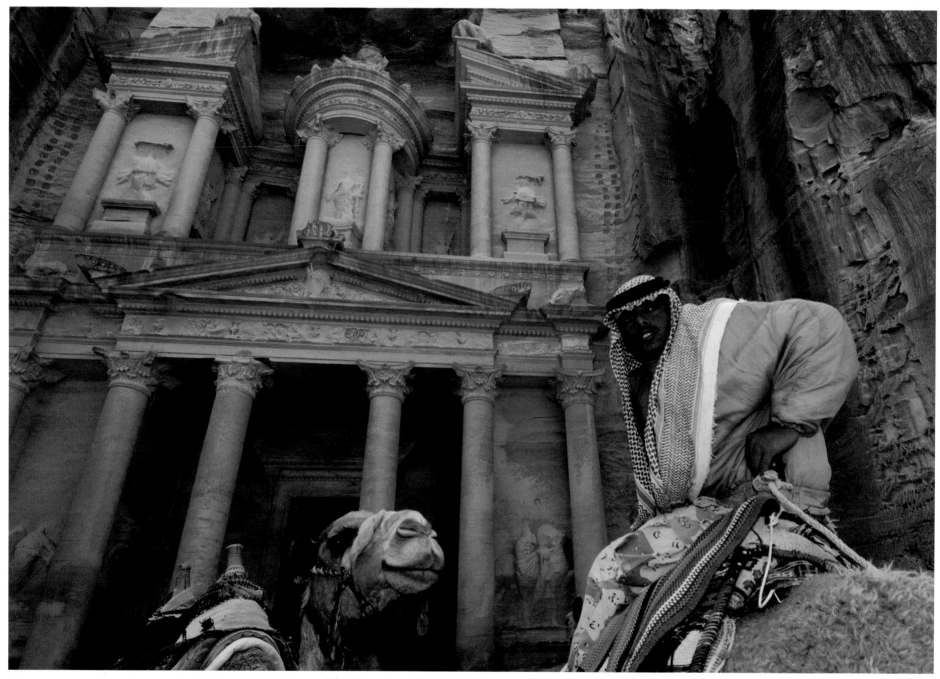

The Treasury, Bedouin and his Camel, Petra

"After the game, the king and pawn go into the same box."
– Italian Saying

The Nabateans, a nomadic tribe who were great traders, established the city of Petra in the fourth century B.C.E. and built the Treasury three hundred years later. A gradual decline in the city's importance led to its being abandoned then lost for several hundred years before Swiss explorer Johann Burkhardt rediscovered it in 1812. Petra has over eight hundred monuments, most of them large burial chambers carved out of the cliffs. The influence of many foreign cultures, including those of Greece, Rome, Egypt, and Assyria, is visible in the architecture.

Europe

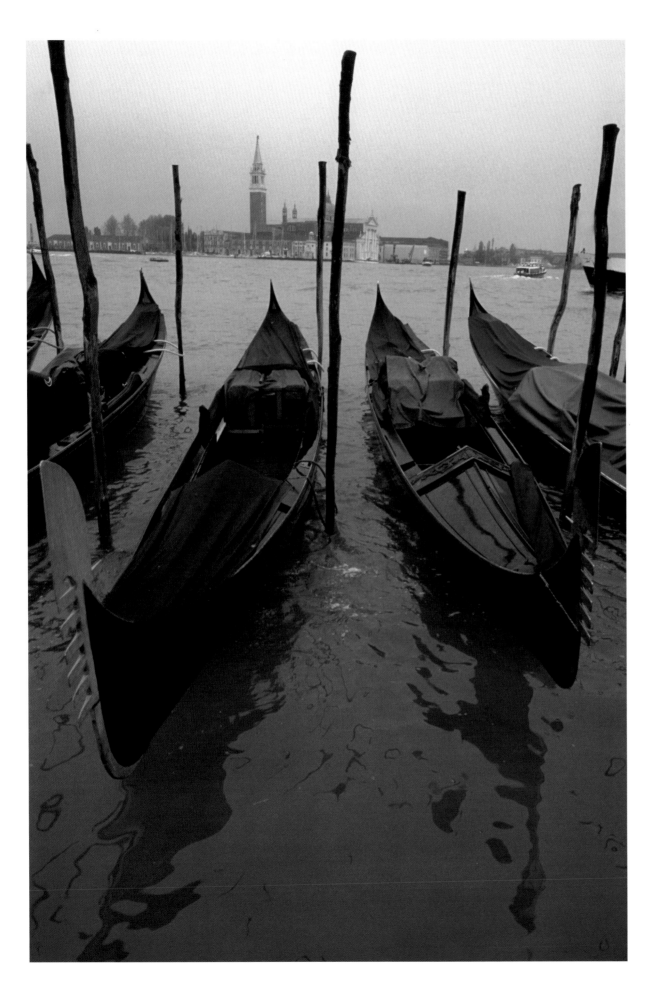

Gondolas, Venice

"Streets filled with water. Please advise."

The humorist Robert Benchley sent this telegram to the New Yorker magazine home office after arriving in Venice on an assignment. From the thirteenth century to the fifteenth, Venice was one of the most powerful city states in the world.

Venice Reflections, Venice (facing page)

"Color possesses me. I don't have to pursue it. It will possess me always, I know it. That is the meaning of this happy hour: color and I are one. I am a painter."
– Paul Klee

In Venice, there are one hundred fifty canals linking the numerous islands that make up the city.

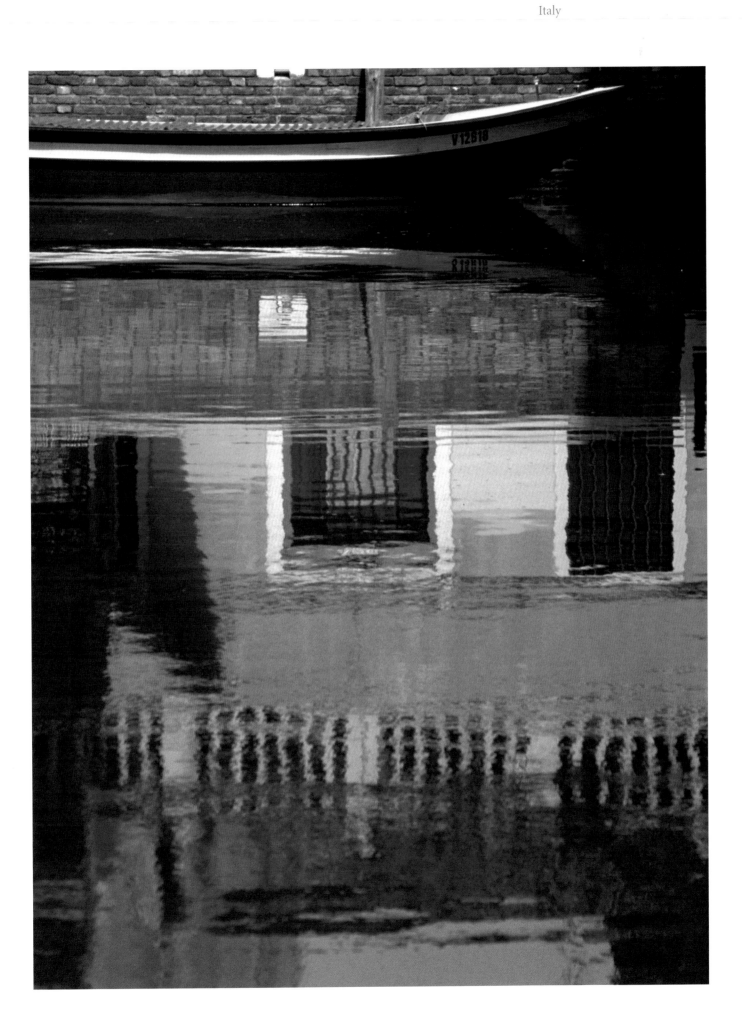

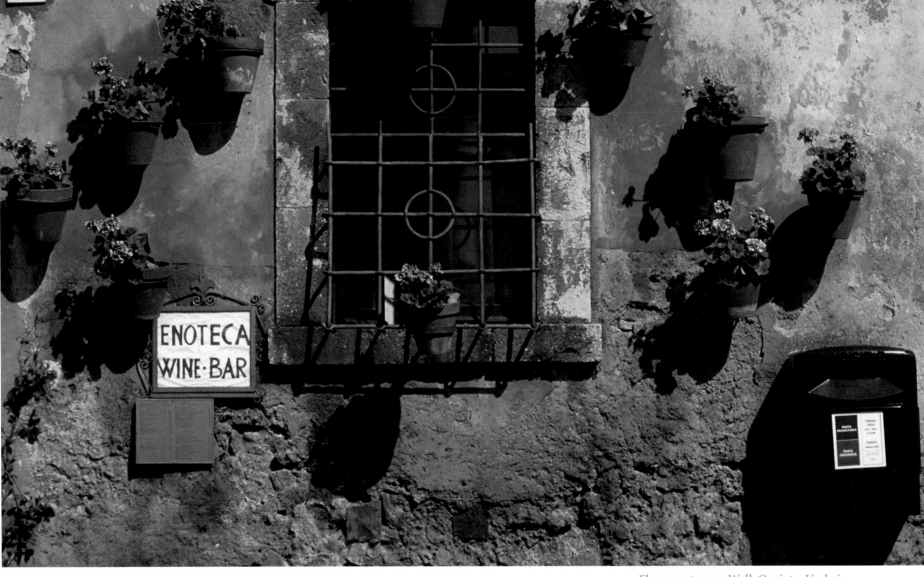

Flowerpots on a Wall, Orvieto, Umbria

"*Spring*
when the world is puddle-wonderful."
– ee cummings

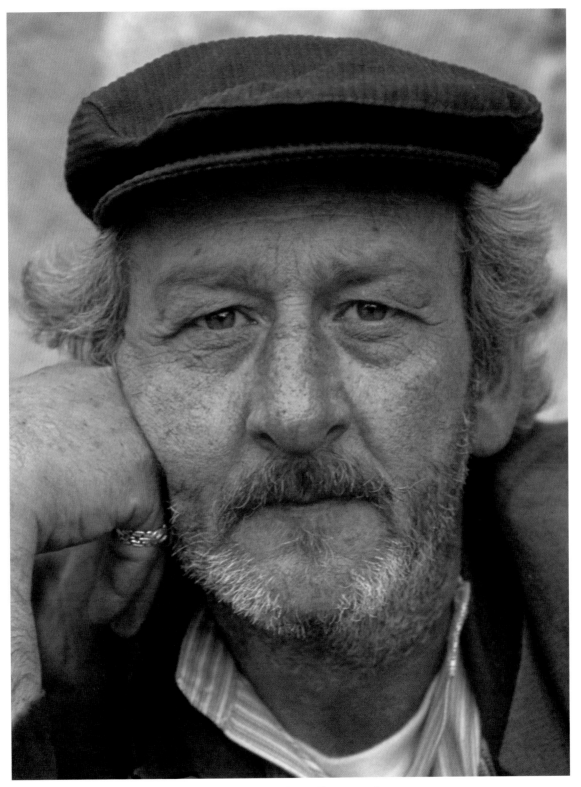

Actor, Bagnoreggio

"I hold the world but as the world, Graziano;
A stage where every man must play a part, and mine
a sad one."
– William Shakespeare

This gentleman, an actor, took great pleasure in posing
for my camera.

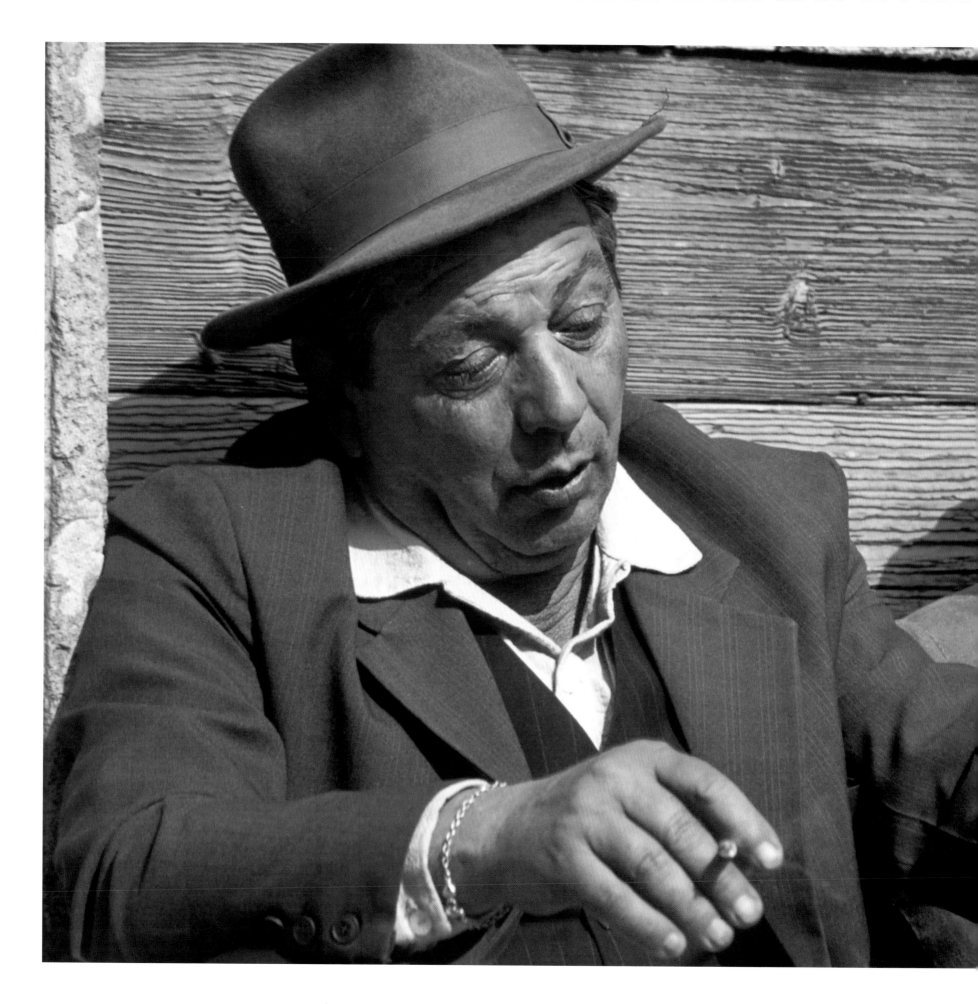

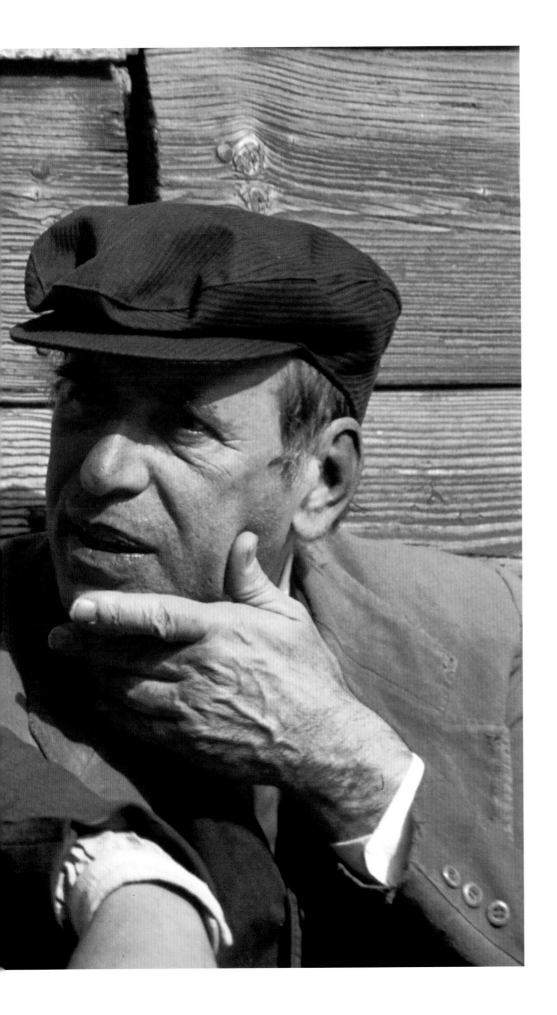

Two Men Talking, Todi, Umbria

"A friend may well be reckoned the masterpiece of nature."
– Ralph Waldo Emerson

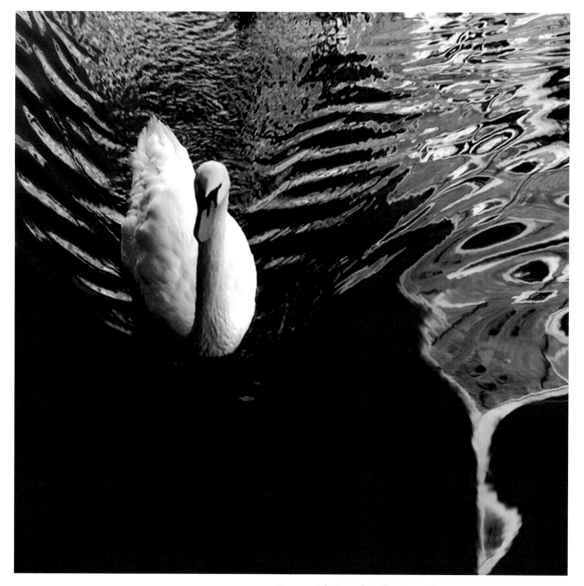

Swan with Canal Reflection, Bruges

"Beautiful dreamer wake unto me,
Starlight and dewdrops are waiting for thee."
– Stephen Foster

Bruges is a city of canals with floating swans and
limpid reflections of gothic buildings. It was one of the
wealthiest towns in Europe from the thirteenth to
the sixteenth century. For me, Bruges is one of Europe's
most romantic towns, with its mixture of gabled hous-
es, meandering canals, windmills, beautiful squares,
great art and a feeling of being transported back to the
middle ages.

Young Woman, Rome

"The red sweet wine of youth."
- Rupert Brooke

First Communion, Luxembourg City

"Be slow in choosing a friend, slower in changing."
– Benjamin Franklin

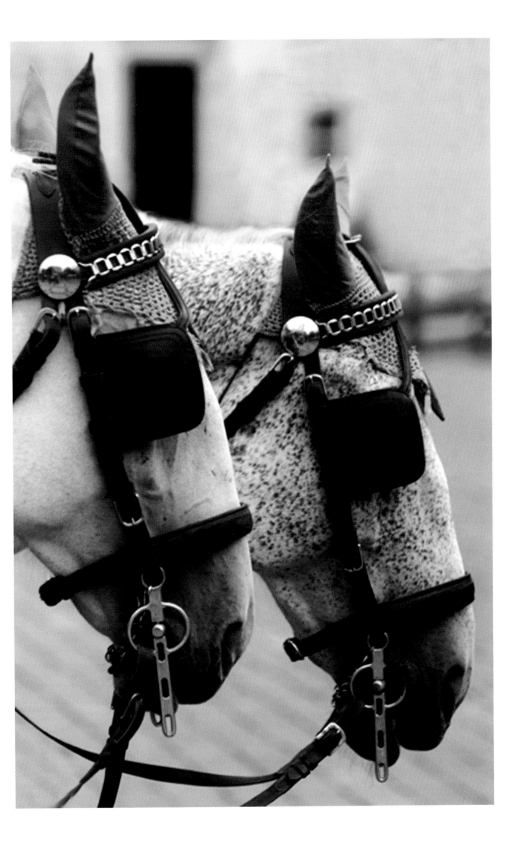

Horses, Old Town Square, Prague

"Marry me and I'll never look at another horse."
– Groucho Marx

Visitors who take a carriage ride behind these
horses feel as if they are living in a past century. Prague
has a rich architectural heritage with outstanding
medieval, baroque, rococo and art nouveau buildings.
The medieval Charles Bridge, spanning a wide
stretch of the River Vltava, is near the Old Town Square
and is a magical place. Those who walk across it are
presented in every direction with views of church
spires, castle walls, towers and roofs of every style and
hue. The Jewish section of Prague is the oldest
ghetto in Europe. The Nazis intended the early gothic
Old-New Synagogue and neighboring cemetery
to be part of their "Museum of the Extinct Race."

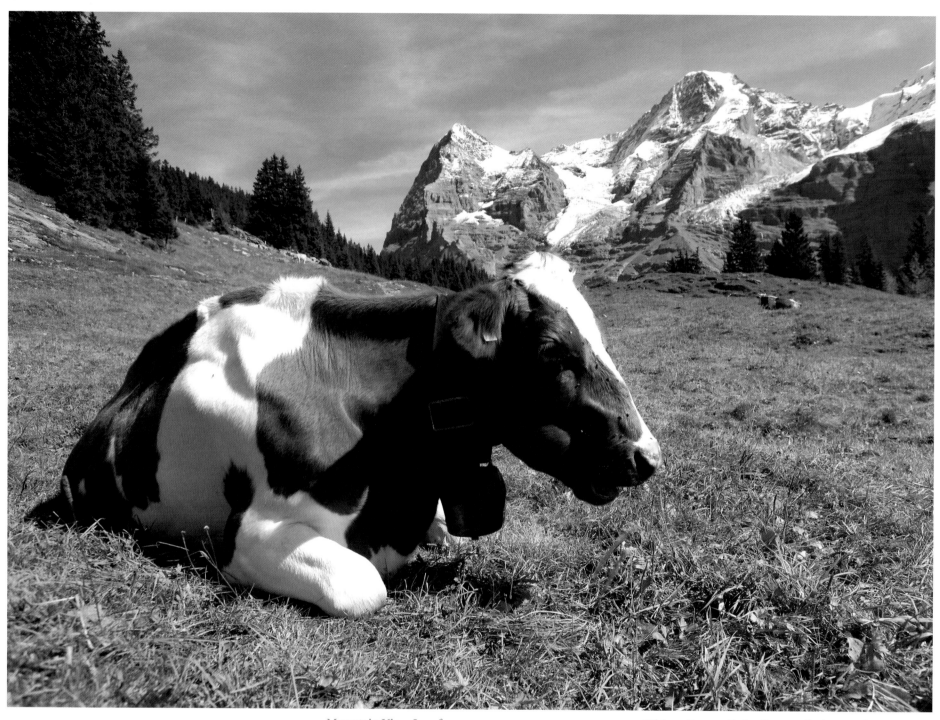

Mountain View, Jungfrau

Biking, Geneva Style, Geneva (facing page)

"I go about looking at horses and cattle. They eat grass, make love, work when they have to, bear their young. I am sick with envy of them."
– Sherwood Anderson

"The true object of all human life is play. Earth is a task garden; Heaven is a playground."
– G.K. Chesterton

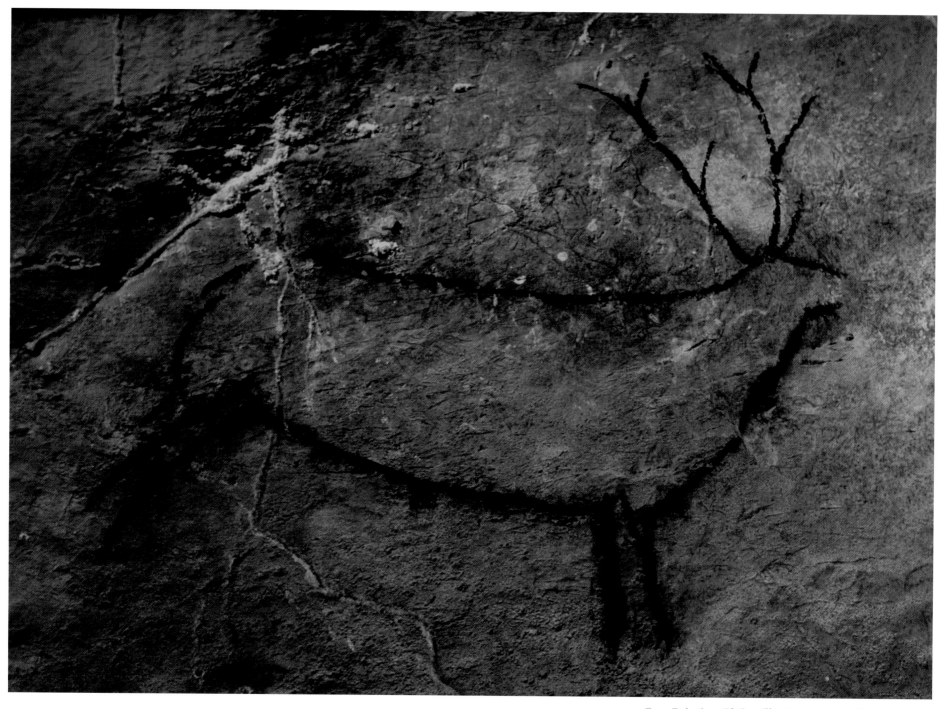

Cave Painting, El Castillo Cave, Puente Viesgo,
Northern Spain

*"Every great work of art has two faces, one toward its
own time and one toward the future, toward eternity."*
– Daniel Barenboim

This painting is thought to be from approximately
eighteen thousand B.C.E. To see it the day after visiting
the Guggenheim Museum was to experience a notable
juxtaposition of human artistic achievements.

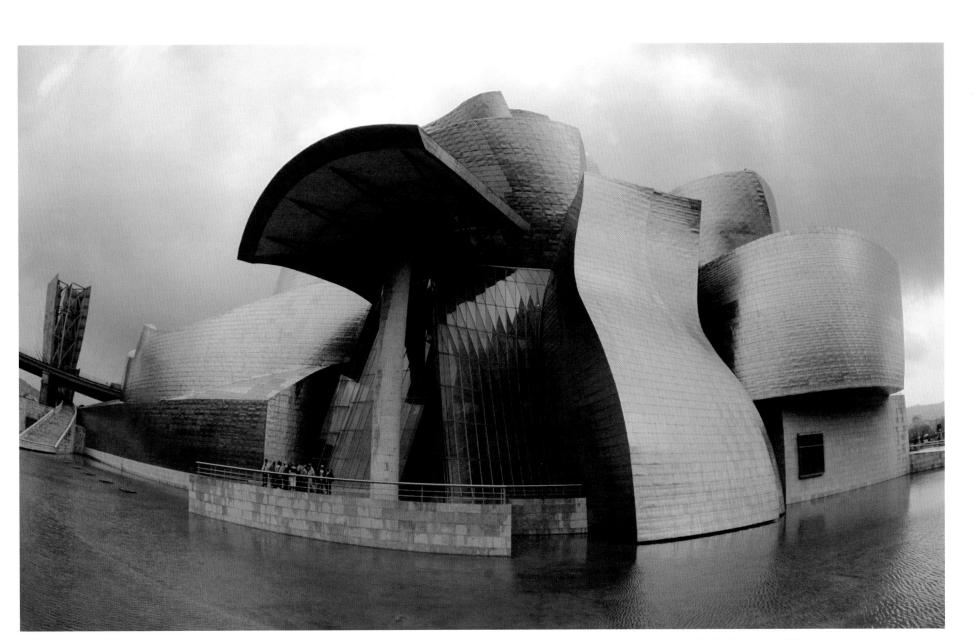

Guggenheim Museum, Bilbao

"Any authentic work of art must start an argument between the artist and his audience."
– Dame Rebecca West

The city of Bilbao in northern Spain contributed one hundred million dollars to the construction of this work of art by the architect Frank Gehry, which was completed in 1997. The large gamble has paid off and made Bilbao one of the most popular tourist destinations in Europe. It was exciting to be in the presence of this masterpiece, a building made of curved steel and titanium plates.

Flamenco Dancer, Barcelona

"The evidence indicates that woman is, on the whole, biologically superior to man."
– Ashley Montague

Flamenco dancing requires intense energy and sensuality. Everyone in the audience fell in love with this dancer.

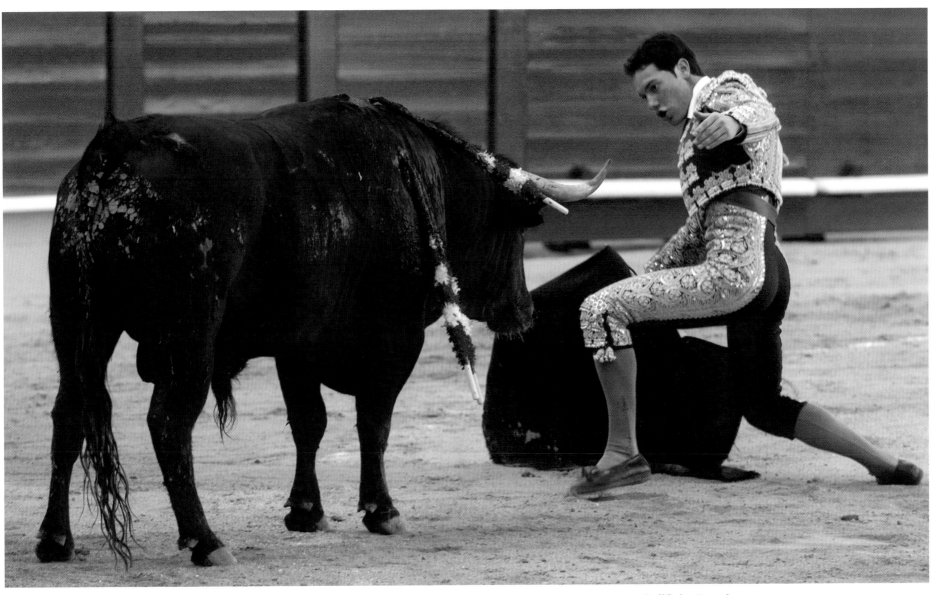

Bullfight, Barcelona

"Bullfighting is the only art in which the artist is in danger of death and in which the degree of brilliance in the performance is left to the fighter's honor."
– Ernest Hemingway

In the course of a bullfight, the matador makes a series of passes with his "muleta," or cape. Soon after I took this photograph, the bull gored the matador. Over the last few years, bullfighting has lost much of its popularity.

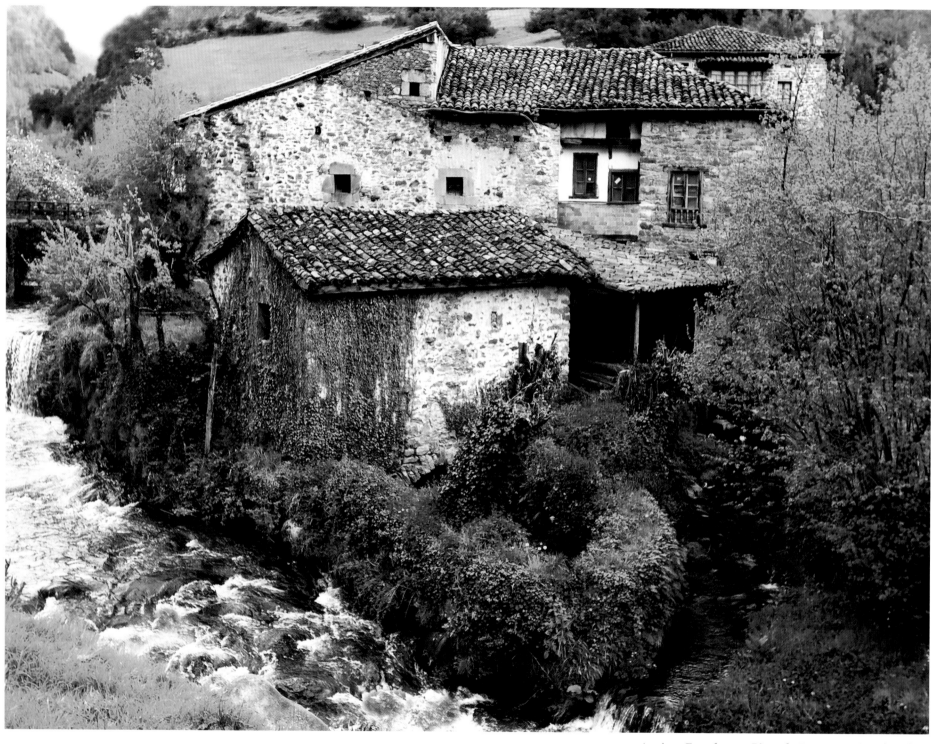

Ancient Farmhouse, Picos de Europa National Park, Northern Spain

"No house should ever be on any hill or on anything. It should be of the hill, belonging to it, so hill and house could live together each the happier for the other."
– Frank Lloyd Wright

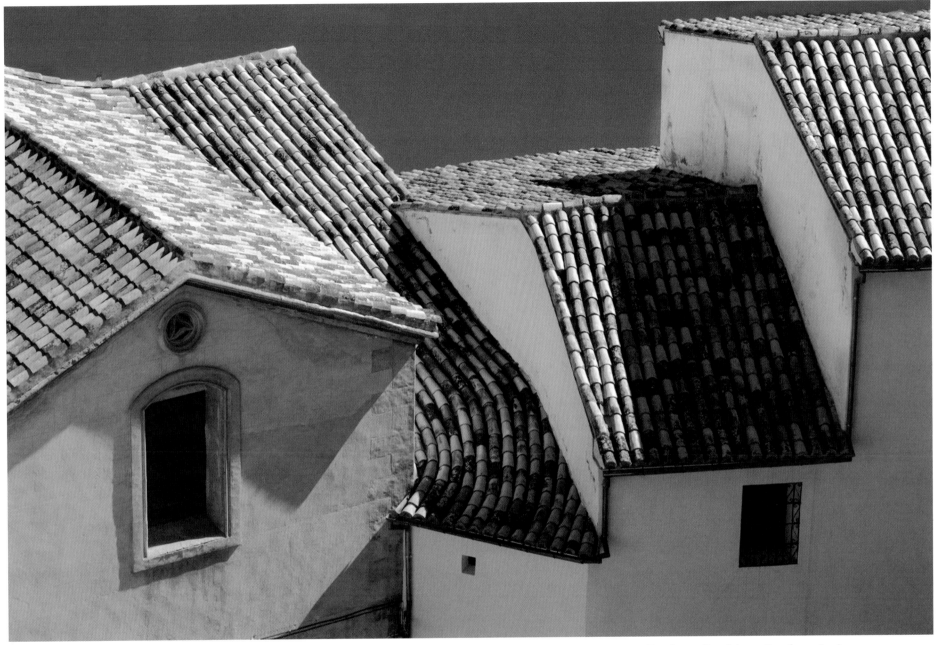

Rooftops, Gaudaleste, Southern Spain

"God is in the details."
– Mies van der Rohe

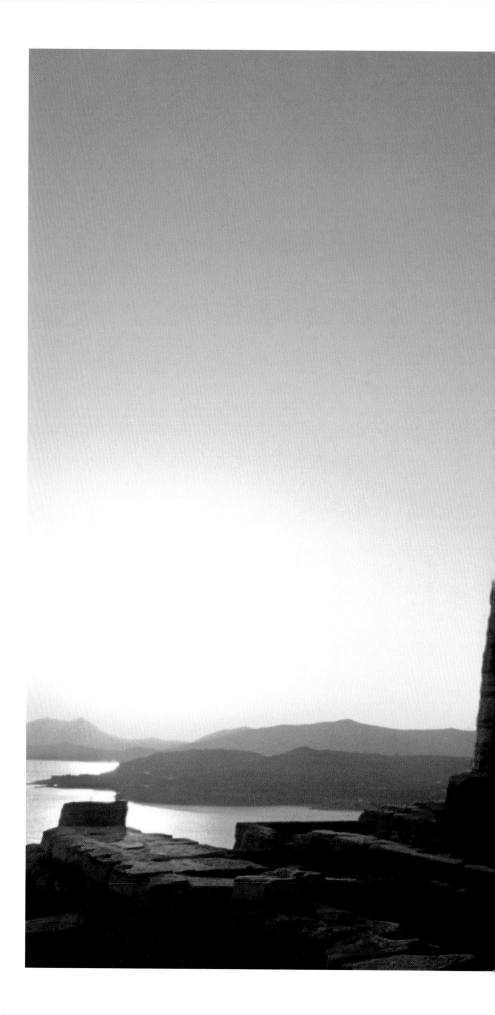

Temple of Poseidon, Cape Sounion

"The art of architecture studies not structure itself,
but the effect of structure on the human spirit."
– Geoffrey Scott

I was fortunate to watch the sunset at this site with
friends and three generations of my family.

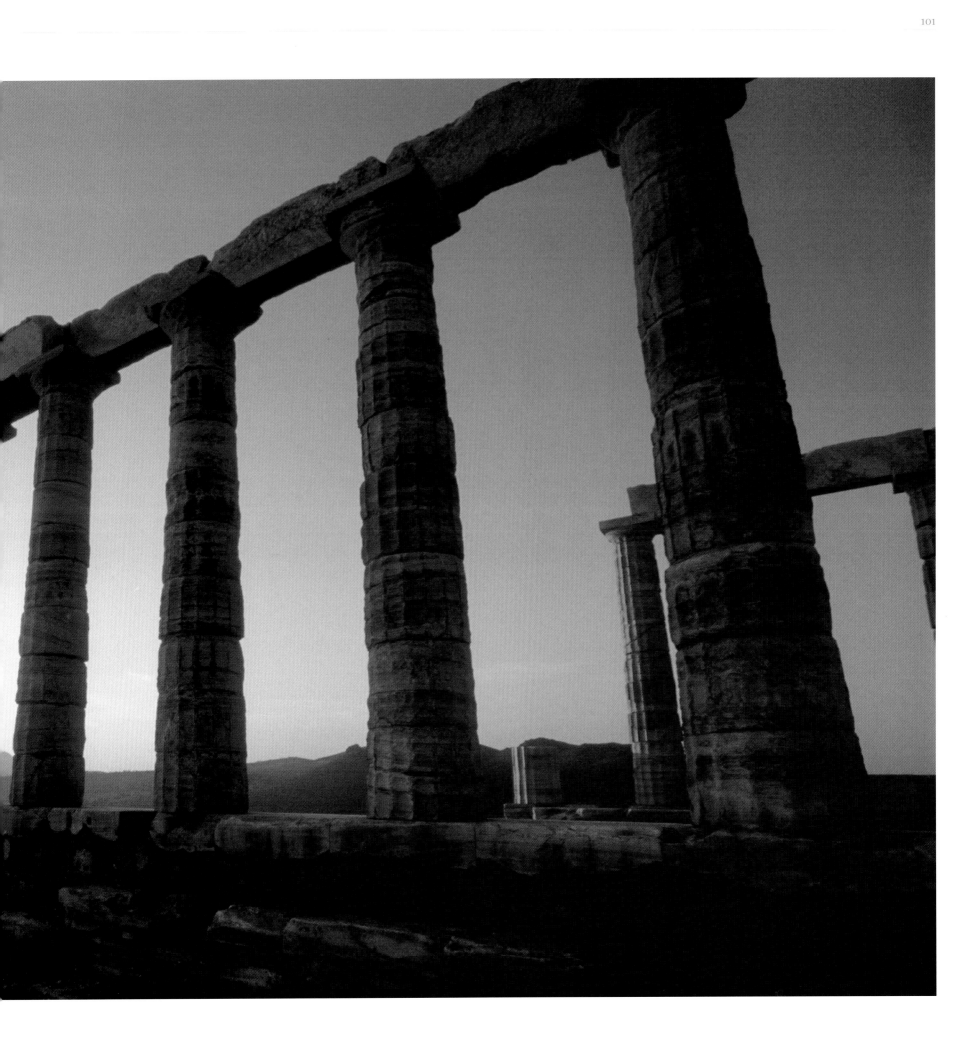

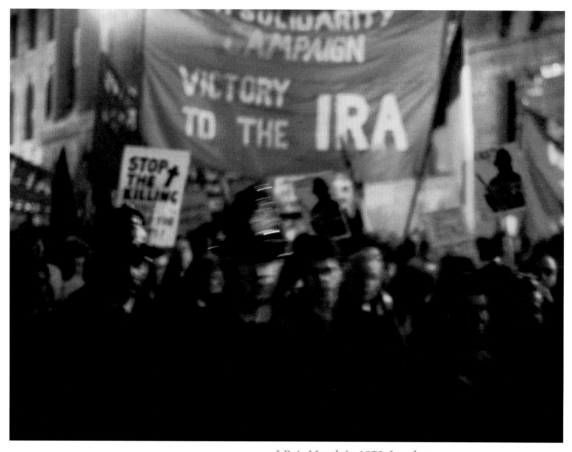

I.R.A. March in 1973, London

*"I hold it, that rebellion … now and then, is a good
thing, and as necessary in the political world as storms
in the physical."*
– Thomas Jefferson

Young Girl at Air Show, Lakenheath Air Force Base, Suffolk

"Curiosity is one of the most permanent and certain characteristics of a vigorous intellect."
- Samuel Johnson

From 1973 to 1975, I was stationed at the U.S. Air Force base at Lakenheath, in Suffolk, England, as an orthopedic surgeon. The earliest photographs in this book were taken at that time. Professionally, it was a remarkably fruitful two years. In addition, I was able to travel throughout Europe as well as to India, Nepal and East Africa. Fortunately, I also found time to meet my future wife. Photography for me in those years was simply a way to record events. It has only recently become a passion and an attempt at revelation rather then representation. Looking back at these early photographs, I was pleasantly surprised to find a few that still resonate with me today. That discovery was the genesis of this book.

Restaurant, Cambridge

"I traveled among unknown men, in lands beyond the sea;
Nor England! did I know till then what love I bore to thee."
– William Wordsworth

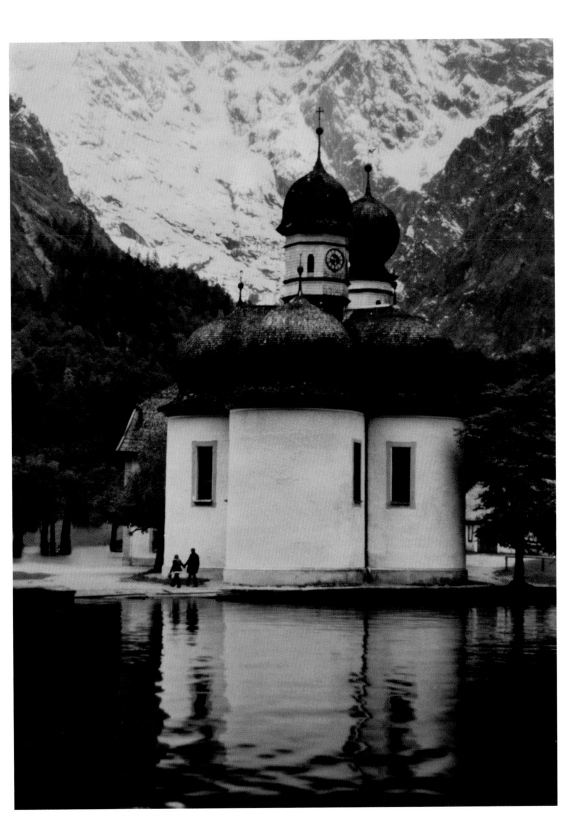

Konigssee, Bavaria

"This castle hath a pleasant seat; the air nimbly and sweetly recommends itself unto our gentle senses."
– William Shakespeare

This peaceful scene at a beautiful lake surrounded by forest-covered mountains, near Berchtesgaden in southern Bavaria, was in striking contrast to what I had seen the day before at Dachau concentration camp.

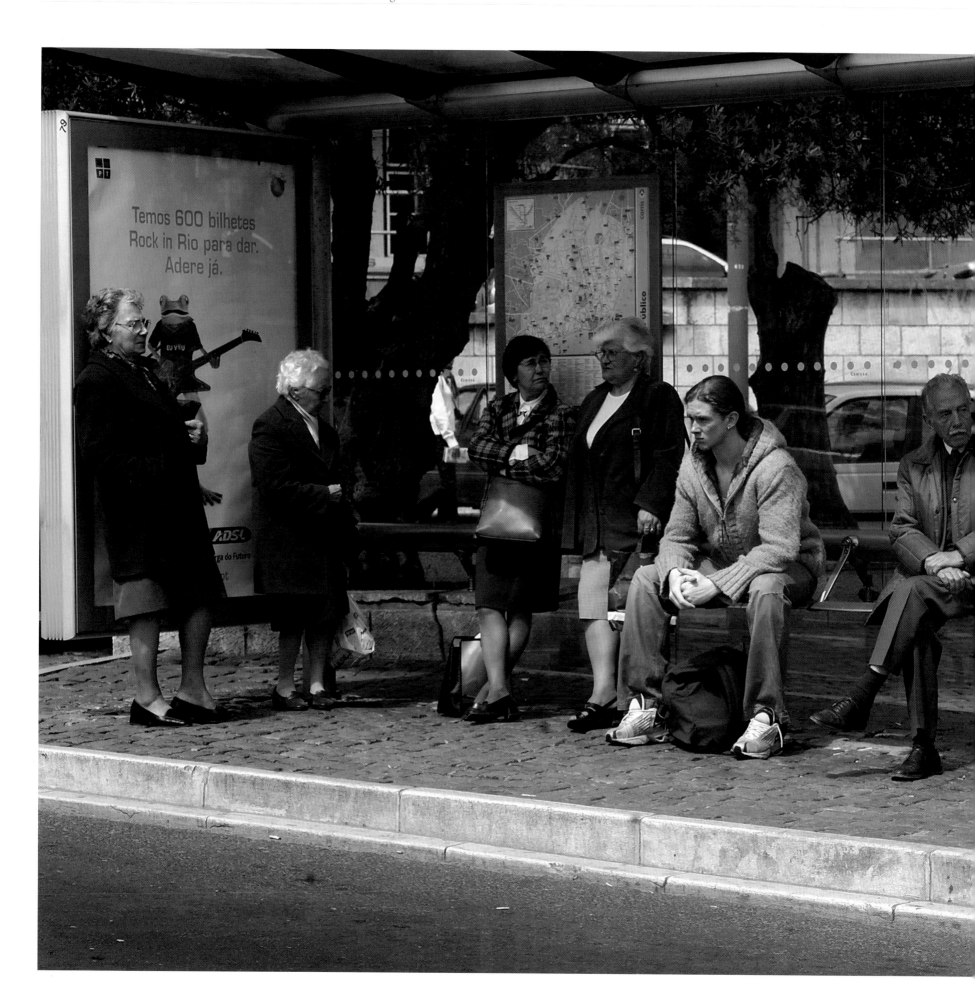

Bus Stop, Lisbon

"Solitude is the profoundest fact of the human condition. Man is the only being who knows he is alone."
– Octavio Paz

Old Building, Cappadocia

"We shape our buildings: thereafter they shape us."
– Winston Churchill

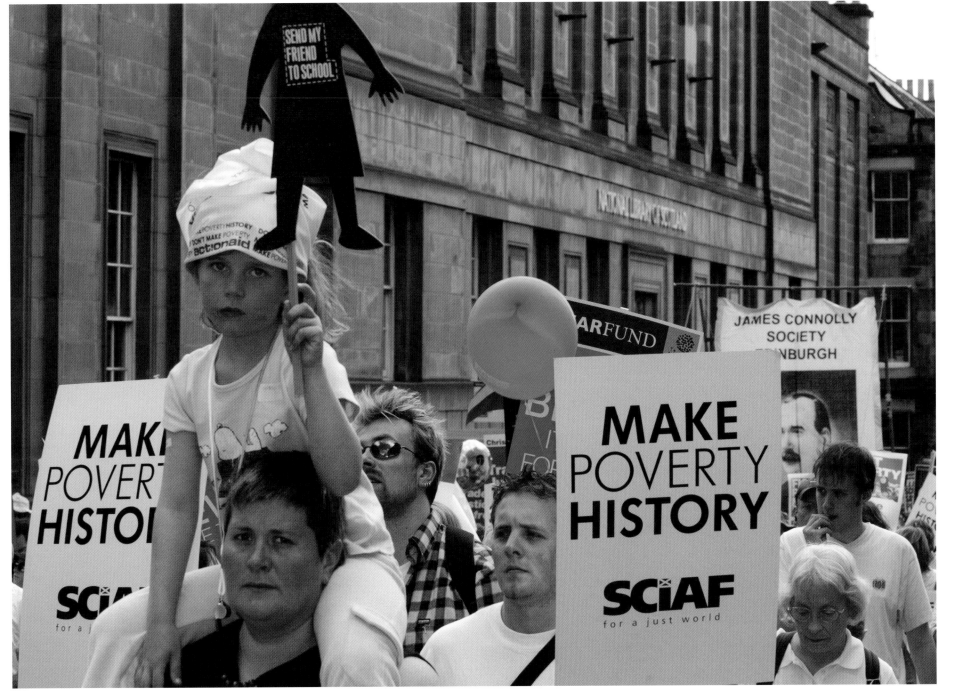

March on Poverty, Edinburgh

*"There is nothing new about poverty. What is new
is that we now have the techniques and the resources
to get rid of poverty. The real question is whether we
have the will."*
– Martin Luther King, Jr.

In 2005 the G8 summit conference was taking place in
Scotland while I was spending time with my wife's
family there. Over one hundred thousand people
marched through the streets of Edinburgh protesting
world poverty and demanding that the leaders of the
major industrialized nations offer solutions to the
problem.

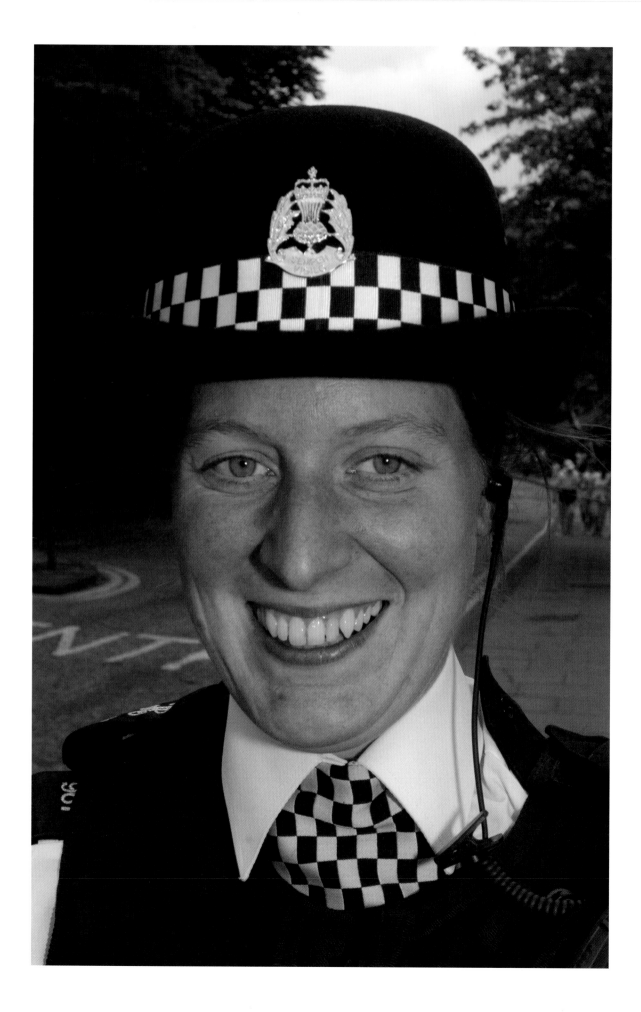

Bobby, Edinburgh

"When a felon's not engaged in his employment
Or maturing his felonious little plans,
His capacity for innocent enjoyment
Is just as great as any honest man's …
Ah! When constabulary duty's to be done,
A policeman's lot is not a happy one."
– W.S. Gilbert

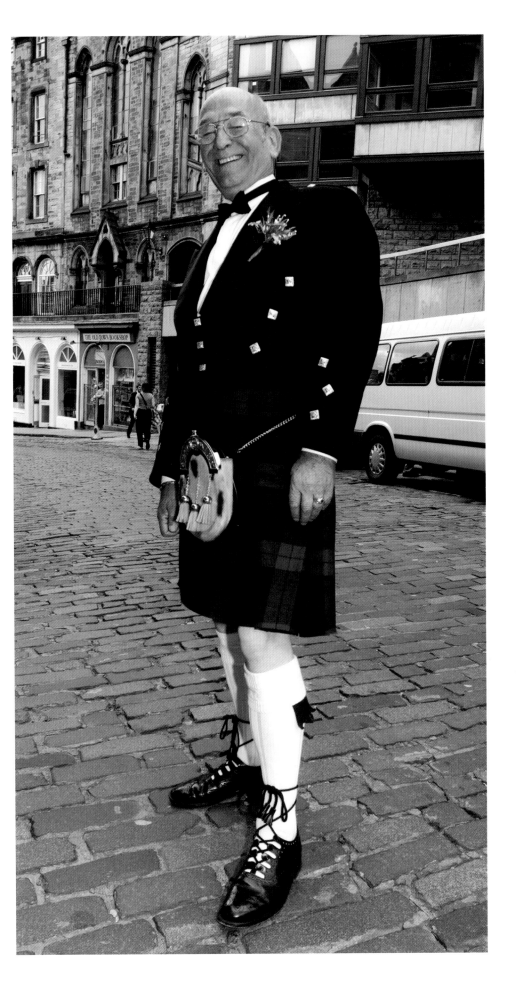

Proud Father of the Groom, Edinburgh

*"Much may be made of a Scotchman, if he be
caught young."*
– Samuel Johnson

Gentleman, Hay-on-Wye

"Nought cared this body for wind or weather
When youth and I lived in 't together."
– Samuel Taylor Coleridge

Gentleman, Ring of Kerry

"Stephen Daedalus is my name,
Ireland is my nation.
Clongowes is my dwelling place,
And heaven my expectation."
– James Joyce

Hermitage Museum, St. Petersburg (formerly Leningrad)

*"The language of art is powerful to those who
understand it and puzzling to those who do not."*
– Richard Leakey

The Kremlin, Moscow

"Russia is a riddle wrapped in a mystery inside an enigma."
– Winston Churchill

The Kremlin, a fortified complex overlooking the Moskva River in the heart of Moscow, dates from the late fifteenth century, when Grand Prince Ivan III commissioned Italian masters to design and construct churches with golden domes. My wife and I went to the Soviet Union in 1984 to help the Refuseniks: Jews who had applied for, and been refused, a visa to leave the Soviet Union. These people, often distinguished scientists and academicians, lost their jobs and were subjected to severe financial, physical and psychological pressure. We encountered many people who, by their example, inspired us. These people were willing to lose their jobs, be deprived of their access to colleagues and books, and to be under constant threat of harassment and even imprisonment because they sought religious freedom and the right to emigrate. Our awareness of the preciousness of freedom took on new meaning after this visit.

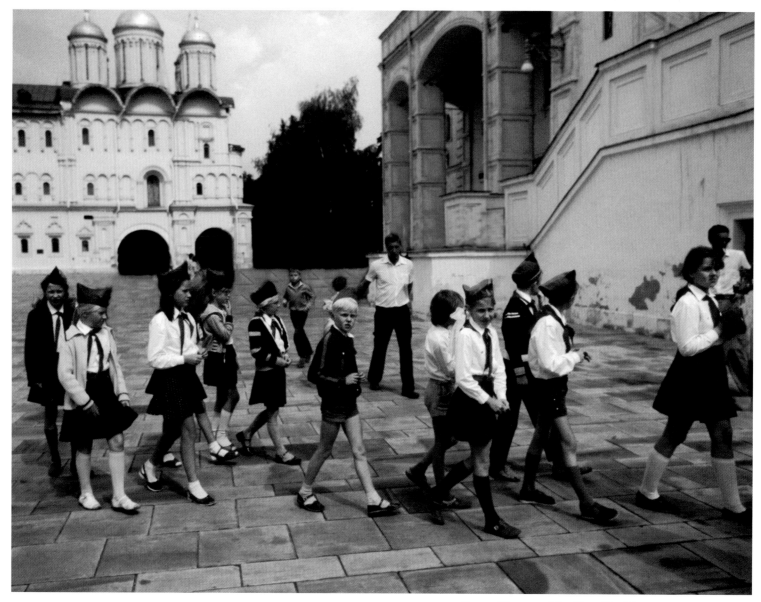

Young Pioneers, The Kremlin, Moscow

*"Wretched and abundant, oppressed and powerful,
weak and mighty, Mother Russia!"*
– Nikolai Nekrasov

This photograph is historically interesting because
these children are members of the Young Pioneers, the
Communist Party youth movement. Their uniform
of red hats and red scarves was a common sight in
communist countries. Almost no one thought in 1984
that, within six years, the former Soviet Union would
dissolve and the Young Pioneers would be extinct.

Early Morning, Left Bank, Paris

"If you are lucky enough to have lived in Paris as a young man, then wherever you go for the rest of your life, it stays with you, for Paris is a moveable feast."
– Ernest Hemingway

I took this photograph from my hotel room on the left bank of the Seine. France for me always will be associated with my honeymoon. It included just the three of us: my wife, my mother-in-law and me.

Asia

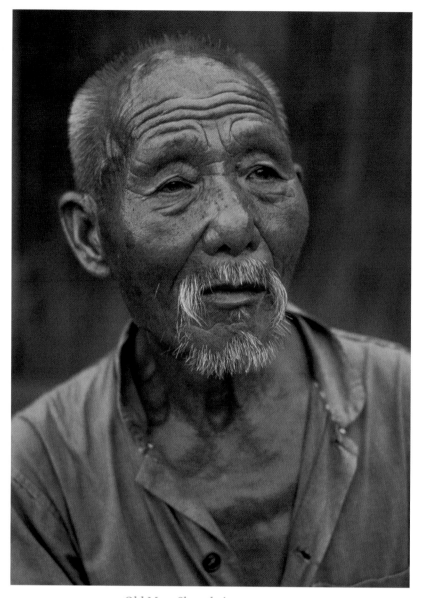

Old Man, Shanghai

*"Nothing and no one can destroy the Chinese people.
They are the oldest civilization on earth. They yield,
they bend to the wind, but they never break."*
– Pearl Buck

When I was in Shanghai in 1982 there were virtually
no cars, only a few government vehicles, and hundreds
of thousands of bicycles. Shanghai is now one of the
world's great modern cities with Asia's largest shopping
mall and over thirteen million people. Every month
thousands more cars are added to the city's streets.

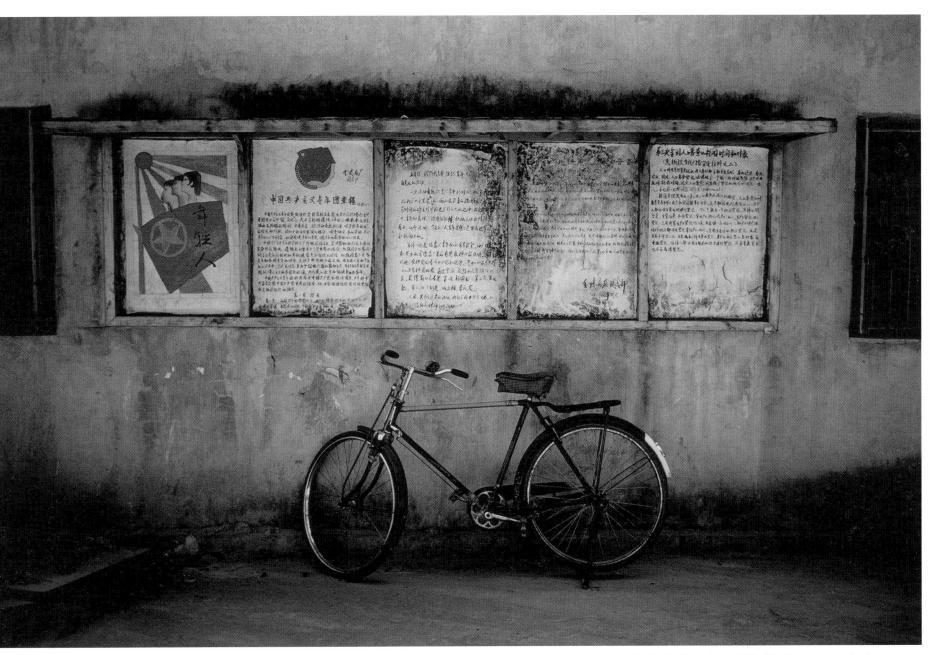

Bulletin Board with Weekly Newspaper, Suchow

"The power is to set the agenda … what we print and what we don't print matters a lot."
– Katharine Graham

In 1982 few people could afford a newspaper so copies were placed on walls. China had a handful of foreign visitors when we visited. Now there are millions of international visitors a year, making China the fourth most visited country in the world.

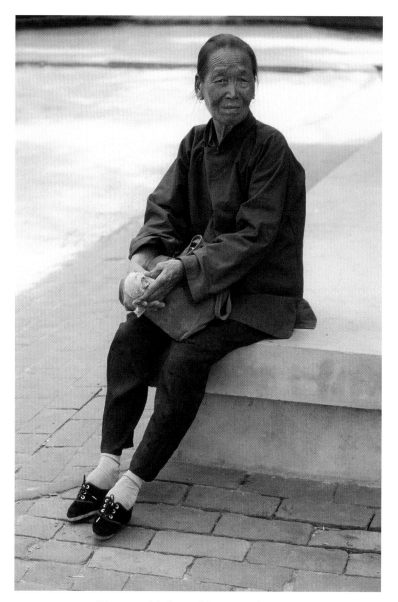

Woman with Bound Feet, Wuxi

"It's too early to tell."
– Chou En-Lai, when asked about the impact of the
French Revolution

The custom of binding feet, which existed for a
thousand years, was outlawed early in the twentieth
century. When this woman was a child, her feet
were deliberately broken so that she would be unable
to work, and her idleness would serve as a status
symbol for her husband.

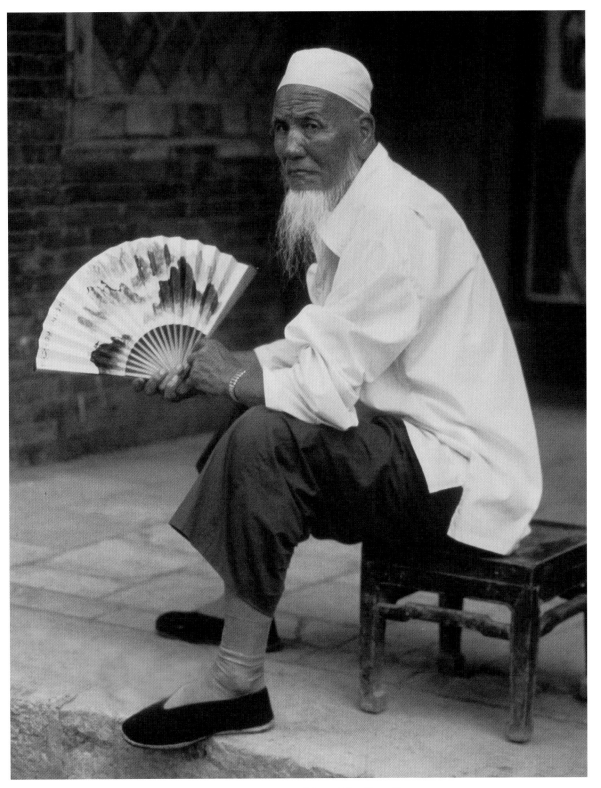

Man with a Fan, Sian

"We don't see things as they are, we see things as we are."
– Anaïs Nin

This man is in a mosque in Sian, which has a large Muslim population.

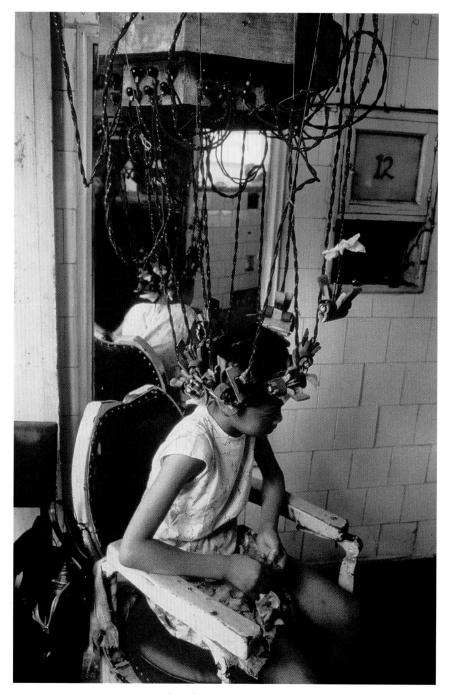

Girl under Hairdryer, Nanking

"All the modern inconveniences."
– Mark Twain

Considering how technologically advanced China is
today, this machine is something of a classic.

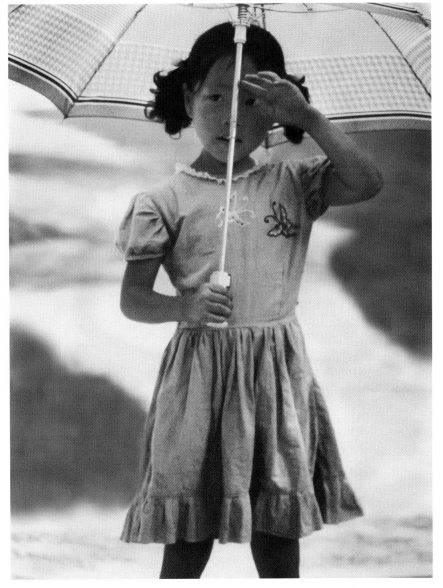

Girl with Umbrella, Beijing (formerly Peking)

"I carry the sun in a golden cup,
The moon in a silver bag."
– William Butler Yeats

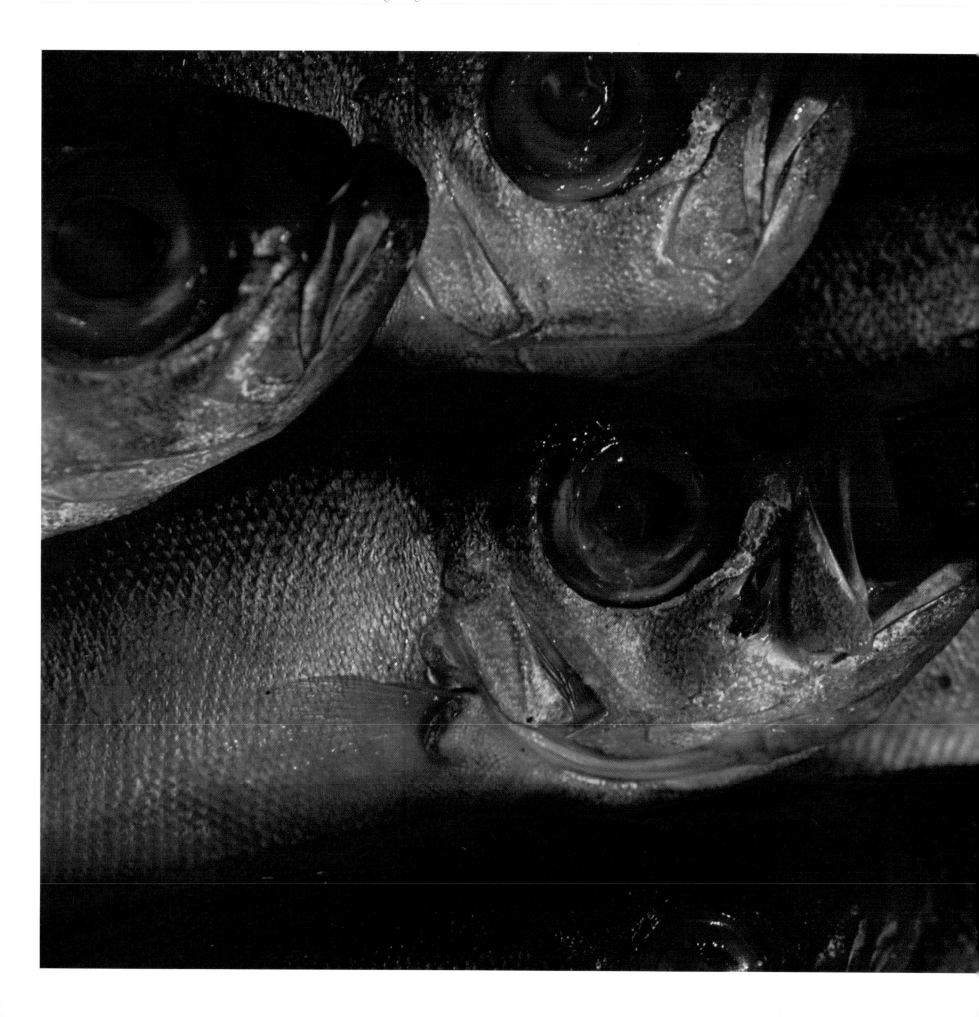

Fish in Market, Hong Kong

"In the house of words was a table of colors. Each poet took the color he needed: lemon yellow or sun yellow, ocean blue or smoke blue, crimson red, blood red, wine red."
– Eduardo Galeano

When I was in Hong Kong it was a British protectorate. Now it is part of China.

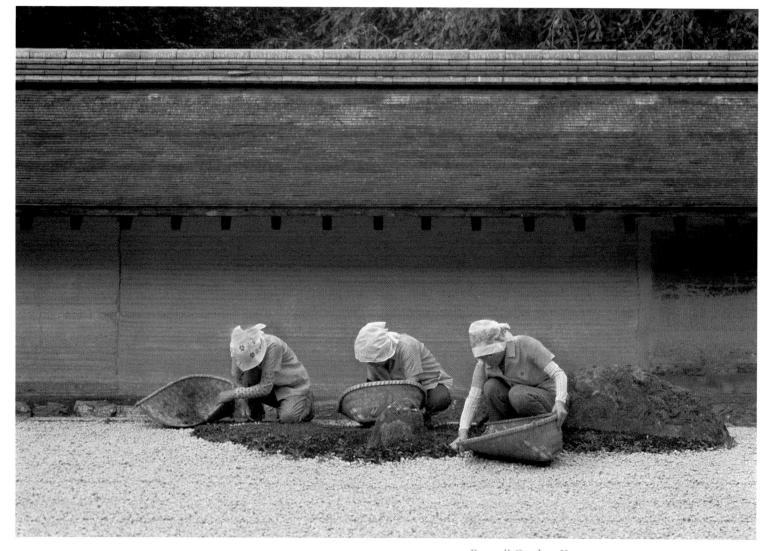

Ryoanji Garden, Kyoto

"Zen wants the pupil to bite his apple, not discuss it."
– Alan Watts

Three women are weeding in the garden, which con-
sists of moss, gravel, and fifteen rocks in three
groups. In the Buddhist world, the number fifteen
connotes completeness. Ryoanji garden expresses
simplicity, emptiness and tranquility, qualities empha-
sized in Zen Buddhism. This form of Buddhism,
which stresses being in the moment and experience
rather than doctrine, is popular in Japan.

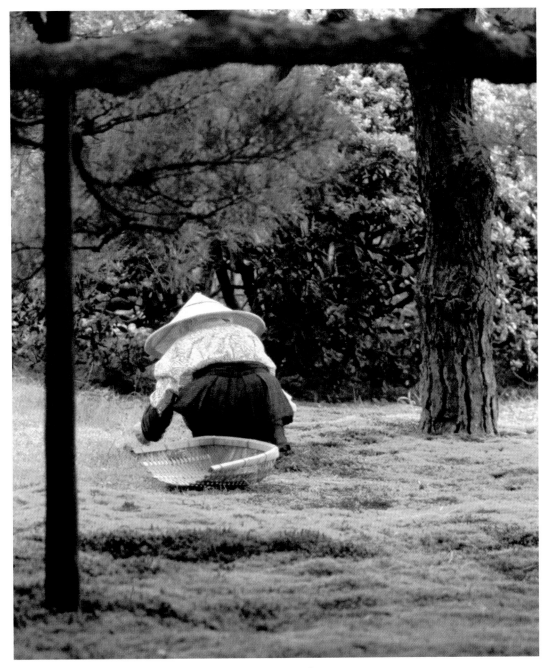

Moss Garden, Kyoto

"Let the beauty we love be what we do. There are hundreds of ways to kneel and kiss the ground."
– Rumi

Moss in Japan, especially in temple gardens, is treated like a beautiful carpet and cleaned every day.

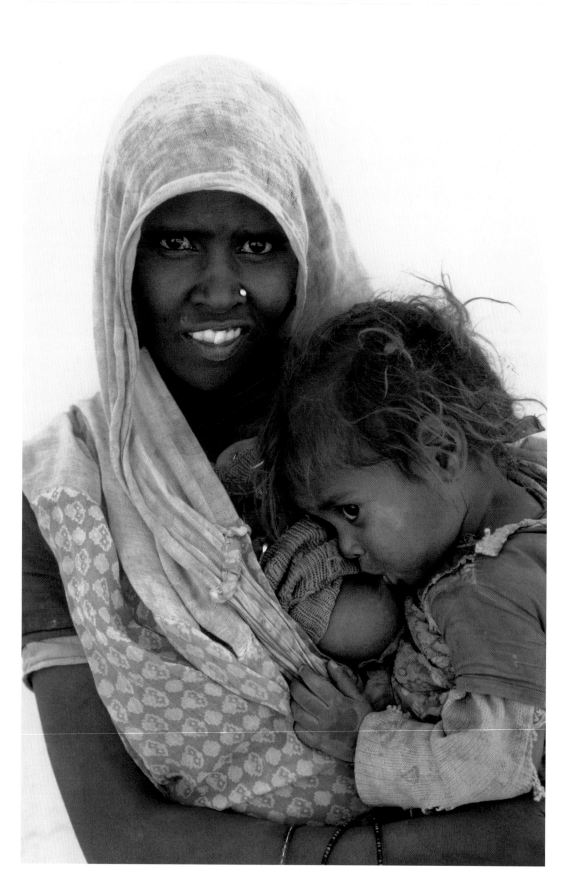

Mother and Child, Benares

"The relationship of parent and child remains indelible and indestructible, the strongest relationship on earth."
– Theodor Reik

The incredible variety of cultures, religions and people that is India was captured for me one lunchtime in Benares when I watched the traffic on the street outside. Apart from large numbers of cars, trucks, buses, bicycles and motorcycles, I also saw the three-wheeled motorcycle taxis known as "tuk-tuks," donkeys, camels, dogs, cows and an elephant. Humans passing by included every skin hue, and almost every style of dress, from business suits to holy men in loincloths, from vividly colored saris to the pure white of widows.

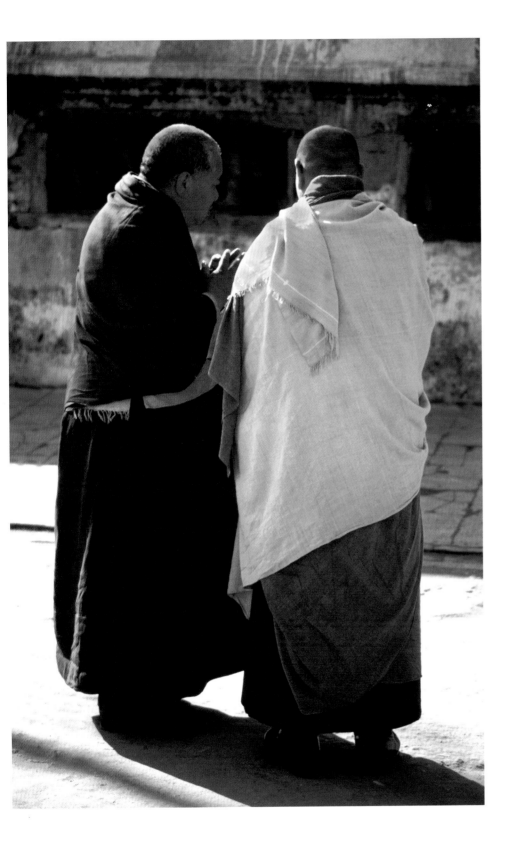

Buddhist Monks, Sarnath

"The essence of true religious teaching is that one should serve and befriend all."
– Mahatma Gandhi

Siddhartha Gauthama, the Buddha, was born in north-ern India in 563 B.C.E. After deep meditation, he attained enlightenment and delivered his first sermon at Sarnath, near Benares. In Buddhism no one is looked upon as a divine savior, because each person must find the path to knowledge through his own efforts. Sarnath at sunset was a scene of tranquility, with monks in meditation and prayer slowly circling a stupa. This contrasted dramatically with the intense activity of the Hindu crowds at nearby Benares.

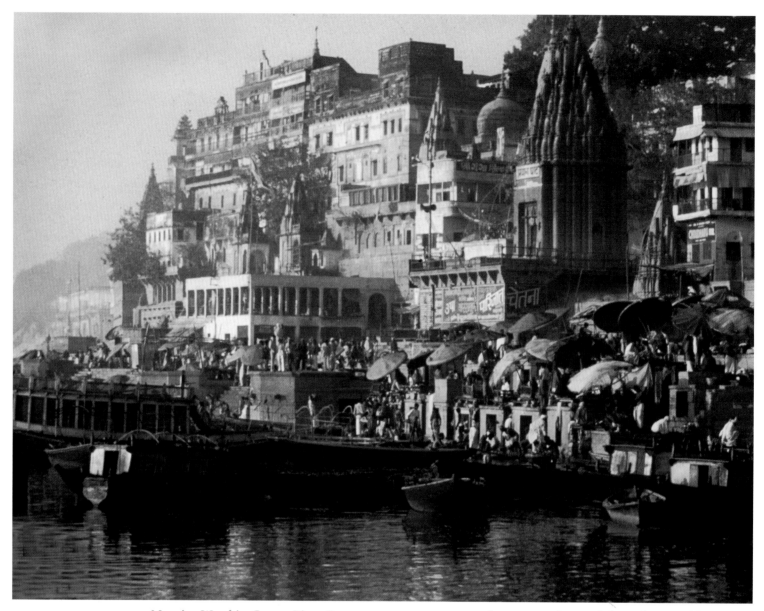

Morning Worship, Ganges River, Benares

"There is no end. There is no beginning. There is only the infinite passion of life."
– Federico Fellini

One of the holiest sites in Hinduism, Benares has been a place of pilgrimage for thousands of years. The Ghats, or steps, have long been the cremation site of devout Hindus, whose ashes later mingle with the waters of the holy Ganges. Very early in the morning, to the accompaniment of chanted prayers blaring over loudspeakers, hundreds of people, interspersed with wandering cows, fill the riverbanks, where they change into white garments and descend into the river. Waist deep, they bathe, pray and lay bouquets of marigolds on the sacred water. As many leave, hundreds more arrive, creating a scene of continual motion, all set against the spirals of smoke from the burning pyres.

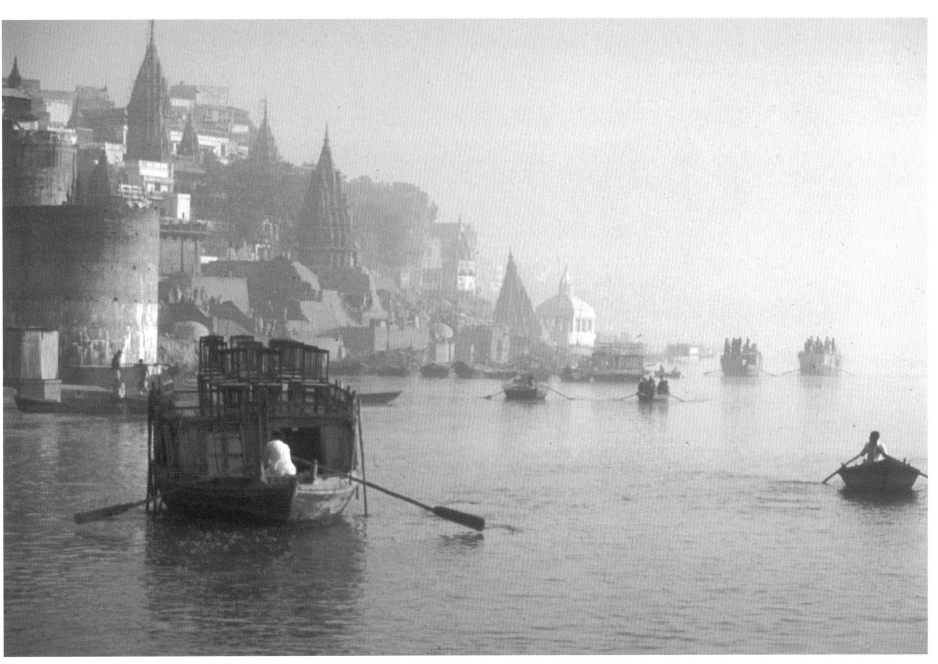

Morning Mist, Ganges River, Benares

"Life is but a day; a fragile dewdrop on its
perilous way."
– John Keats

Morning Mist, Keoladeo National Park

"The fog comes in on little cat feet. It sits... on silent haunches and then moves on."
– Carl Sandburg

This national park near the town of Bharatpur is a sixty-four-thousand-acre tract of land that attracts the largest concentration of wildlife in Asia. Numerous migratory birds are attracted to its wetlands. For centuries it was a private hunting preserve, where a former viceroy of India once shot 4,273 birds in one day. It became a sanctuary in 1956.

Milkman Making His Morning Rounds, Keoladeo National Park (facing page)

"Thou, O God, dost sell us all good things at the price of labor."
– Leonardo da Vinci

Only bicycles or bicycle rickshaws are permitted in the park, which gives it a very peaceful quality.

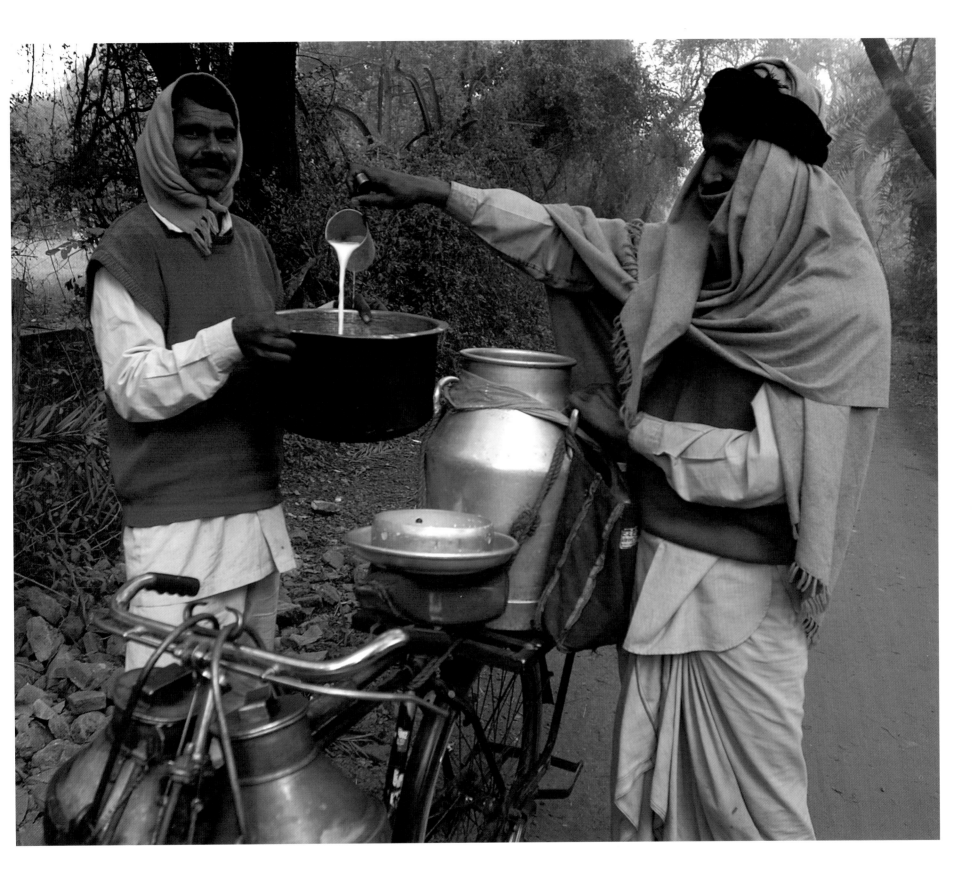

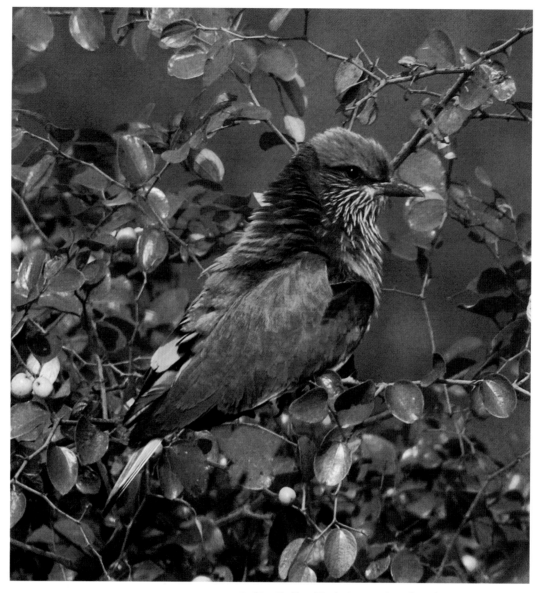

Indian Roller, Keoladeo National Park

"She was a phantom of delight when first she gleamed
upon my sight.
A lovely apparition, sent to be a moment's ornament."
- William Wordsworth

Rollers look as if they have been dipped in many
paints. They get their name from the males' mating
displays when, while flying toward the ground,
they rock from side to side to show off their prominent
wing patches.

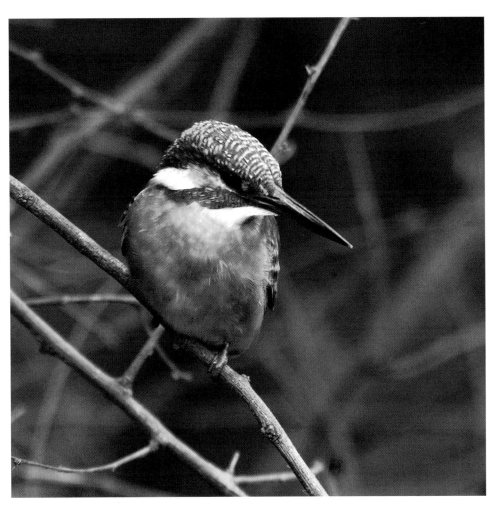

Common Kingfisher, Keoladeo National Park

*"It was the Rainbow gave thee birth, and left thee all
her lovely hues."*
– W.H. Davies

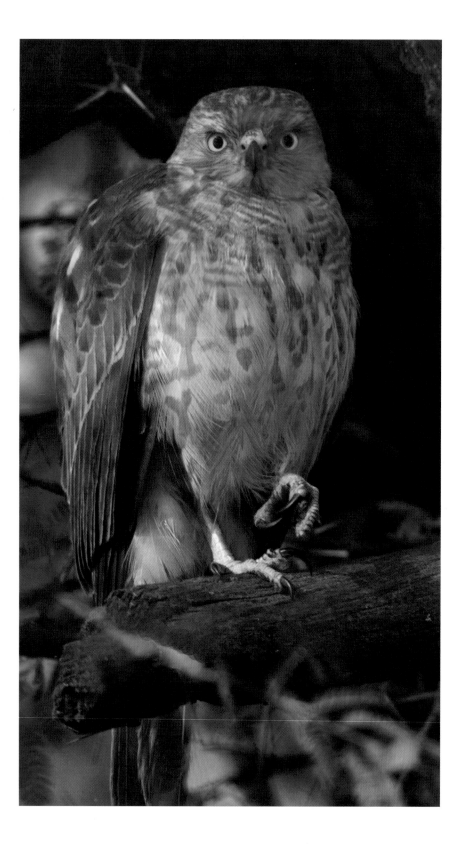

"*A velvet hand. A hawk's eye. These we should
all have.*"
– Henri Cartier-Bresson

An aggressive hunter, the sparrow hawk is unusual in
that, when pursuing its prey, such as birds or reptiles, it
flies through branches or very close to the ground.

"*Small rooms or dwellings discipline the mind, large
ones weaken it.*"
– Leonardo da Vinci

Owls are usually shy and well camouflaged but these
owlets inhabit open woods and are more visible.
They feed on reptiles, insects, small birds and mam-
mals. They often nest in holes in trees.

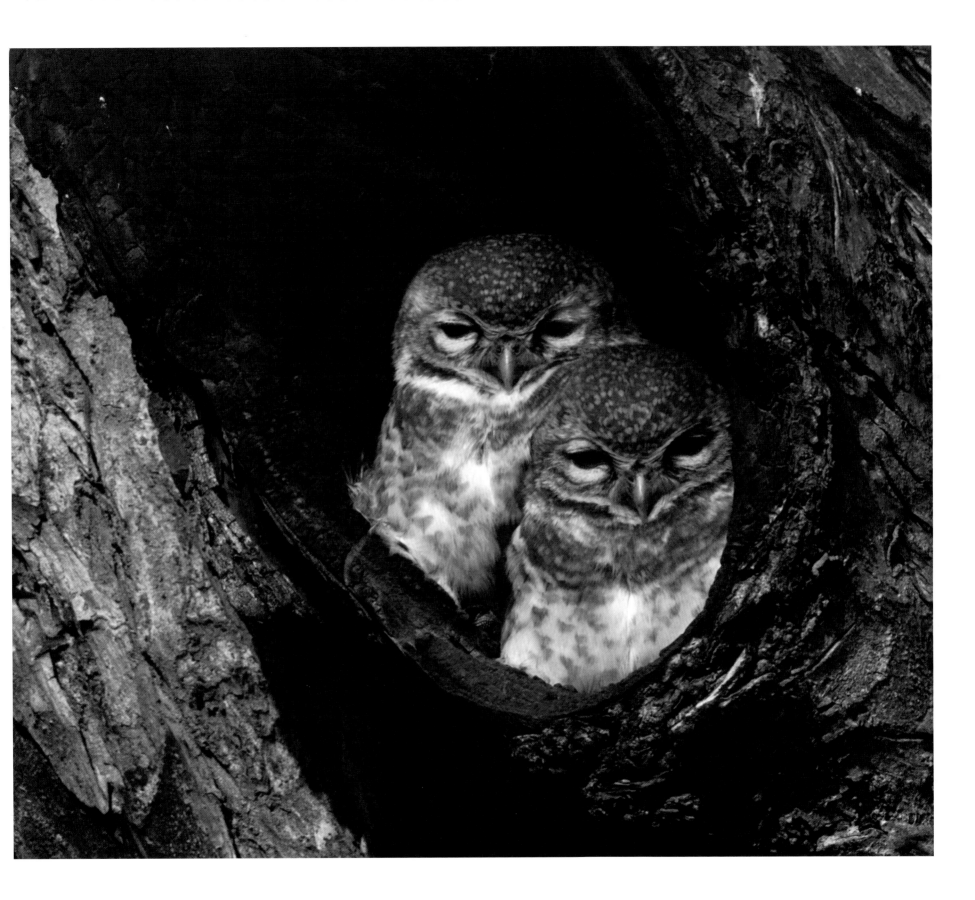

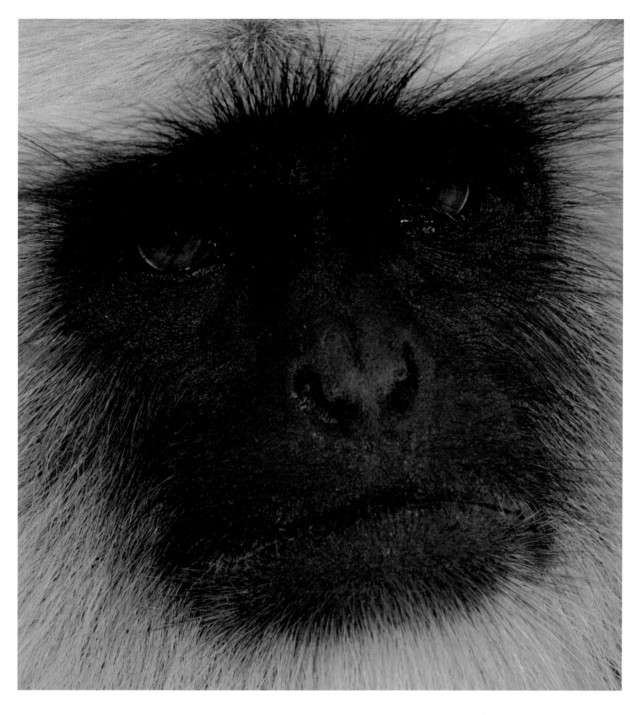

Black-faced Monkey, Jodhpur

"At a remote period, from Old World monkeys, man, the wonder and glory of the universe, proceeded."
– Charles Darwin

"Is man an ape or an angel? I am on the side of the angels, and I repudiate with indignation ... those newfangled theories."
– Benjamin Disraeli

These monkeys roam freely about ancient monuments in the city of Jodhpur.

Polo Match, Jaipur (facing page)

*"You were a lord if you had a horse. Far back, far back in our dark soul the horse prances ...
the symbol of surging potency and power of movement, of action, in man."*
– D.H. Lawrence

The British ruled India from the 1700s to 1947. Among Great Britain's positive contributions to India are the rule of law, the British educational system, a unified concept of country and an extensive infrastructure of roads, railroads, and administrative buildings. The very British sports of cricket and polo are still popular in India today.

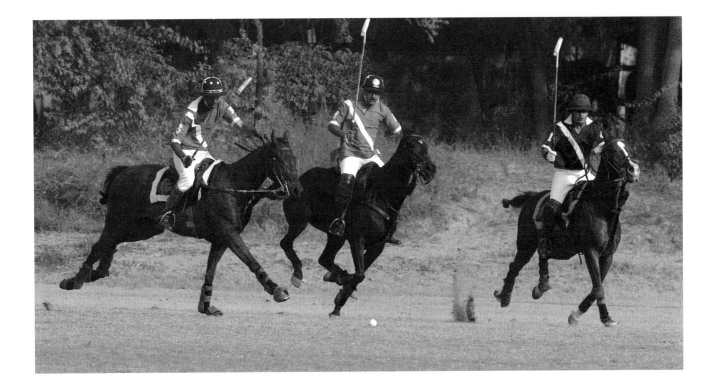

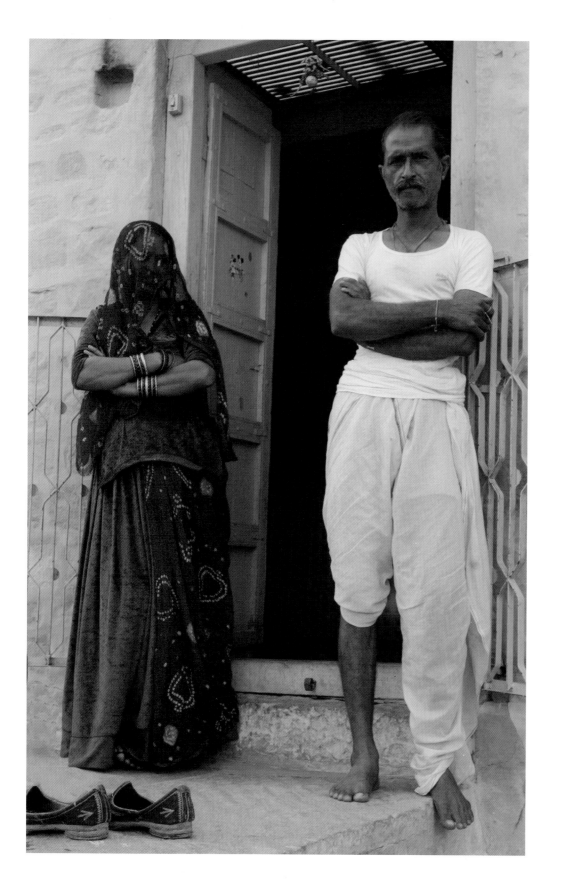

Husband and Wife, Jodhpur

"Let there be spaces in your togetherness."
– Kahlil Gibran

A husband and wife stand in front of their home in Jodhpur, known as the Blue City because the walls of the houses are painted blue.

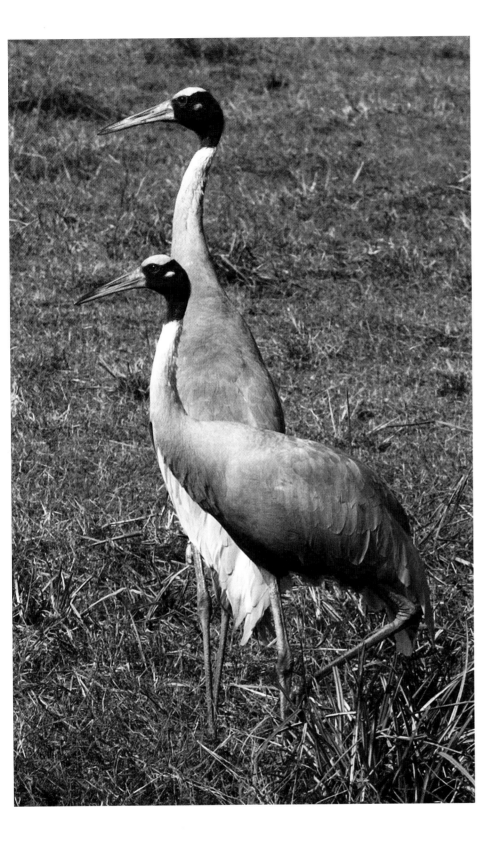

Sarus Cranes, Keoladeo National Park

"Grow old along with me! The best is yet to be."
– Robert Browning

The world's tallest flying birds, sarus cranes mate for life.

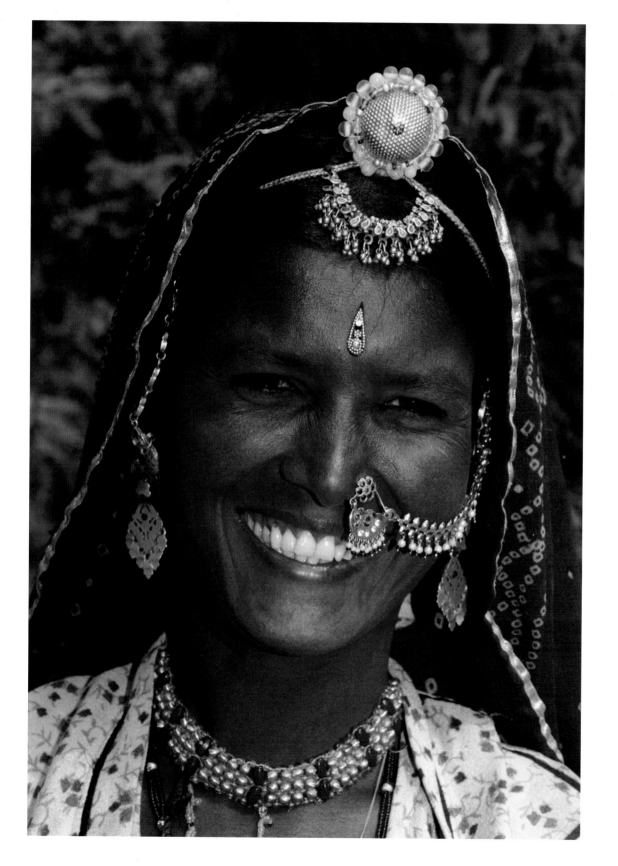

Gypsy, Jodhpur

"Brave new world that has such people in it."
– William Shakespeare

Gypsies in India traditionally wear silver jewelry.

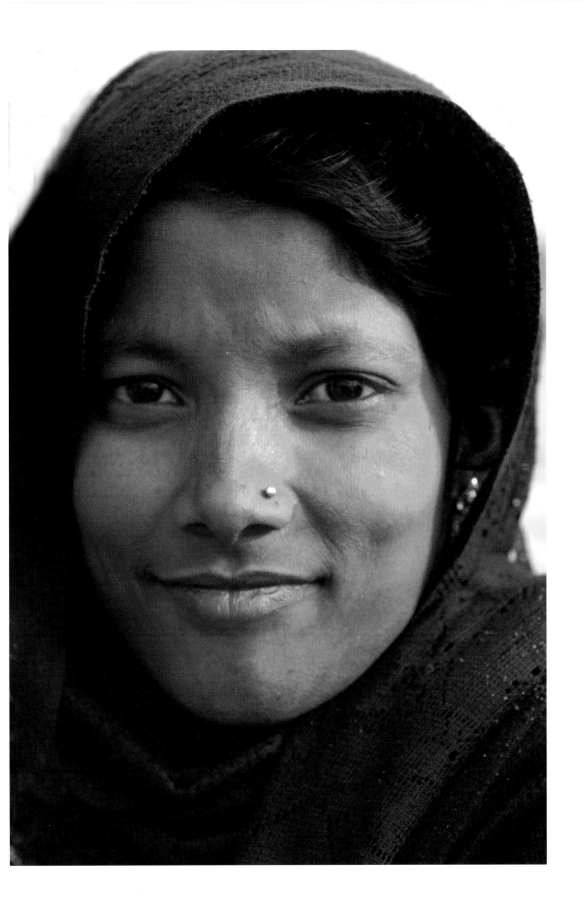

Laundry Woman, Rajasthan

*"A lady, garmented in light
From her own beauty"*
– Percy Bysshe Shelly

The saying goes that whatever one says about India is true and that the opposite is equally true. For example, India's economy has been one of the fastest growing in the world, and many billionaires recently have been created. However, two-thirds of the population live in small villages, and prosperity has touched very few of them.

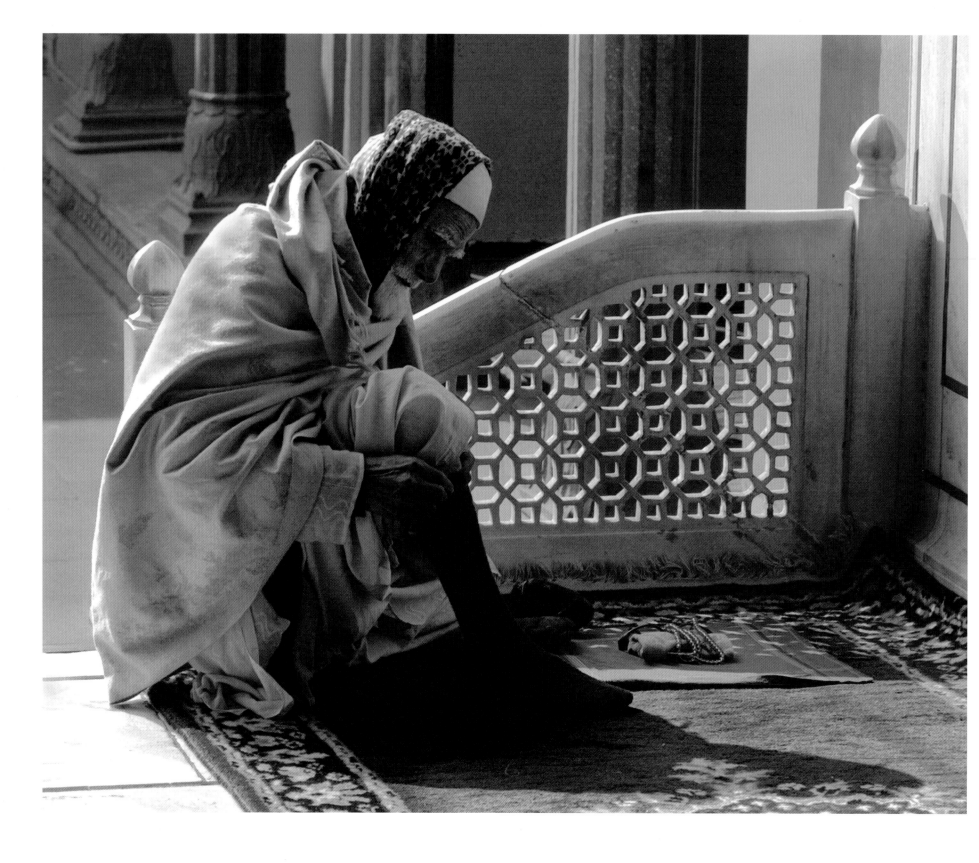

Muslim Praying, New Delhi (previous page)

"God is like a mirror. The mirror never changes, but everybody who looks at it sees something different."
– Harold Kushner

This man is making his preparations to pray at the Jama Masjid Mosque in New Delhi. It was built by Shah Jahan, the Moghul emperor who built the Taj Mahal. Many of the great architectural works in northern India were built by the Moghuls, Islamic emperors who conquered and ruled India from the mid sixteenth to the beginning of the eighteenth century. Today, there are one hundred twenty million Muslims in India. At Independence in 1947, India was partitioned to create Muslim Pakistan and Hindu India. However, forty million Muslims remained in India, and now India has more Muslims than does Pakistan.

Mother and Child, Udaipur

"Those who love the young best stay young longest."
– Edgar Friedenberg

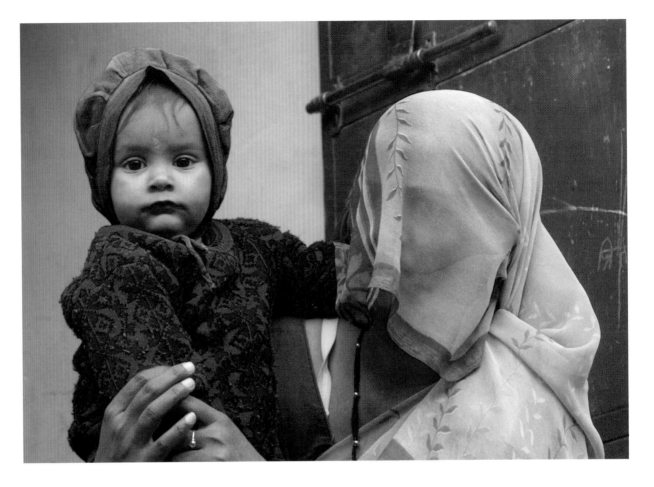

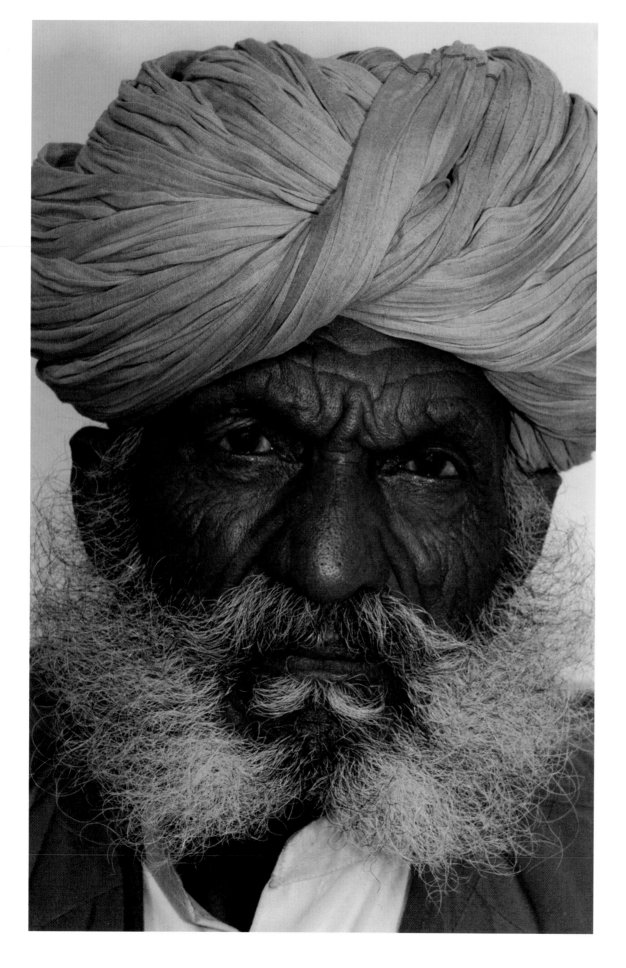

Hindu Man, Jodhpur

"Religions are all so many paths leading to the same goal."
– Swami Vivekananda

Hinduism is the religion of eighty percent of India's population. Unlike Christians and Muslims, who believe that there is one true path that leads to one God, Hindus hold that there are innumerable ways to worship and there are many paths. They feel that existence and reality are subjects too vast to be encompassed within a single set of beliefs. Devotional procedures are each individual's personal responsibility. Hindus believe that the universe is part of an endless cycle of creation, preservation and dissolution. Karma is the law of cause and effect, through which individuals can create their own destiny by their thoughts and deeds. Thus a person's behavior in this life will help determine the next one. Although there are many deities, people typically develop an affinity for one or two, especially Brahma the creator, Vishnu the preserver, or Shiva the destroyer, or one of their many manifestations. In Hindu temples, deities are decorated with garlands of flowers and prayers are fervent.

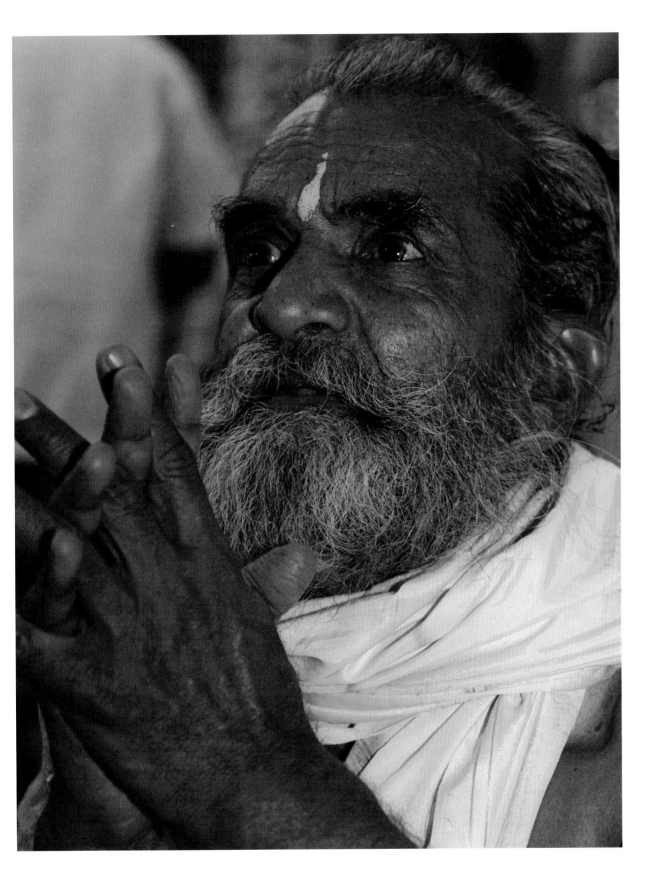

Jain Praying, Ranakpur Temple, Rajasthan

"Thou waitest for the spark from heaven …"
– Matthew Arnold

The Jain religion emphasizes reverence for all forms
of life. As a consequence, observant Jains are strict
vegetarians. Even root vegetables, such as potatoes
and onions, are forbidden, because pulling them
out of the ground destroys the plant. The most ortho-
dox Jains wear masks and sweep the sidewalk in
front of themselves, because even insects are not to be
harmed. Asceticism, meditation, and pilgrimage to
holy places are important components of this religion.
Jains accept the idea of God and see him in the lives
of their prophets and leaders. I was fortunate to attend
a ceremony at Ranakpur temple, which dates from
1446. Inside there are 1,444 intricately carved pillars,
not one of them the same. The temple was covered
in gold and silver leaf and statues were decorated
with flowers.

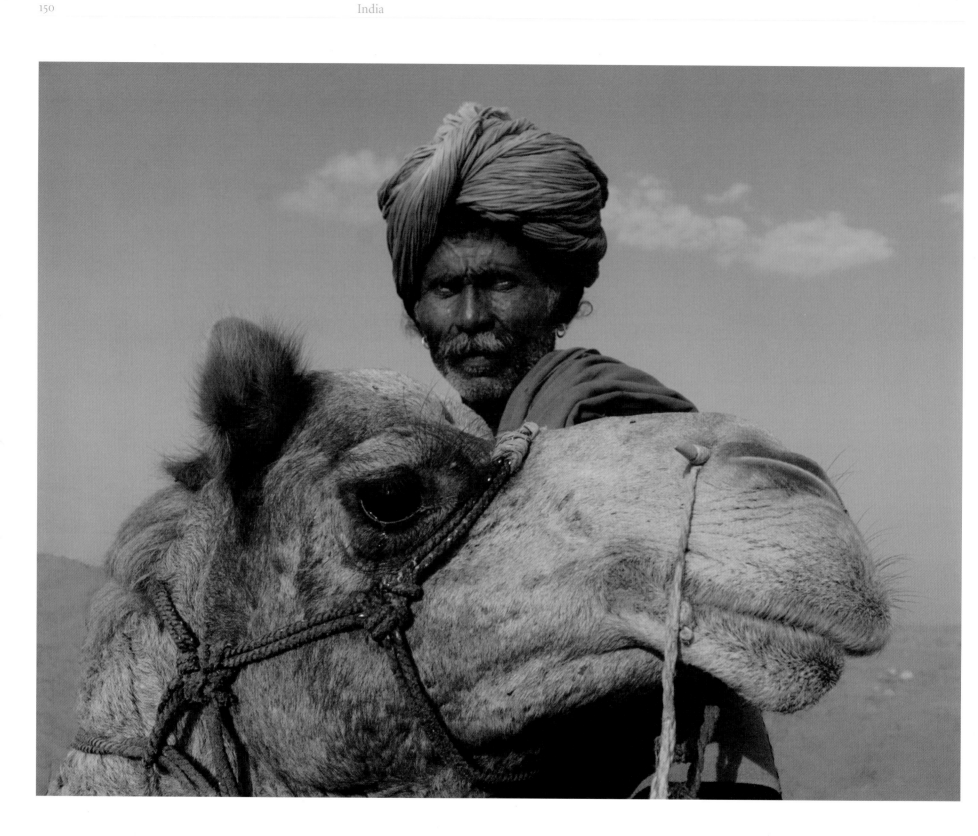

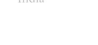

Camel and Camel Driver, Thar Desert, Northwest India (previous page)

"The camel has a single hump; the dromedary two;
Or else the other way around,
I'm never sure, are you?"
– Ogden Nash

I spent a memorable afternoon on the back of this camel, riding through the desert.

Grandfather and Grandson, Jaiselmer

"Childhood is a short season."
– Helen Hayes

After traveling for hours across the barren Thar Desert, the traveler sees in the distance the fabled city of Jaiselmer, a medieval sandstone fort on a hill. In the far west of India, only a few miles from today's border with Pakistan, the city prospered for centuries as an important trading center along the Silk Road. This grandfather and grandson were in a small village near Jaiselmer. The makeup on the child's eyes is to protect him from the "evil eye," and to help keep insects out of his eyes.

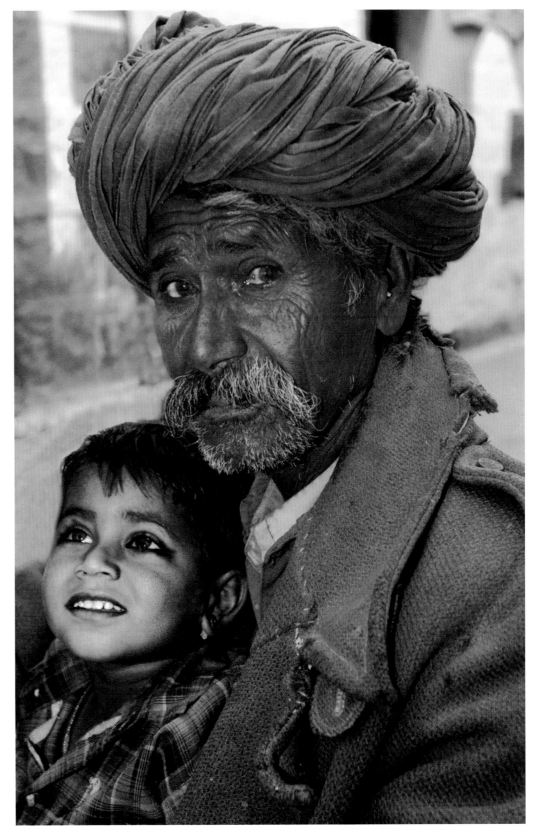

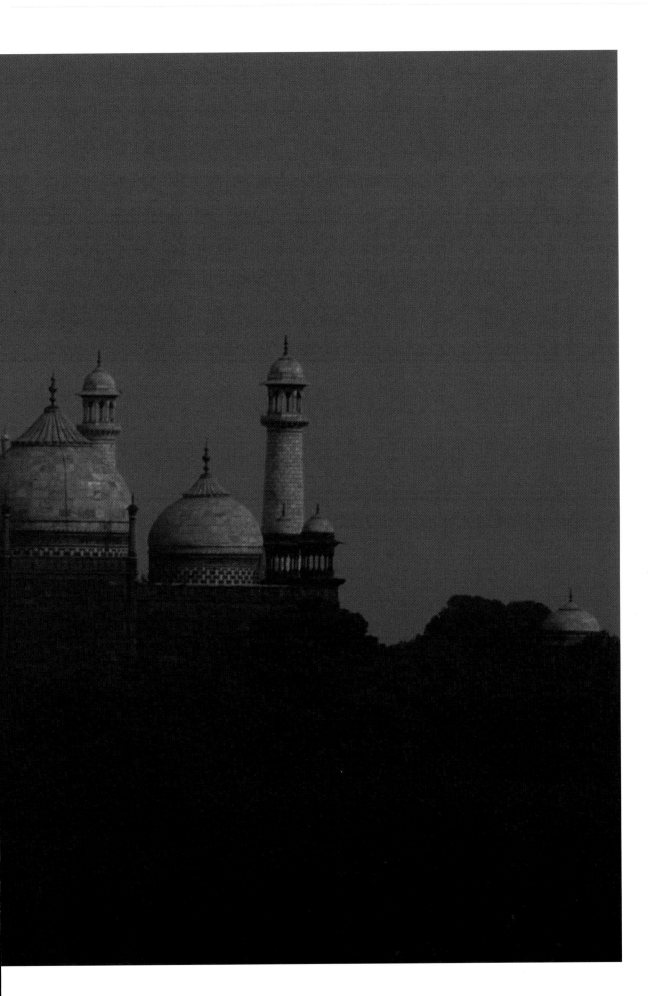

Taj Mahal at Sunset, Agra

"The serenity of Shangri-La... it shimmered in repose from which all the fret of existence had ebbed away, leaving a hush as if moments hardly dared to pass."
– James Hilton

The inspiration for the Taj Mahal is well known but bears retelling. Shah Jahan, one of the great Moghul emperors, was devoted to his favorite wife, Mumtaz Mahal. She traveled everywhere with him until, accompanying him on a military campaign, she died at age thirty-nine giving birth to their fourteenth child. The emperor went into mourning for two years. Then, in 1622, he planned her magnificent memorial, which took twenty-two years to complete, utilizing twenty thousand workers and one thousand elephants. The building is magnificent: a luminous fantasy that is perfectly proportioned and delicate in every detail. This view of the Taj Mahal is particularly poignant because it was taken from the Agra or Red Fort. After seizing power, Shah Jahan's son imprisoned his father in this fort. For the last eight years of Shah Jahan's life, he could only gaze upon his wife's tomb from afar.

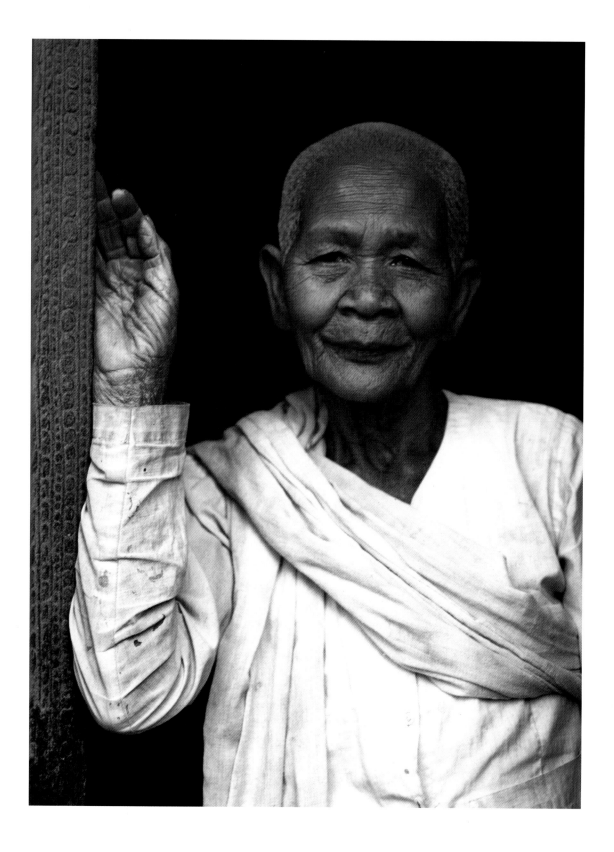

Buddhist Nun, Pagan

"What is the way of Buddha? It is to study the self. What is the study of the self? It is to forget one's self. To forget oneself is to be enlightened by everything in the world."
– Dogen

There are two major forms of Buddhism, Theraveda (Hinayana) and Mahayana. Eighty percent of the Burmese people are Theraveda Buddhists. They believe that each individual must find his own enlightenment, without the help of an intermediary, and great emphasis is placed on an austere way of life. Becoming a nun is a path to enlightenment. It requires celibacy, the renunciation of all possessions, and a vow to injure nothing and to offend no one.

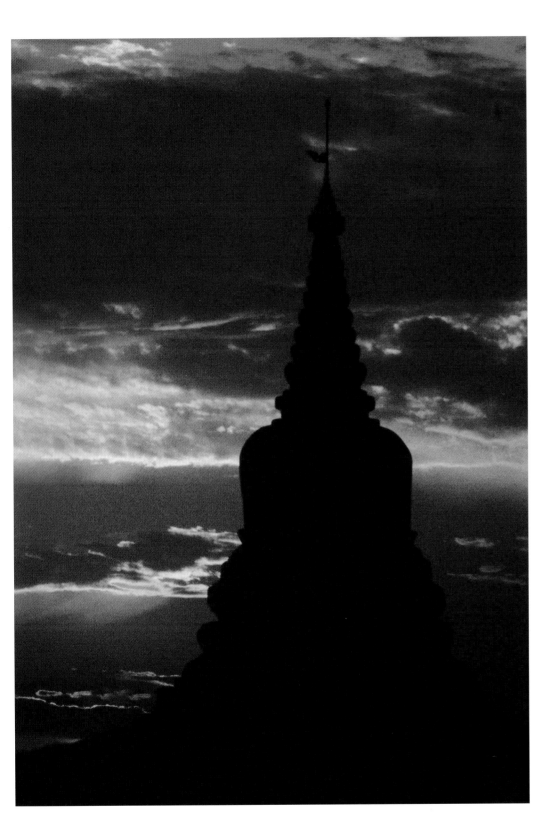

Shwedagon Pagoda, Yangon (formerly Rangoon)

*"The Schwedagon was superb, glistening with gold, like
sudden hope in the dark night of the soul."*
– Somerset Maugham

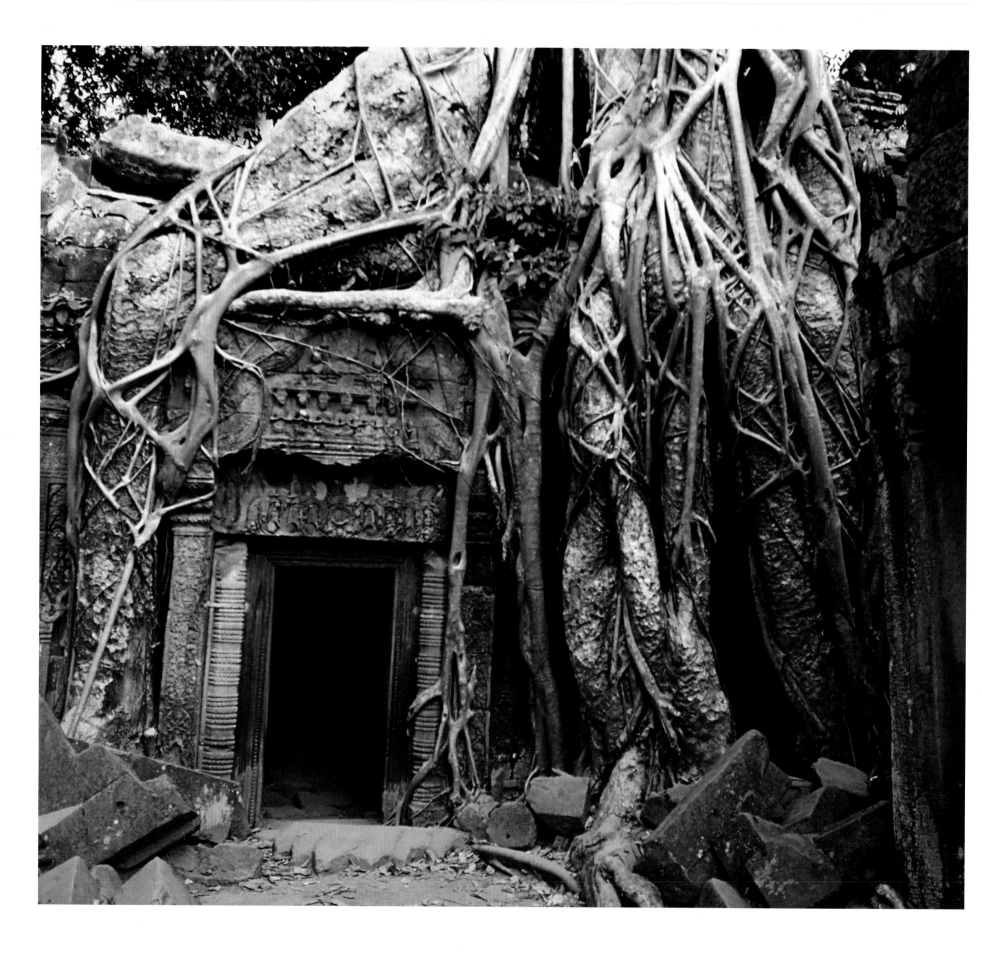

Ta Prohm, Siem Riep (previous page)

"All art, permanent or temporary, has a life in the immediate experience, but then has a life in the imagination."
– Anish Kapoor

Constructed in 1186 as a Buddhist monastery, Ta Prohm accommodated twelve thousand people, and another eighty thousand were employed to service the complex. It was abandoned for centuries before being rediscovered in the late nineteenth century. The image permanently imprinted on my memory is of the giant kapok trees that grow from the great stone walls and are gradually consuming the entire structure.

Bayon Temple, Siem Riep

"The veneration paid to tradition accumulates from generation to generation, until at last it becomes holy and excites awe."
– Friederich Nietzsche

The Bayon Temple, built around 1200, is at the center of the walled city of Angkor Thom, the capital of the Khmer Empire. At its height this kingdom, which lasted from 802 to 1431, included present-day Myanmar (formerly Burma), Laos and the Malay Peninsula. The Bayon rises dramatically above the surrounding trees. Each of its thirty-seven surviving towers has four huge face sculptures, fifteen feet high, which smile benignly outward in four directions.

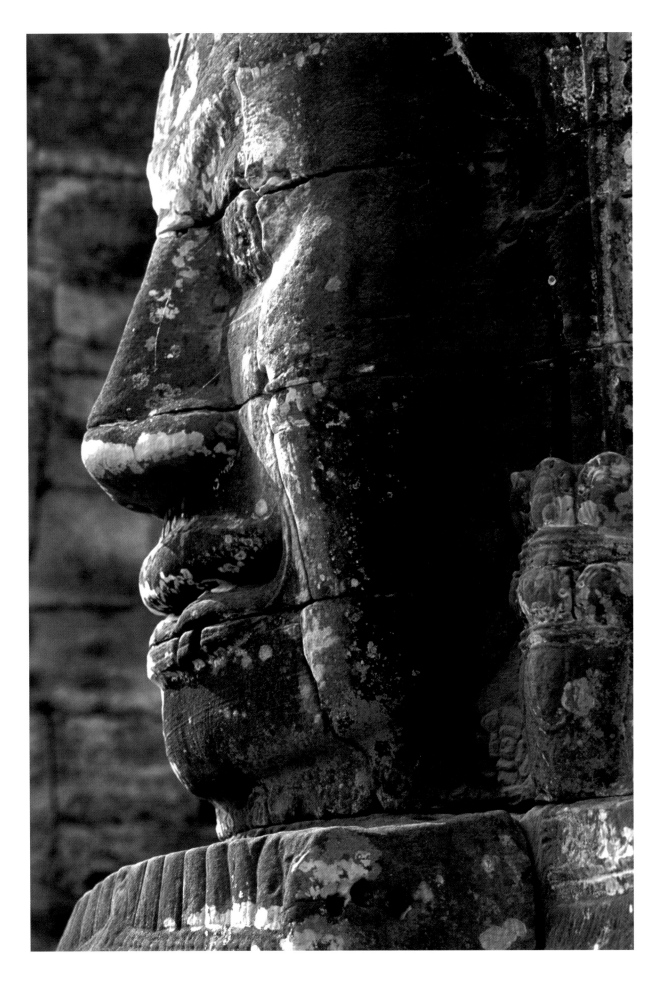

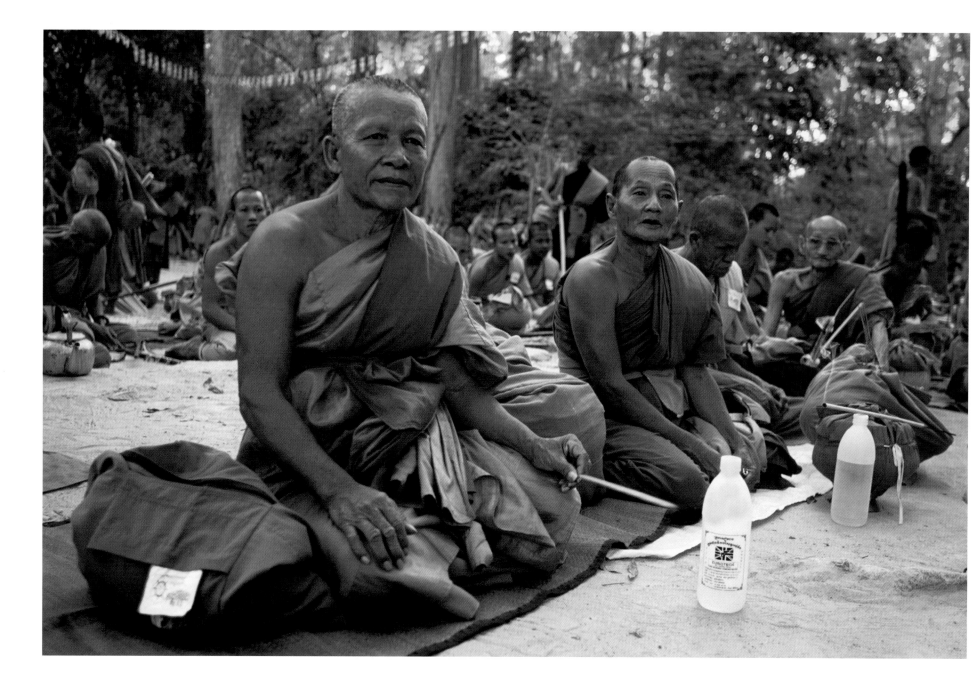

Buddhist Monks, Siem Riep (previous page)

*"Surely the simplification of our wants is a thing
greatly to be desired."*
– Mahatma Gandhi

Dozens of monks had gathered near the Bayon Temple
and were preparing to sleep in the forest. It was a
special sight, because in the 1970s most of the monks
in the country were killed by Pol Pot when he took
control of Cambodia from 1975 to1978. The stated
goal of his revolutionary group, the Khmer Rouge, was
to create a nation of peasants in an agrarian society.
Education and family were deemed unimportant.
To that end, mass executions took place that targeted,
among others, monks, people who spoke a foreign
language, the educated elite and military commanders.
Hundreds of thousands more were worked to death
farming or on building projects. Eventually, close to
two million people, about twenty percent of the popu-
lation, were killed. Pol Pot and the Khmer Rouge were
overthrown by Vietnamese troops in 1978.

Buddhist Monk, Siem Riep

*"The true value of a human being is determined
primarily by the measure and sense in which he has
attained liberation from the self."*
– Albert Einstein

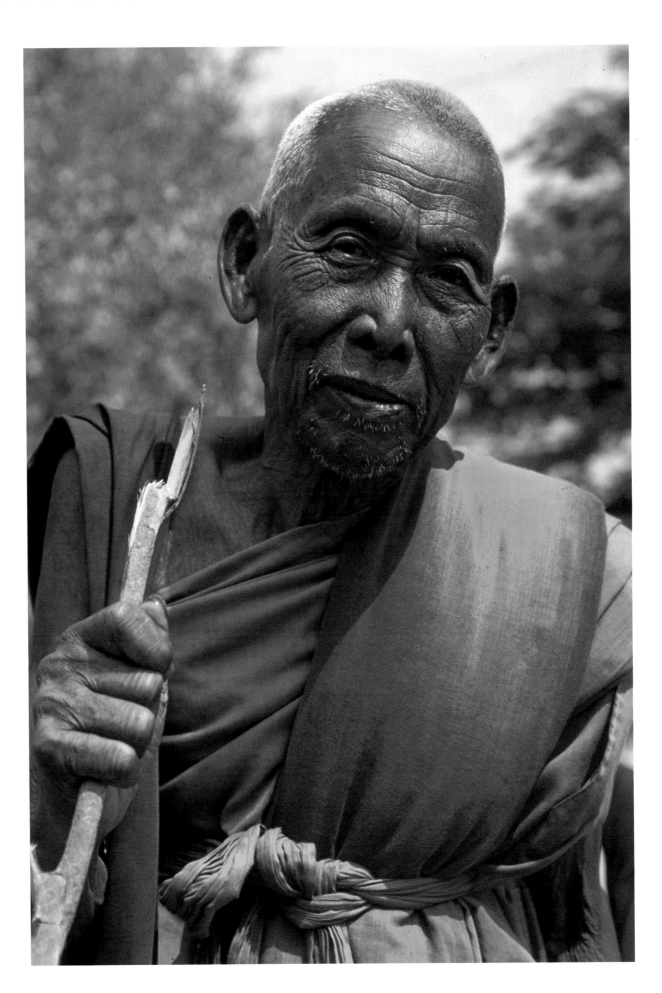

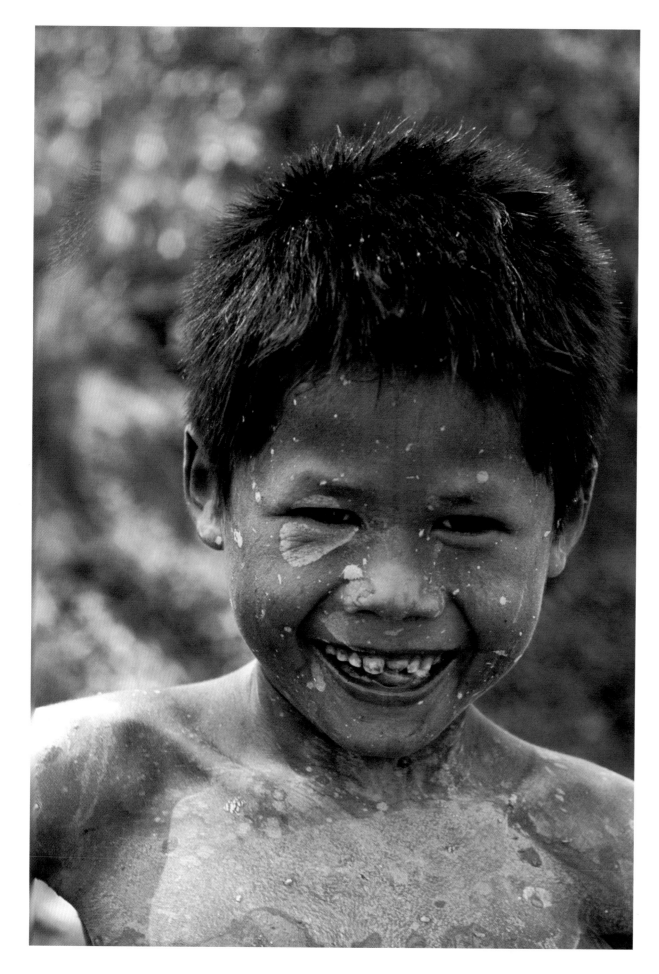

Muddy Boy, Siem Riep

"Happiness does not depend on outward things, but on the way we see them."
– Leo Tolstoy

Many peasant farmers around Siem Riep have a small fishpond near their home that supplies the family with food. As the dry season sets in and the pond begins to dry up, the family fishes in the mud at the bottom of the pond to make sure no protein escapes them. This young boy is pleased with his successful fishing adventure.

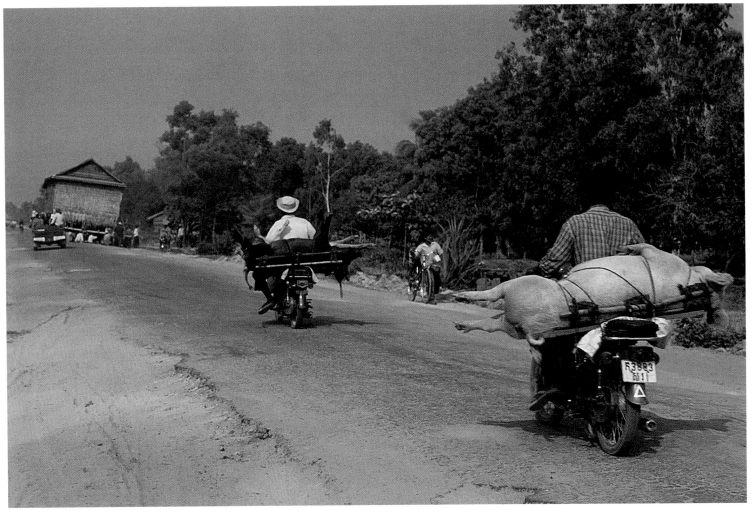

Highway, Siem Riep

"I am fond of pigs. Dogs look up to us, cats look down on us. Pigs treat us as equals."
– Winston Churchill

On the main highway from Siem Riep to the capital, Phnom Penh, a house is being moved without machines by men rolling logs under it. Other men, on motorcycles, are transporting live pigs.

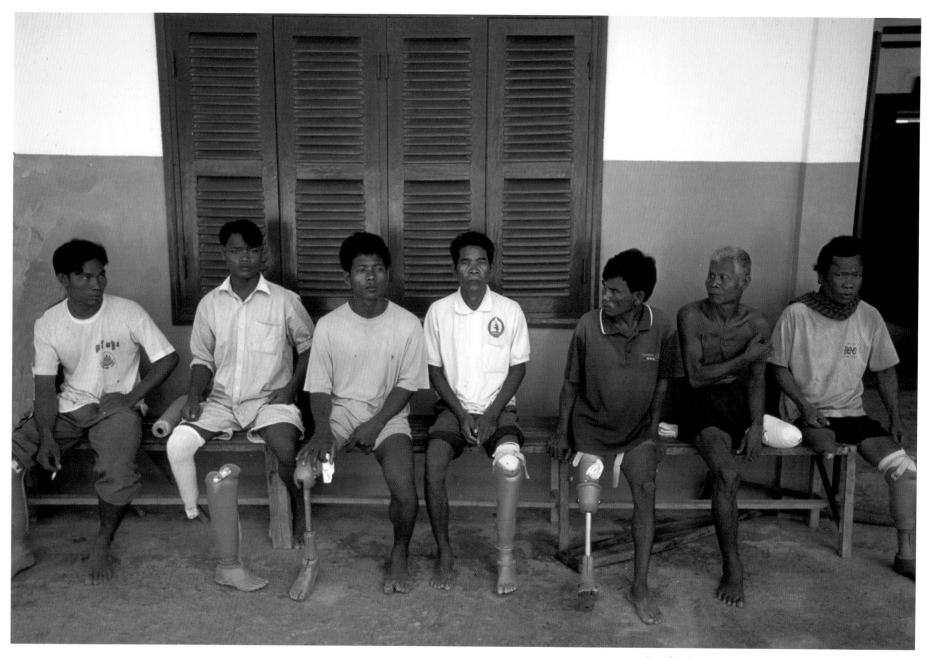

Land Mine Victims, Siem Riep

"Be kind, because everyone you meet is fighting a hard battle."
– Bob Dylan

Victims of land mines come from their villages to this rehabilitation center in Siem Riep. In two weeks, they are fitted for a prosthesis and learn to use it. When they return to their homes they are able, once again, to become useful members of their community. Over ten thousand land mines were laid in Cambodia from the 1970s until 1991, their locations not recorded. Several thousand have been identified, often by people who live or work near them being blown up. International organizations are helping in efforts to find the rest.

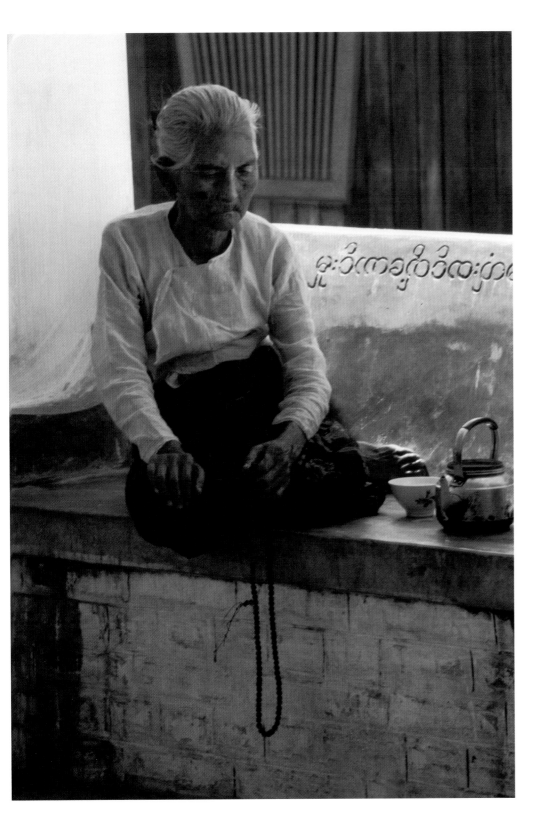

Buddhist Woman Praying, Bangkok

"Live with men as if God saw you; speak to God as if men heard you."
– Seneca

In Thailand, as in Myanmar, the majority of people follow Theraveda Buddhism.

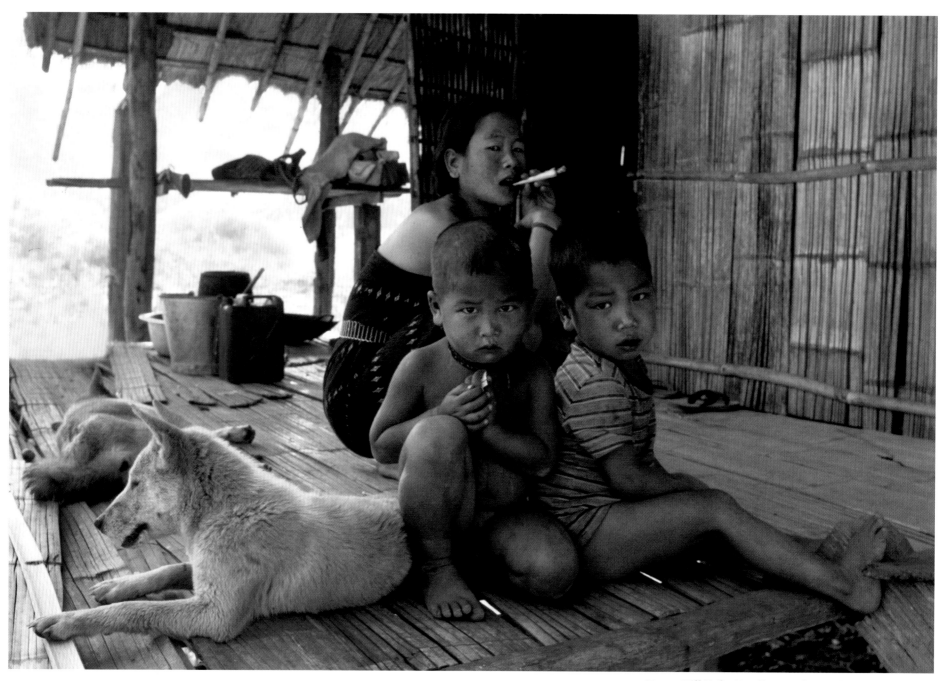

Karen Hill Tribe Family, Northern Thailand

"Children are the anchors that hold a mother to life."
– Socrates

Six culturally distinct peoples, including Karen and
Hmong, live in Northern Thailand. These hill tribes
never completely came under the control of the central
government. Guerrilla fighters and heroin traffickers
have moved through their territories for decades.
In 1986, some members of this isolated village had
scarcely ever seen foreigners.

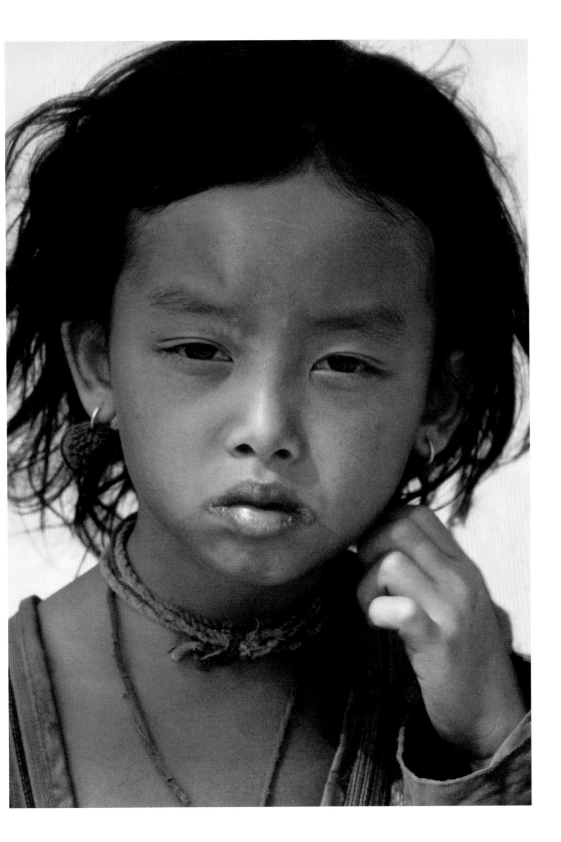

Hmong Girl, Northern Thailand

"The music in my heart I bore, long after it was heard no more."
– William Wordsworth

I took this photograph twenty years ago, and the image of this child has haunted me ever since.

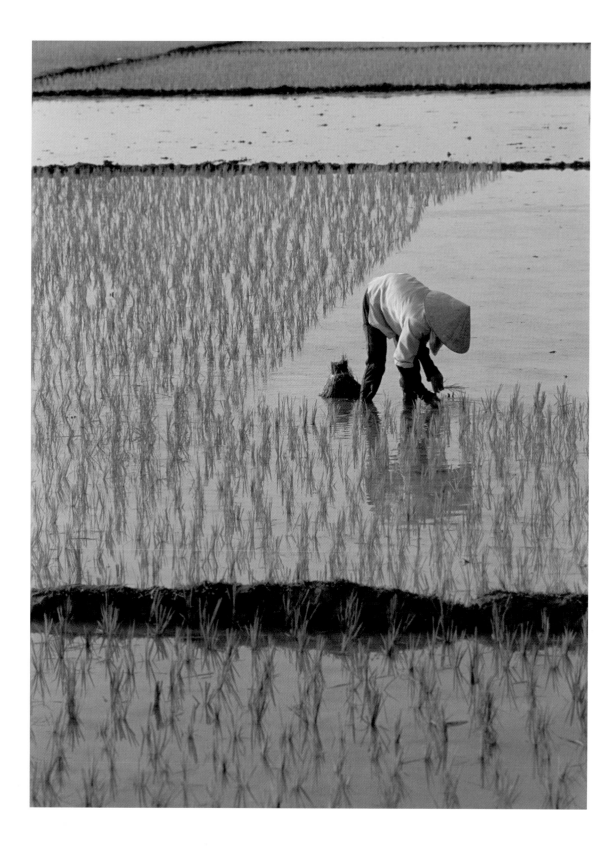

Woman in Rice Field

"A day's work is a day's work, and the man who does it needs a day's sustenance, a night's repose and due leisure, whether he be painter or ploughman."
– George Bernard Shaw

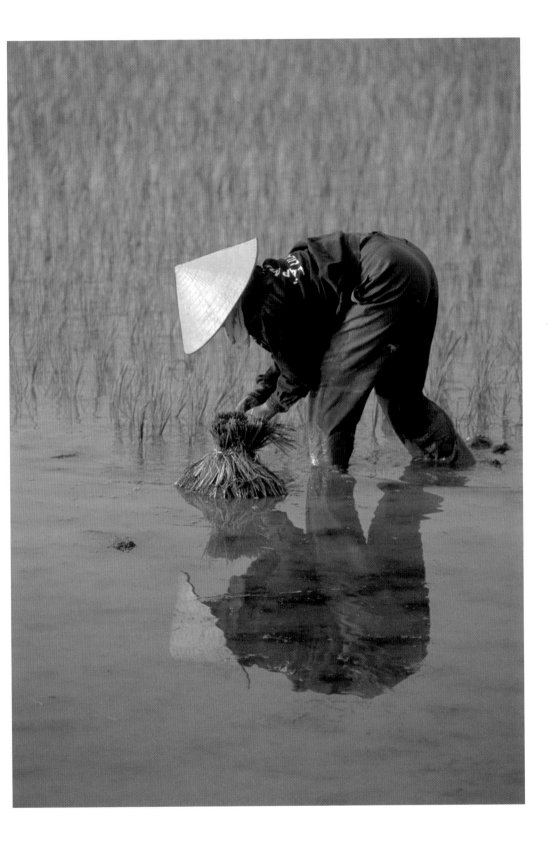

Woman in Rice Field

"When work is a pleasure, life is a joy! When work is a duty, life is slavery."
– Maxim Gorky

Growing a crop of rice is extremely labor intensive and farms in Vietnam produce three crops a year. Transplanting rice seedlings into flooded paddies in bare feet exposes the farmer to parasites and the possibility of arthritis.

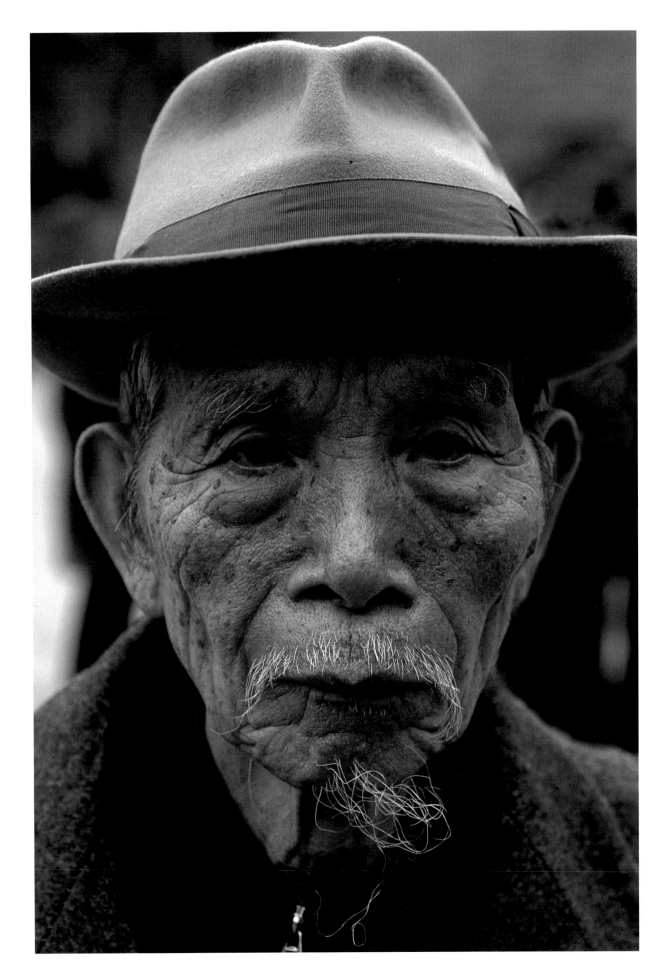

Old Man, Hanoi

"If you inquire what people are like here, I must answer,
the same as everywhere else."
– Johann Wolfgang von Goethe

In Hanoi I approached several older men who almost
certainly had fought against Americans in the Vietnam
War. All were pleasant. I detected no hint of hostility,
and no one refused to have his picture taken.

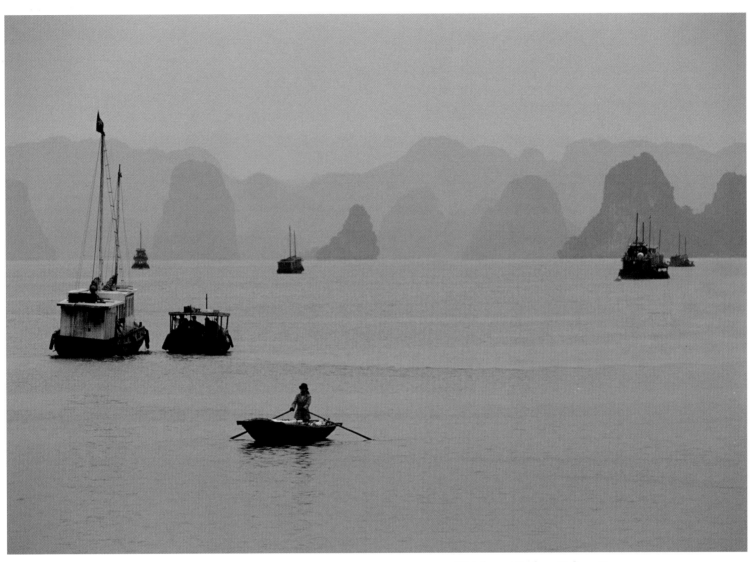

Haiphong Harbor, Halong Bay

*"They said, 'You have a blue guitar. You do not play
things as they are.'
The man replied, 'Things as they are, are changed
upon a blue guitar'."*
– Wallace Stevens

This magnificent landscape is composed of three
thousand limestone islands. Sailing among them,
I passed pearl farmers as well as fishermen working
from sampans and stopped at grottos and caves,
one of which was used by the Viet Cong as a hideout
during the war with the United States.

Balinese Women at Festival

"Men are born equal, but they are also born different."
– Erich Fromm

Bali is a tiny area of Hinduism in Muslim Indonesia.
It is a land of celebration where there are always
colorful religious festivals occurring in the villages.
These young dancers made their own costumes
for a village temple event.

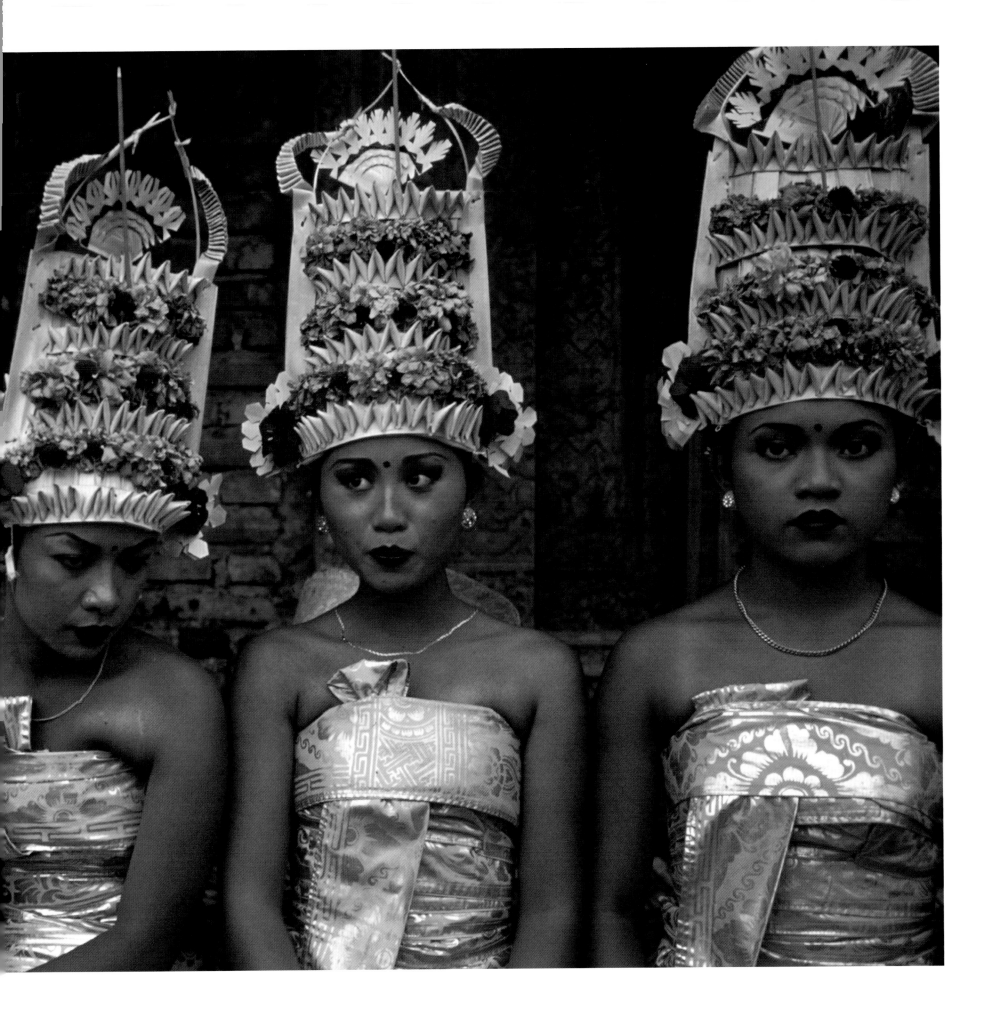

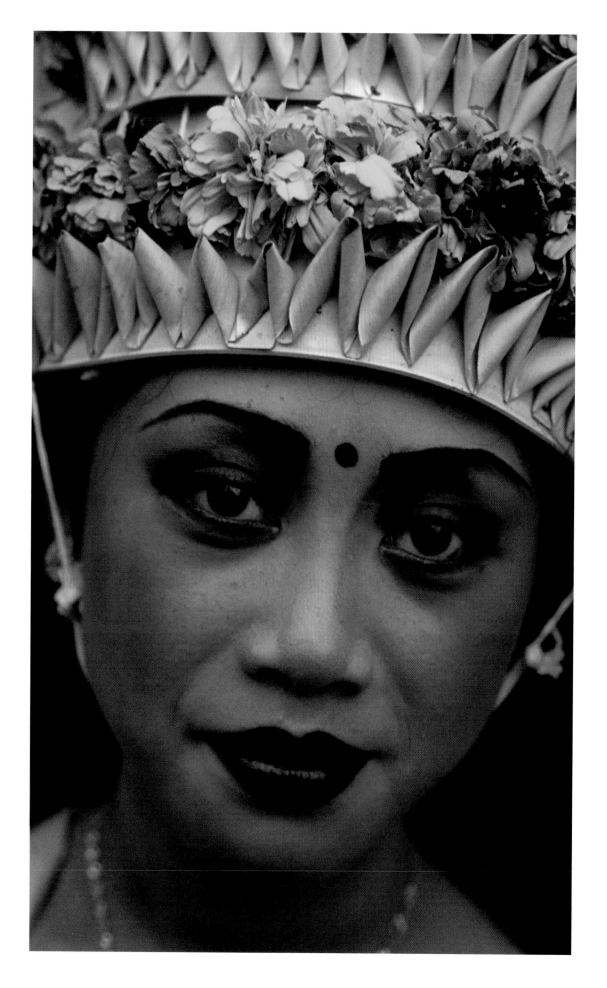

Balinese Woman at Festival

"*The innocent and the beautiful have no enemy but time.*"
– W.B. Yeats

This headdress was woven from palm leaves and decorated with marigolds.

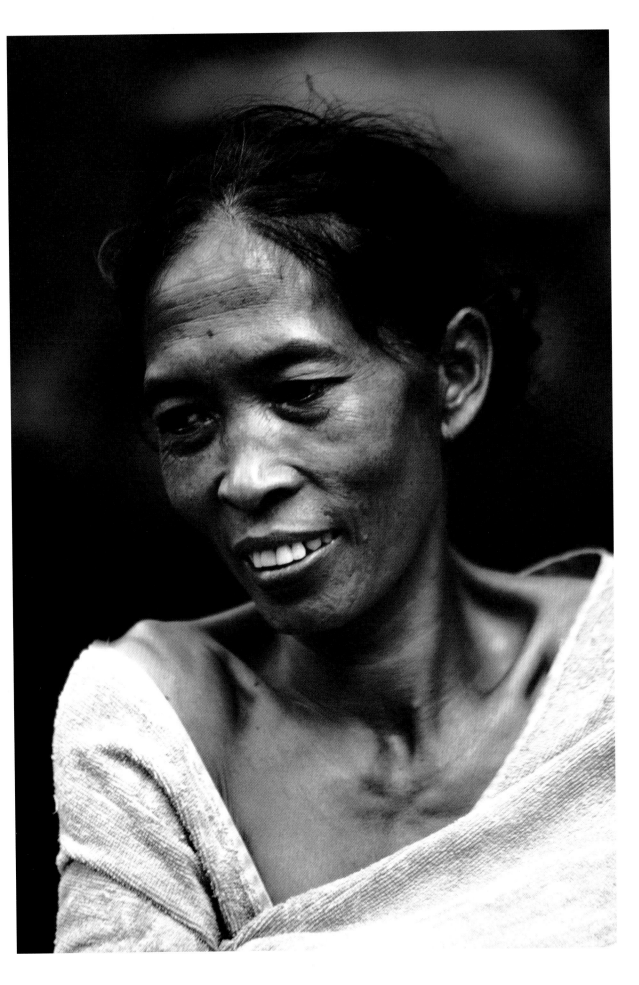

Woman in the Countryside on Her Way to Market

"I think your whole life shows in your face and you
should be proud of that."
– Lauren Bacall

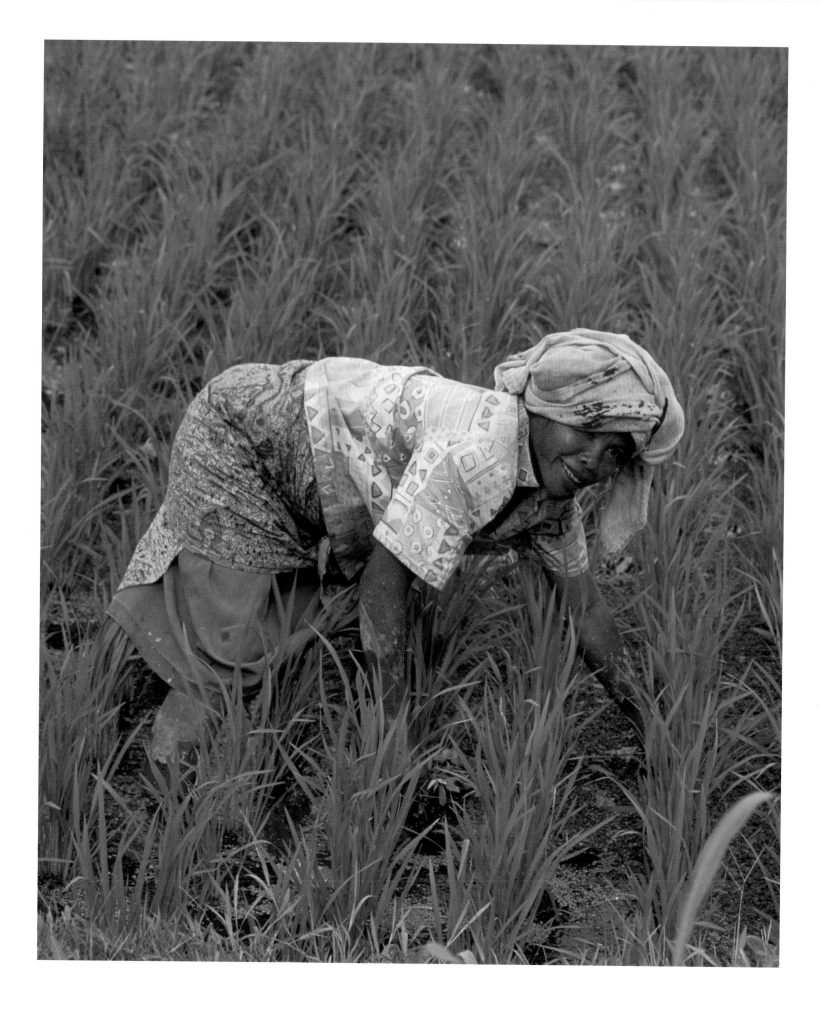

Woman Working in Rice Paddy (previous page)

"I stuck my head out of the window this morning and spring kissed me bang in the face."
– Langston Hughes

Men and Oxen Plowing a Rice Paddy

"All work is noble, work alone is noble, and a life of ease is not for any man."
– Thomas Carlyle

Rice paddies must be plowed more than once to ensure that they are ready for transplanting rice seedlings. These oxen required muzzles because they were inclined to bite each other.

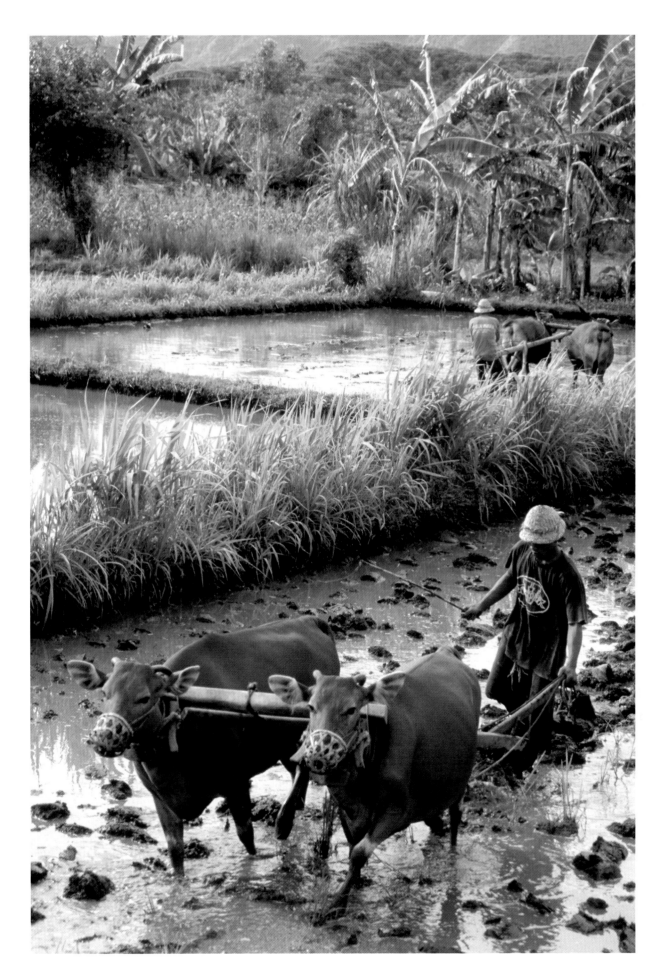

"To the average westerner, the East has always been the land of mystery and its inward spirit still remains strange and remote."
– Kenneth Clark

Dedicated to the Buddha, stupas are solid hemispherical structures often containing holy relics. Praying Buddhists walk counterclockwise around the stupa spinning the prayer wheels, while Buddha's eyes gaze down upon them.
One fifth of the world's population today is Buddhist. Mahayana, one of the two major forms of Buddhism, predominates in Nepal. It holds out the possibility of salvation for all. A believer can achieve Nirvana by following the example of the Bodhisattvas, enlightened beings who, over many lifetimes, have acquired the knowledge and virtue to attain Nirvana but have delayed their transcendence to help other mortals reach a similar state of perfection. Thus, an individual can help or be helped by others to attain Nirvana, rather than each one having to find his own way.

"If you walk, just walk. If you sit, just sit."
– Zen Maxim

I was in Kathmandu on Christmas Day 1974. At that time, the Nepalese were not as accustomed to visitors as they are today. When I entered the dining room of our hotel in the afternoon, I saw a Nepalese gentleman squatting in the corner blowing up balloons. He was helping to prepare for what, to him, must have been a strange holiday. We did not speak each other's language, but we simultaneously burst out laughing at the existential absurdity of the scene. It was an unforgettable moment.

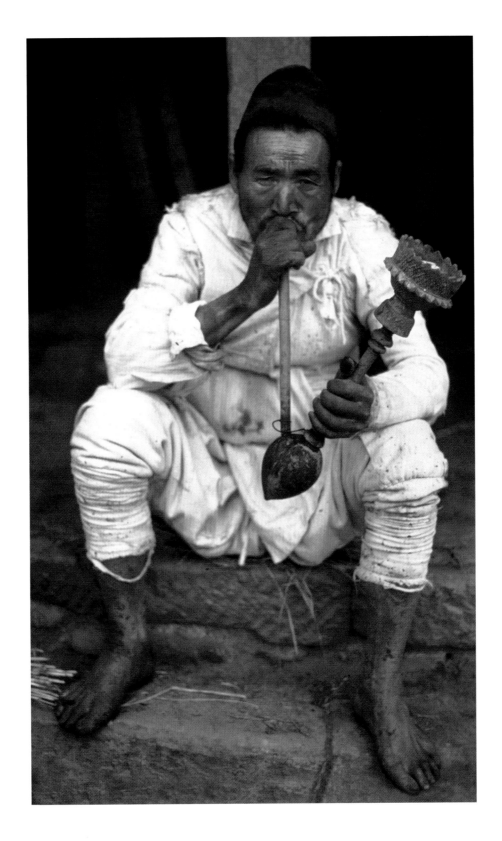

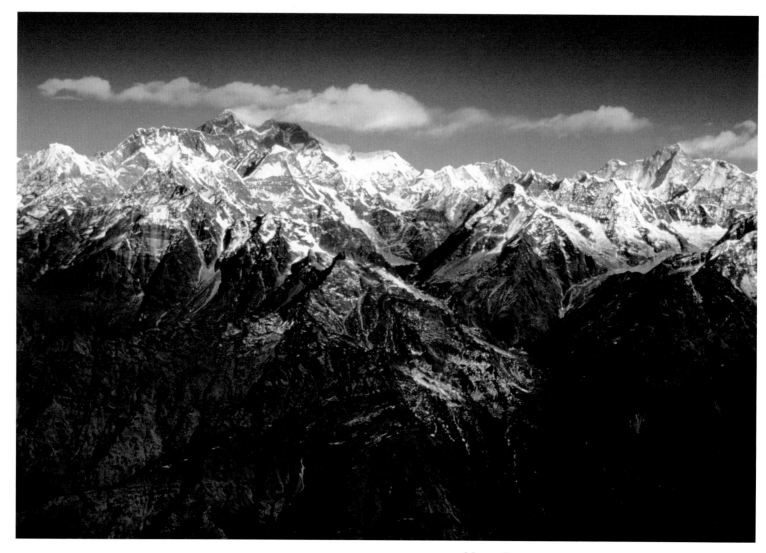

Mount Everest

"If I have seen further, it is by standing upon the shoulders of giants."
– Sir Isaac Newton

Australasia

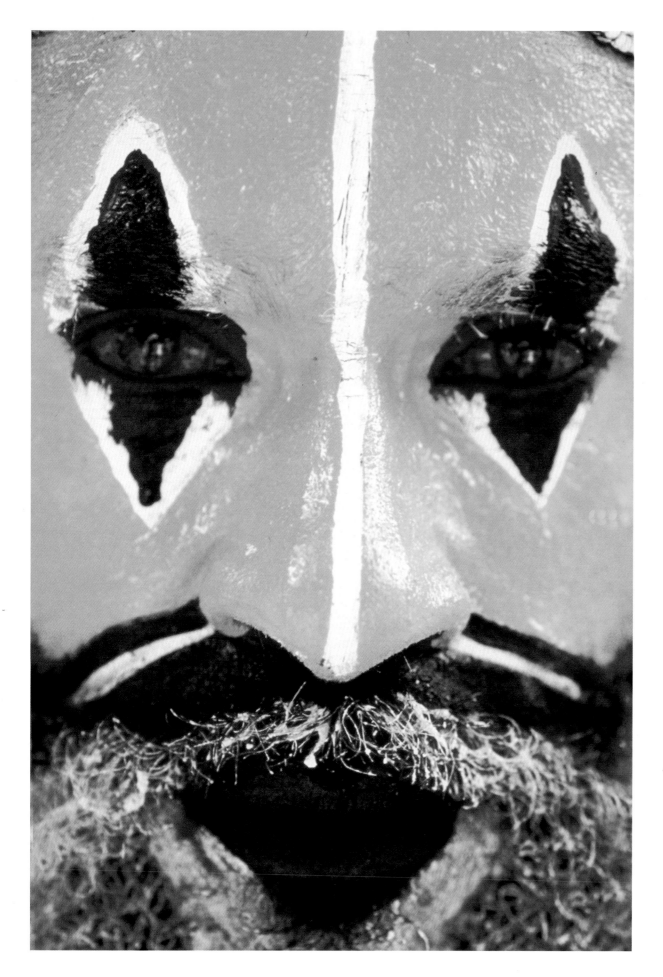

Huli Wigman, Highlands

"Oh wad some power the giftie gie us,
To see oursels as others see us!"
– Robert Burns

When preparing for a ceremony or for battle, the Huli
Wigmen elaborately paint their faces and adorn their
bodies with animal skins and bones. About one million
people live in the Highlands in the interior of New
Guinea. The outside world was completely unaware of
their existence until the 1930s. Cannibalism was
eliminated only in the 1960s.

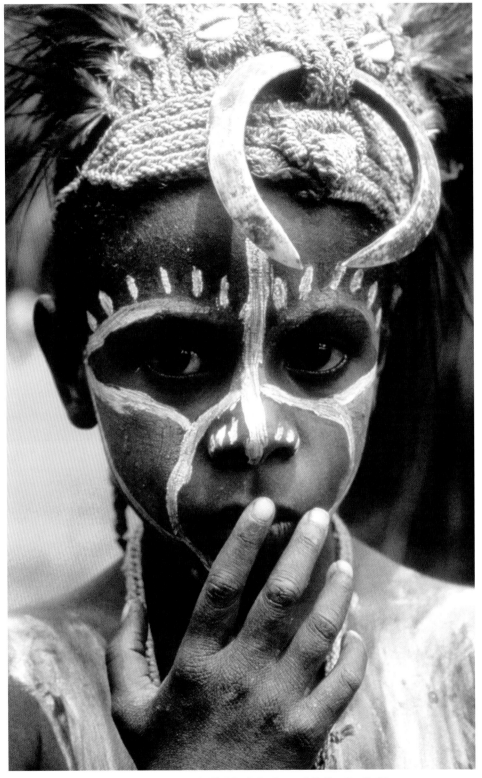

A Child of the Iatmul Tribe, Sepik River

"The world is but canvas to our imagination."
– Henry David Thoreau

A participant in a crocodile dance, this child lives in
a village beside the Sepik River. Since the villagers'
lives revolve around the river, the ubiquitous crocodile
is both feared and revered.

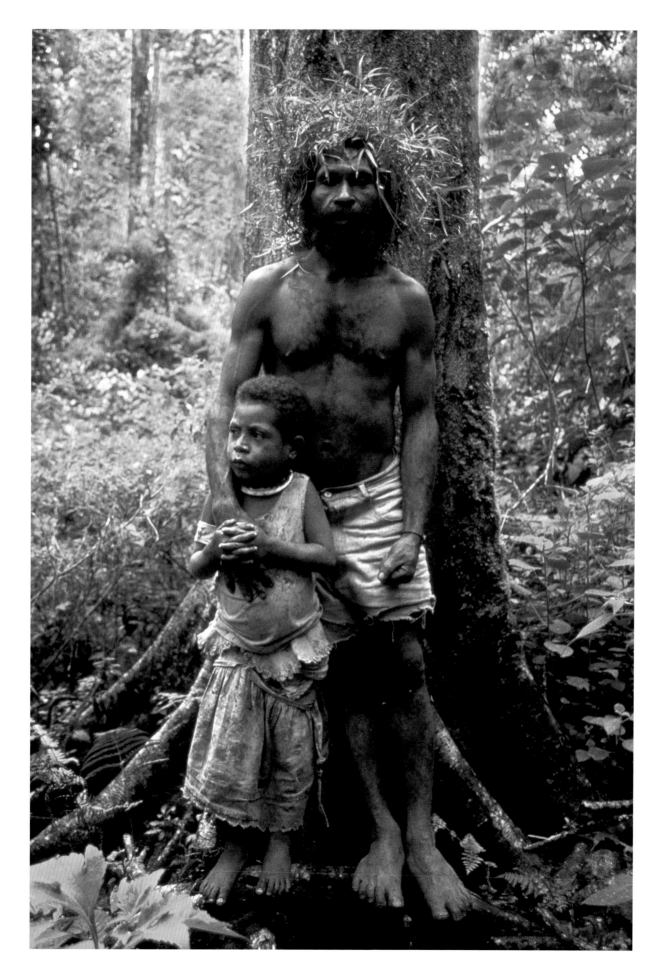

Huli Wigman and Child, Highlands

"The childhood shows the man as morning shows the day."
– John Milton

While walking through the forest in the Highlands of New Guinea, I came across this man and his child. The grass on his head was simply for adornment.

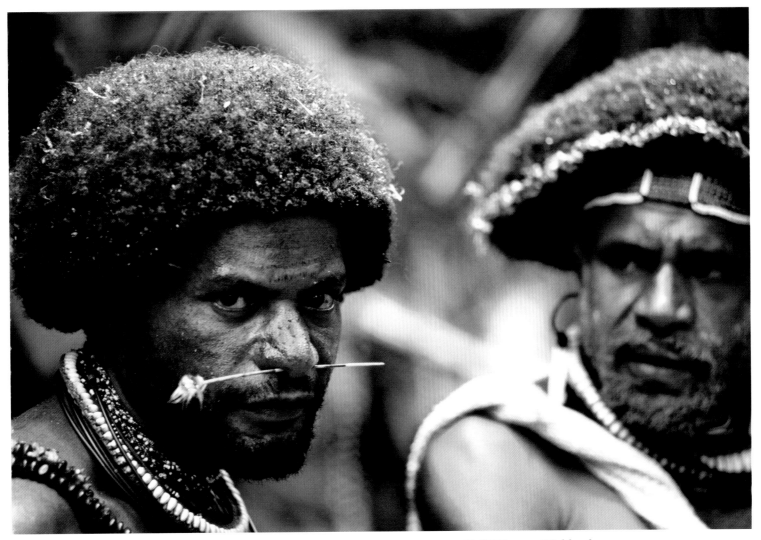

Huli Wigmen, Highlands

"Friendship needs a certain parallelism of life, a community of thought, and a rivalry of aim."
– Henry Adams

The Huli women work hard all day cultivating the crops in the fields while the men relax, talk and grow their hair to make wigs for themselves. The man on the right is wearing a wig fabricated from his own hair. The man on the left is still growing his. The wig, decorated with flowers, feathers and shells, is worn for ceremonial occasions.

Fly-fishing Gear, Lake Brunner, South Island

"Fly-fishing – feels like opening day in the Garden of Eden."
– Howell Raines

New Zealand is a fly-fisherman's paradise. I met several people who make annual trips to New Zealand from the United States just to go fly-fishing. After catching some large brown trout myself, I could easily understand their enthusiasm.

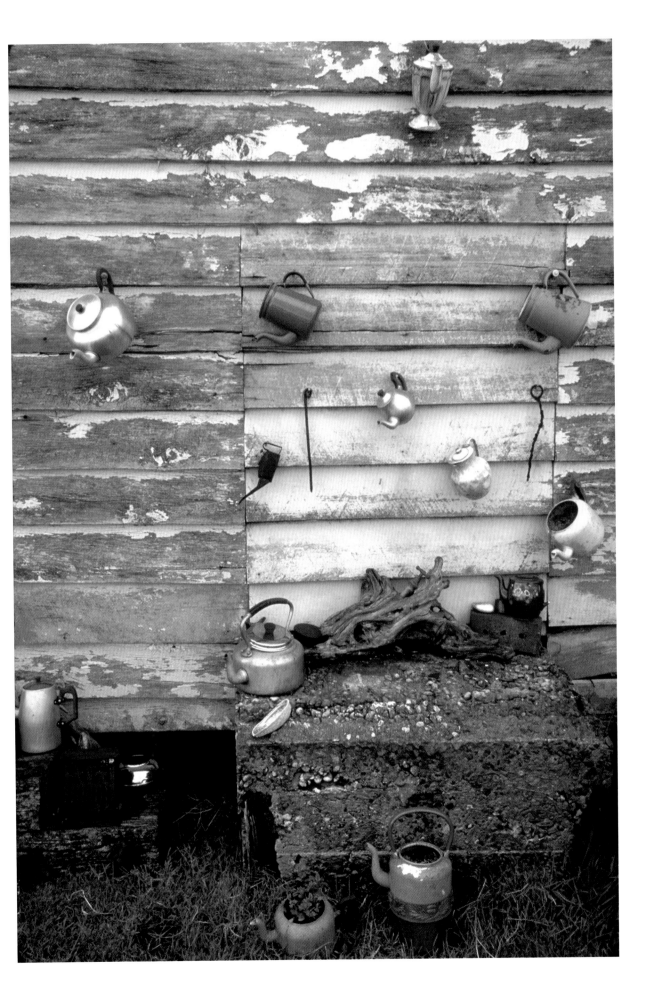

House with Teakettles on the Wall, South Island

"You are a king by your own fireside, as much as any monarch on his throne."
– Miguel Cervantes

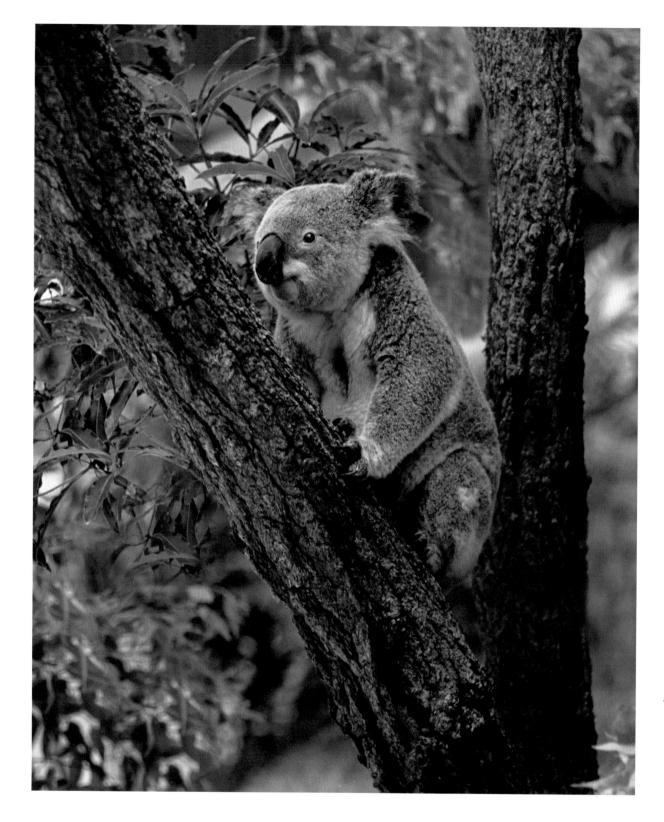

Koala, New South Wales

"Everyone is in the best seat."
– John Cage

A marsupial that spends the first six months of its
life in its mother's pouch, the koala is a food specialist,
eating only eucalyptus leaves.

South and Central America, and Caribbean Islands

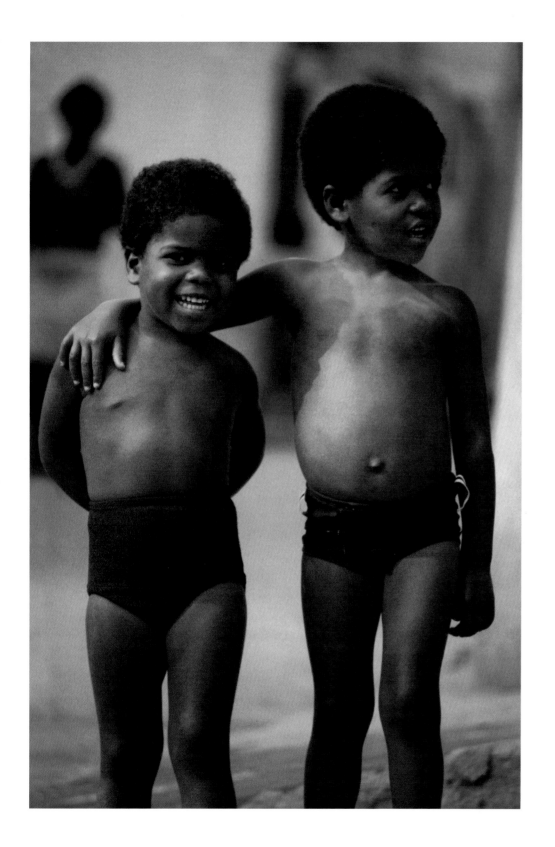

Young Boys, Valparaiso

"You don't live in a world all alone. Your brothers are here too."
– Albert Schweitzer

My daughter spent a semester in Chile during her junior year at university. She lived in Valparaiso, where I saw these young boys while visiting her.

Cock of the Rock, Amazonian Rain Forest
(facing page)

"The world is so full of a number of things, I'm sure we should all be as happy as kings."
– Robert Louis Stevenson

This male bird, once described as resembling a winged Day-Glo football, spends a large amount of its time displaying itself for females. Simply put, evolution has led to males with the grandest plumage attracting the ladies. To do so, the males congregate in a clearing in the forest known as a lek, a sort of avian singles bar. Once the male mates, the female is left with the responsibilities of nest building and caring for the young.

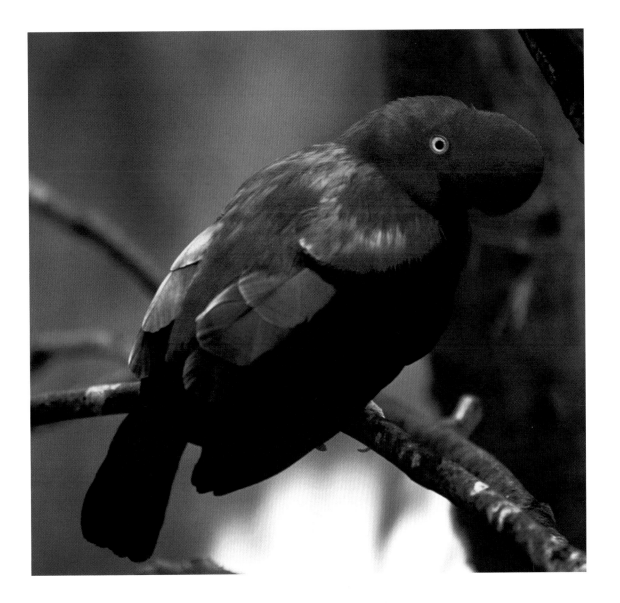

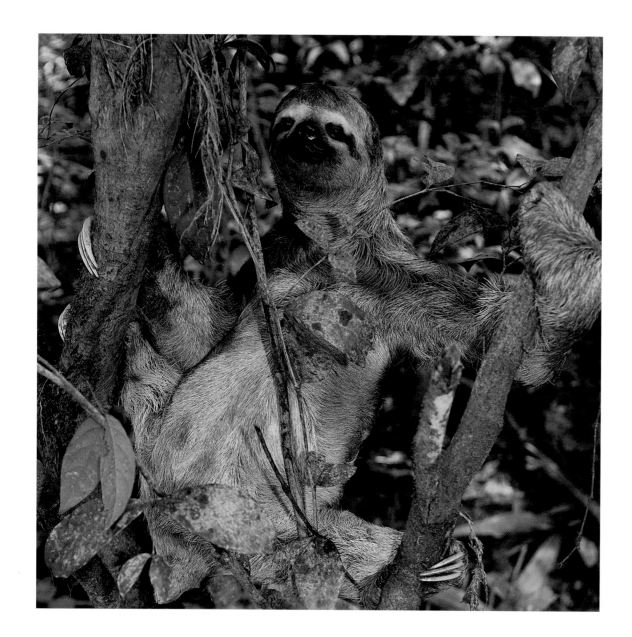

Brown-throated Three-toed Sloth, Amazonian
Rain Forest

"I never travel without my diary. One should always
have something sensational to read in the train."
– Oscar Wilde

This animal lives most of its life in the high branches of
a few cecropia trees. Its "toes," which are in fact long
curving claws, enable it to attach itself to a tree or hang
upside down. It moves extremely slowly and sleeps a
lot because its diet of cecropia leaves provides minimal
nutrition. Once a week it laboriously climbs down
to the ground to defecate and bury its feces. Since it is
most vulnerable to attack at this time, there must be
strong evolutionary pressures to explain this behavior.
One theory is that the sloth is helping to fertilize its
main tree—-a form of recycling. Also, burying the feces
prevents predators from smelling them, and more
easily finding the sloth.

Brown-throated Three-toed Sloth, Amazonian
Rain Forest (facing page)

"*Things are beautiful if you love them.*"
– Jean Anouilh

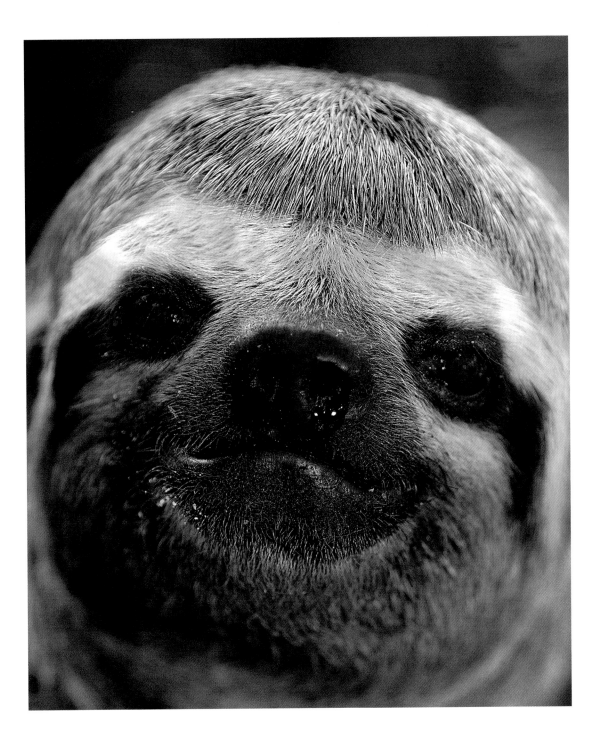

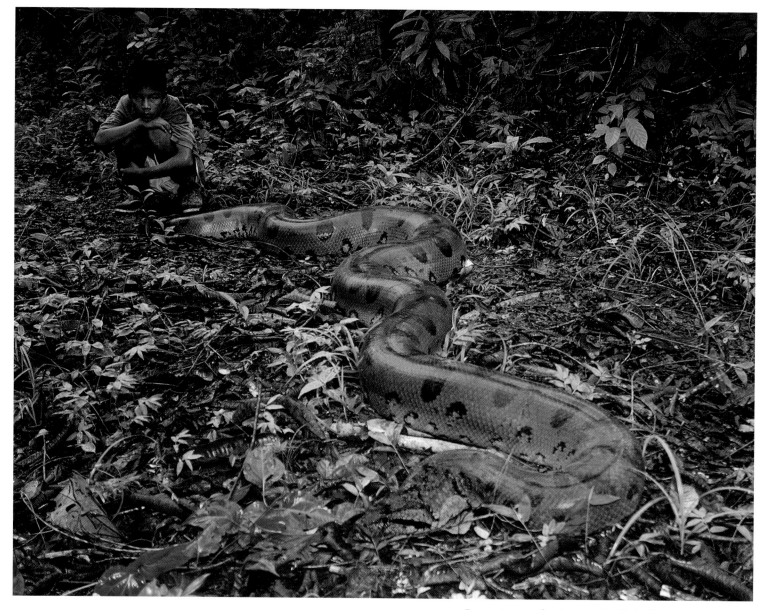

Green Anaconda, Amazonian Rain Forest

"I have been a success: for sixty years I have eaten, and have avoided being eaten."
– Logan Pearsall Smith

The world's largest and heaviest snake, the anaconda grows up to thirty-five feet long. It can kill large prey including deer, young jaguars, and even caimans. It has been known to constrict and kill humans. Because it becomes so heavy, it lives much of the time in water to support its weight, although occasionally it will be found on land searching for prey, as was the case here.

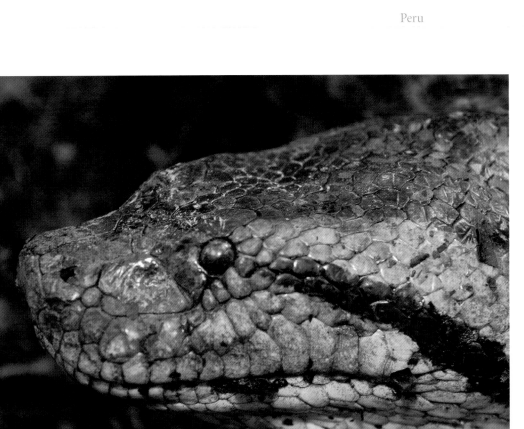

Green Anaconda, Amazonian Rain Forest

"I've an irritating chuckle, I've a celebrated sneer,
I've an entertaining snigger, I've a fascinating leer …
But although I try to make myself as pleasant as I can,
Yet everybody says I'm such a disagreeable man."
– W.S. Gilbert

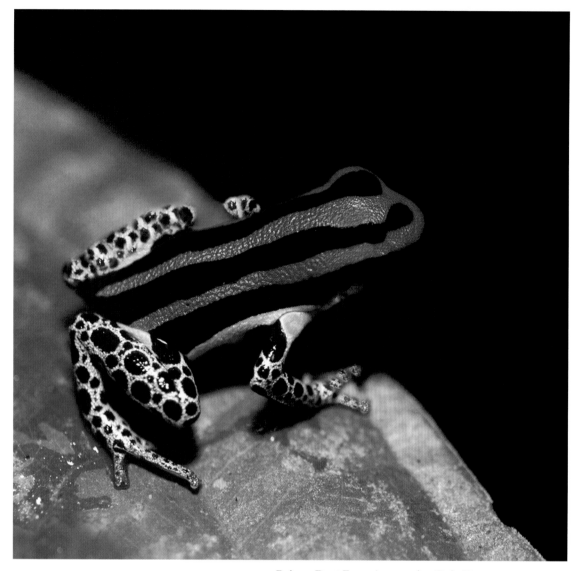

Poison Dart Frog, Amazonian Rain Forest

"A frog,
clinging to a banana leaf—
and swinging, swinging."
– Kikahu

This frog, holding onto a small leaf, was one inch long.
Poison dart frogs have striped patterns of orange,
red and yellow that glow neon-like against a dark back-
ground, warning would-be predators. They produce
alkaloid toxins that cause paralysis. Some species are
the most toxic of all living creatures, and are lethal to
the touch.

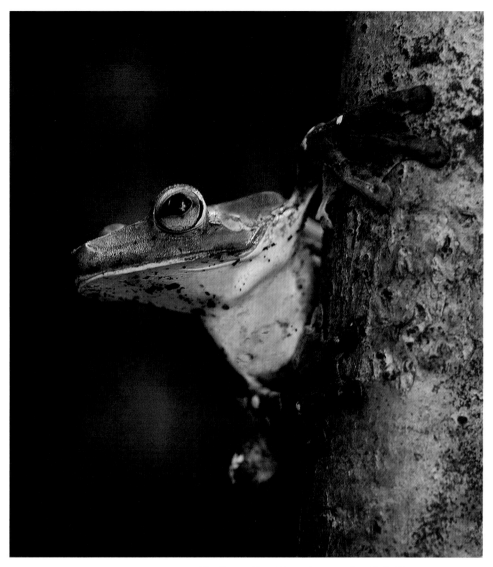

Gladiator Tree Frog, Amazonian Rain Forest

"We are all notes in the same grand symphony."
– Bill Wittliff

This three-inch-long frog has adhesive pads on its
toes to provide a firm grip as it moves about on leaves
and branches. It forages at night for insects and
sleeps during the day. To escape predators, it can jump
rapidly, blend into the environment with camouflage
coloring, curl up and play dead or release poisonous
secretions on its skin.

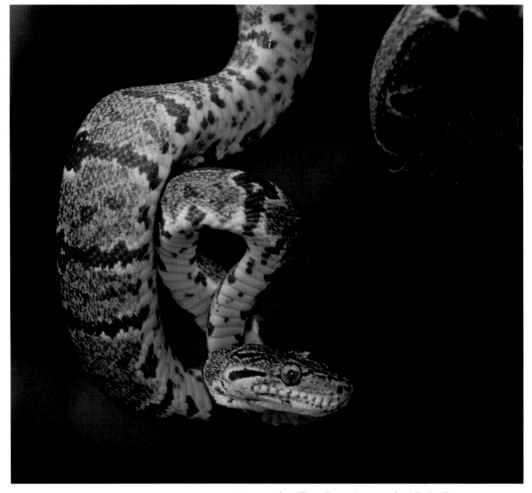

Amazonian Tree Boa, Amazonian Rain Forest

"Edible: Good to eat and wholesome to digest—as a worm to a toad, a toad to a snake, a snake to a pig, a pig to a man and a man to a worm."
– Ambrose Bierce

The Amazonian tree boa feeds primarily at night and often hangs downward to ambush its prey, such as a bird, bat or lizard. This snake comes in a variety of colors.

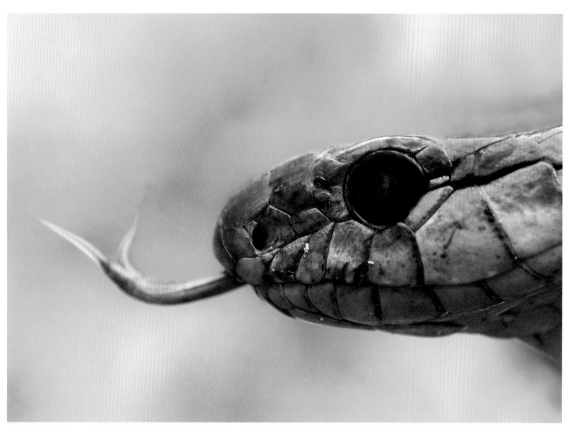

Green Whip Snake, Amazonian Rain Forest

"Some lick before they bite."
Greek Saying

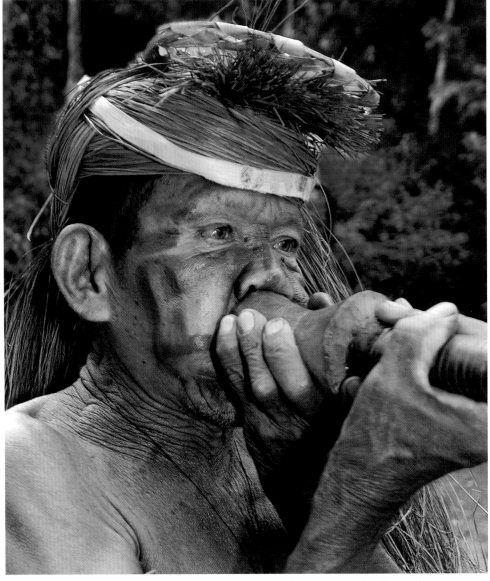

Yagua Clan Chieftain Demonstrating a Blowgun,
Amazonian Rain Forest

"In the jungle, the Indian knows everything."
– Surinamese Proverb

*"Every time a shaman dies, it is as if a library
burned down."*
– Mark Plotkin

Traditionally used for hunting animals, blowgun darts
were tipped with curare from lianas or with lethal
toxins from poison dart frogs. The wooden blowgun is
of considerable size and weight. I tried it, and to my
astonishment hit a small target.

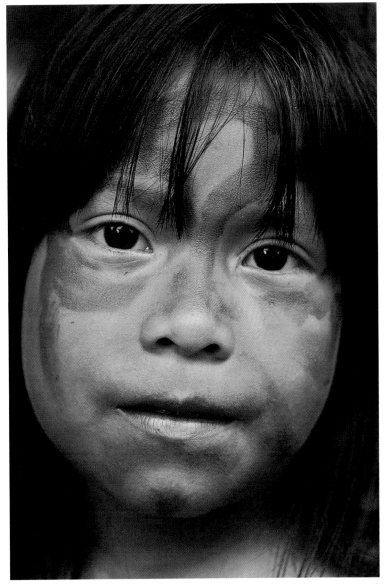

Young Girl, Yagua Tribe, Amazonian Rain Forest

"We are stardust, we are golden, and we got to get
ourselves back to the garden."
– Joni Mitchell

Today, there are two hundred thousand Amerindians
from fifty-three ethnic groups in the Peruvian
Amazon. The numbers are dwindling rapidly as the
lure of western culture becomes harder to resist.
I visited a family from the Yagua tribe.

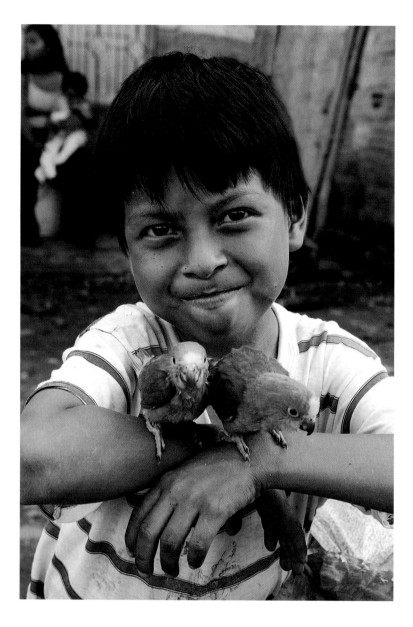

"Now there is one outstandingly important fact regarding spaceship earth, and that is that no instruction book came with it."
– R. Buckminster Fuller

Iquitos, a city of six hundred thousand inhabitants, which can be reached only by airplane or boat, is the gateway to the northern Amazonian basin. The world's tropical forests occupy only six percent of the earth's land mass, but they contain seventy-five percent of the plant and animal species. The greatest diversity of species in the world is to be found in Peru's Amazonian rainforest. It has three hundred species of mammals, over two thousand species of fish (more than the Atlantic Ocean), four thousand butterfly species, seventeen hundred species of birds, three hundred species of reptiles and over fifty thousand plant species. An area of rain forest the size of New York City is being lost every day.

Great Egret, River Tuichi, Tributary of the Upper Amazon (facing page)

"The quieter you become, the more you can hear."
– Baba Ram Dass

Great egrets eat fish and other aquatic organisms. For long periods, they stand solitary and motionless in shallow water in ponds and rivers, waiting for their prey. For several days, my family and I stayed in the Amazonian rain forest. We traveled in a twenty-eight-foot-long dugout canoe up the river Tuichi. When the river wound through a gorge in the Andes Mountains, the scene seemed closer to a Chinese landscape painting than an image of the Amazonian lowlands. At the campsite in a forest clearing, our sleeping quarters consisted of mosquito netting suspended on poles over a low wooden platform. We used our backpacks and books for pillows. We were advised to tuck in our mosquito netting thoroughly to keep out the tarantulas.

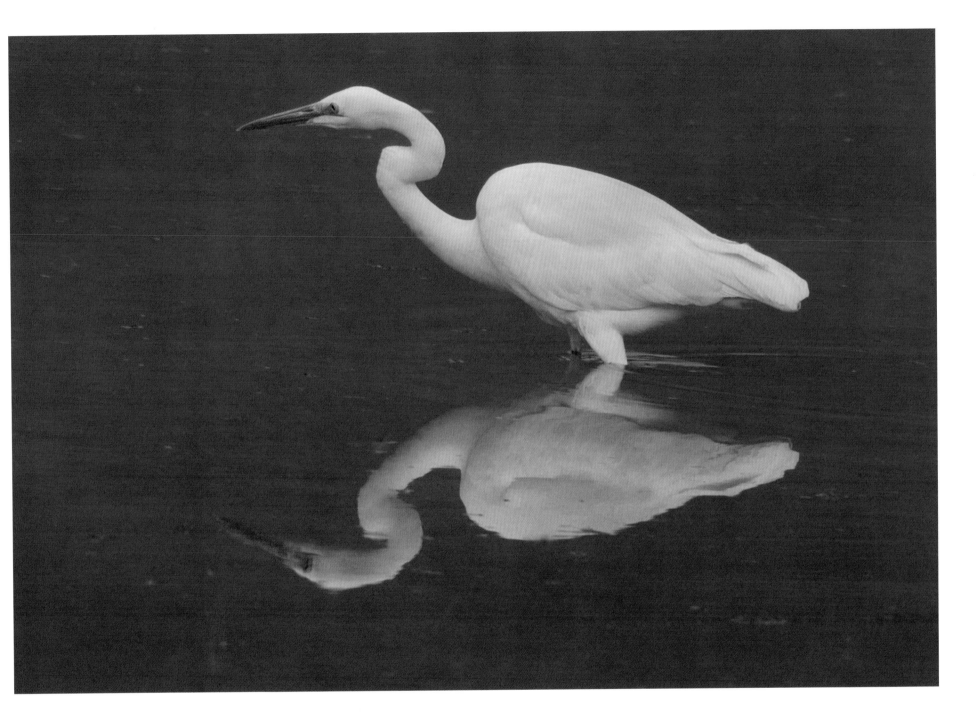

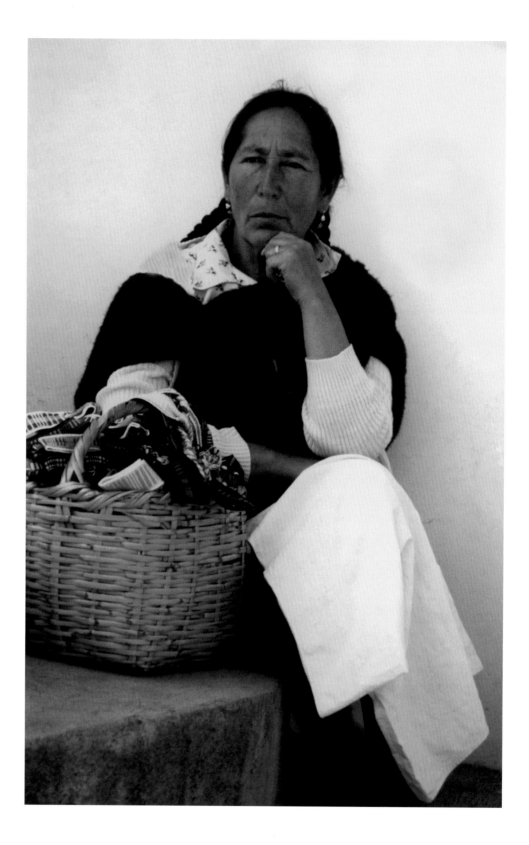

Otovalo Indian Woman, Otovalo (previous page)

"One is not born a woman: one becomes a woman."
– Simone de Beauvoir

Giant Galapagos Tortoise, Galapagos Islands

"I love everything that's old: old friends, old times, old manners, old books, old wines."
– Oliver Goldsmith

Darwin's theory of evolution postulated that organisms change over many generations as they adapt to new or changing environments. For example, Galapagos finches developed into different species as a result of adapting to discrete conditions in separate islands. Thus, from a single ancestor evolved a seed-crushing finch, an insectivorous finch, and a leaf-eating vegetarian finch, each with its own distinct beak. Tortoises also played an important part in Darwin's theory. On islands where vegetation is sparse and high off the ground, they have carapaces raised in front to allow their necks to stretch forward to reach for food. On islands with richer vegetation, the carapace is thick in front, allowing the tortoise to push through the dense undergrowth. A Galapagos tortoise may weigh more than five hundred pounds.

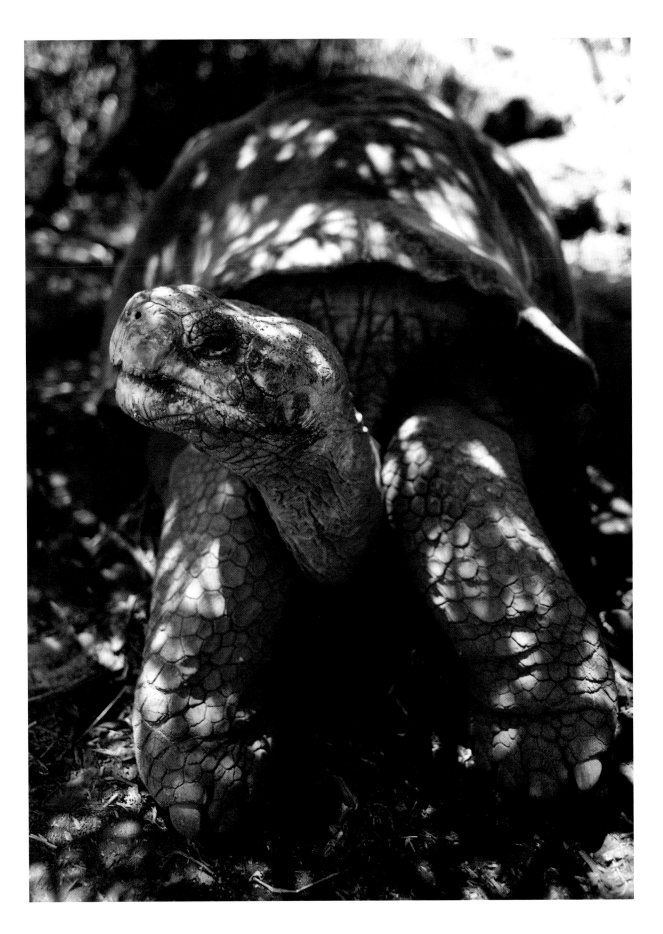

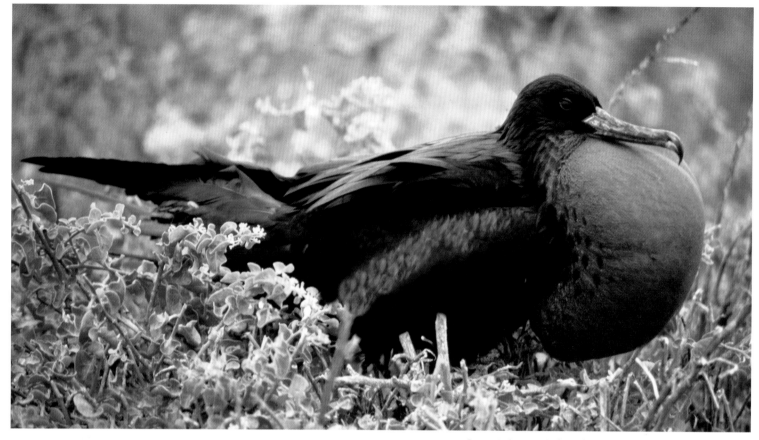

Great Frigate Bird, Galapagos Islands

"Ain't misbehavin'. I'm savin' all my love for you."
– Andy Razaf

The male great frigate bird shows off his inflated red gular pouch during the mating season. This bird has a seven-foot wingspan. It is very fast and it often attacks other seabirds in the air, causing them to give up their food.

Red-footed Boobies, Galapagos Islands

"Barkis is willin'"
(Barkis's proposal of marriage to Peggoty in "David
Copperfield")
– Charles Dickens

It is unusual for seabirds to nest in trees, but the
red-footed boobies' prehensile feet enable them to do
so. They dive at great speed from considerable
heights into the water to catch fish. Boobies, like much
of the fauna on the Galapagos Islands, have no
natural predators and consequently no fear. Being able
to photograph within a few feet of them was an
unusual experience.

Iguazu Falls

"The heavens declare the glory of God, and the firmament showeth his handiwork."
– The Bible

The majestic scale, thunderous noise and sheer beauty of these falls overwhelm the visitor with a sense of the power of nature, making viewing them one of life's most spiritual experiences. The massive volume of water plunges two hundred twenty-five feet into the canyon below. It pours over two hundred seventy-five falls—spread over almost one and a half miles—in a luxuriant tropical forest alive with butterflies, toucans and monkeys.

French Angelfish

*"Presidential advisers... gliding in and out of
the corridors of power with the opulent calm of
angelfish swimming through an aquarian castle."*
– Henry Allen

Often considered the best scuba diving area in
the Caribbean, the coral reefs around Bonaire are
in excellent condition, with abundant fish life.
This angelfish feeds primarily on sponges and, to
avoid predators, it is built to be able to escape
into narrow crevices in the reef.

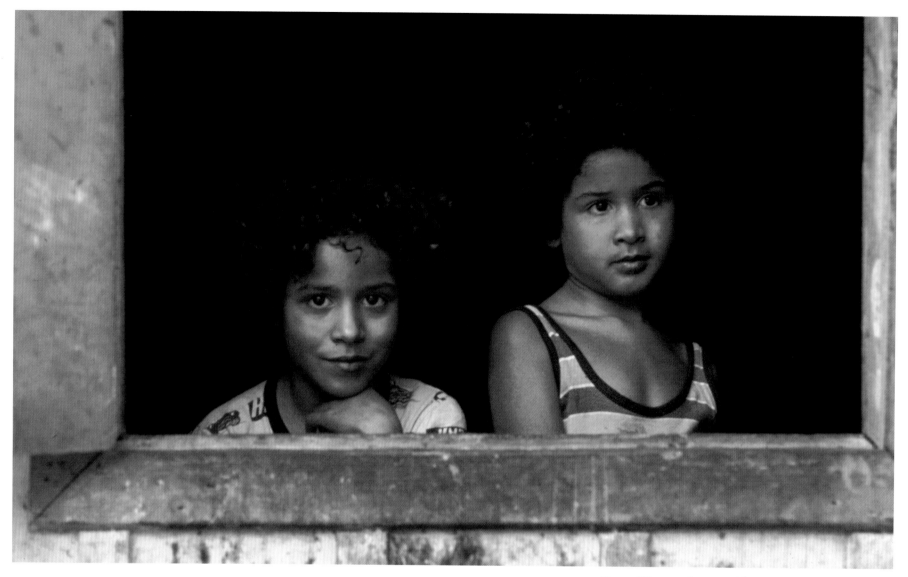

Young Women, Countryside near Belem

"Go and catch a falling star...
Teach me to hear mermaids singing..."
– John Donne

Belem is a large city at the mouth of the Amazon river. The size of the Amazon is astonishing, containing 20 percent of the fresh water in the world. It originates in the Andes Mountains only one hundred twenty miles from the Pacific Ocean, yet flows for four thousand miles before reaching the Atlantic; large ships can navigate up the river for over twenty-three hundred miles to Iquitos in Peru; it is two hundred miles wide at its mouth. Flying from one side of the mouth of the river to the other, one passes over an island the size of Switzerland.

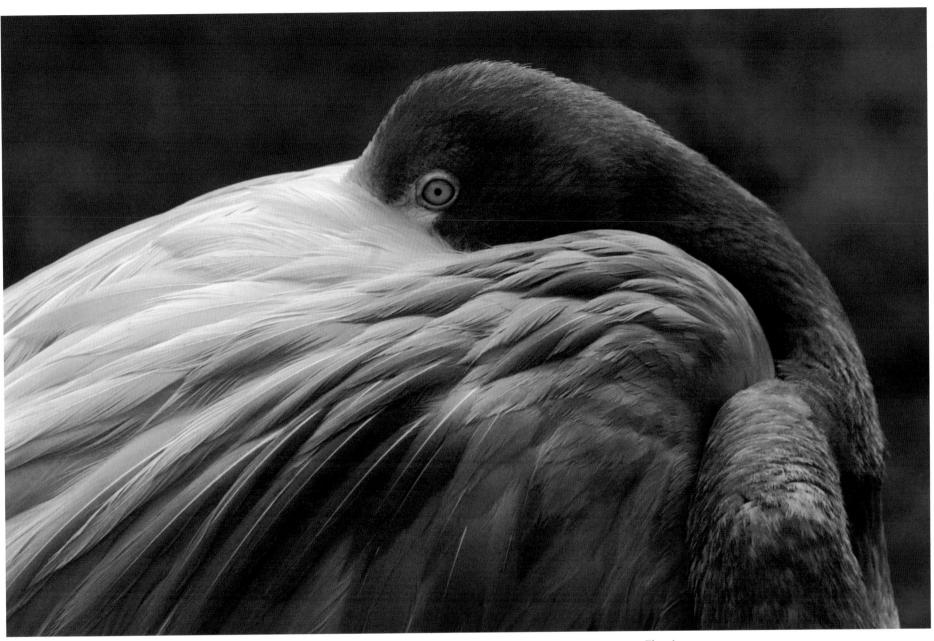

Flamingo

"Color is joy. One does not think of joy. One is carried by it."
– Ernest Haas

Flamingos flock together in large numbers. Their diet consists of algae, brine shrimp and small crustaceans, which affect the coloring of their feathers. They gather food in a most unusual way: they skim the shallow water with their beaks immersed and inverted.

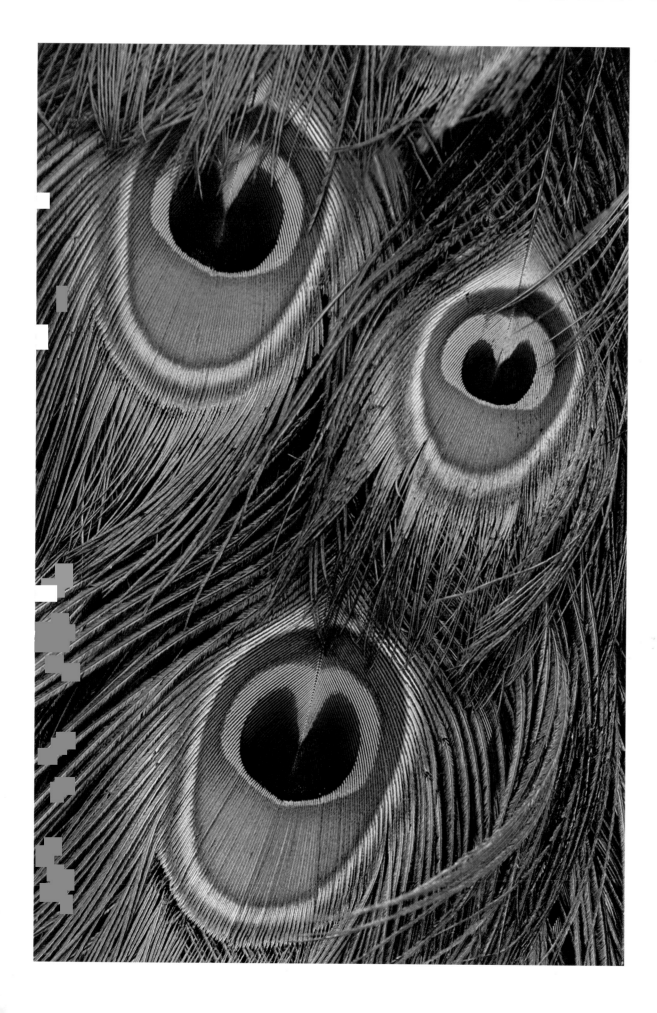

Peacock, Nassau

"… *a garden full of stately views,*
of borders, beds and shrubberies, and lawns
and avenues,
with statues on the terraces and peacocks strutting by;
but the glory of the garden lies in more than meets
the eye."
– Rudyard Kipling

This peacock gently strolling on an estate in Nassau
provided quite a contrast to another experience
my daughter and I had near the island. We put on
chain mail suits and descended fifty feet below the
ocean surface to feed Caribbean reef sharks. Several at
a time of these ten-foot-long wild creatures would
brush up against us as they fought to reach the food we
held on our spears. It was quite an adrenalin rush.

Model, Havana

"Am I the person who used to wake in the middle of the night and laugh with the joy of living? Who danced till long after daybreak, and who more than once gazed at the full moon through a blur of great romantic tears?"
– Logan Pearsall Smith

In spite of the economic hardships of living in Cuba, the people remain resilient. They are creative, friendly and gracious. The positive accomplishments of the Communist dictatorship led by Castro, at eighty years old the longest-ruling leader in the world, have been many: great improvement in health care, a literacy rate of ninety-nine percent, free education through college and full employment. He has great support from the rural population, which has benefited most from the redistribution of wealth. On the negative side, he has kept a dossier on many citizens and has imprisoned critics. His nationalization of businesses and industry has resulted in a lack of incentives and a collapse of the economy, leading to decay of the infrastructure, especially the beautiful colonial buildings in old Havana. The current poor economic conditions have forced some physicians and engineers to work as busboys and taxi drivers. Cuba's future after Castro's death remains a huge and tantalizing unknown.

Ford Motor Car, Havana

"The greatest task before civilization at present is to make machines what they ought to be, the slaves, instead of the masters of men."
– Havelock Ellis

Visually, Cuba has scarcely changed since the 1950s. Hundreds of American cars from that time are still in use, and almost all buildings predate 1959, the year of Fidel Castro's revolution. The exceptions are some Soviet-built apartment blocks and several huge resort-style hotels constructed in the mid-1990s. These tourist accommodations were Castro's concession to capitalism, built in order to alleviate Cuba's severe poverty following the disappearance of huge subsidies after the collapse of the Soviet Union. Most of the buildings in downtown Havana are elegant examples of Spanish architecture from Cuba's colonial era, which began with Columbus's arrival and continued into the 1860s.

Performance at the Tropicana Night Club, Havana

"Movements are as eloquent as words."
– Isadora Duncan

This Las Vegas-style kitschy review, with over a hundred singers and dancers, has operated continuously since the 1930s. It goes against the principles of Castro's austere revolution but, with seating for fourteen hundred people nightly, it brings in much-needed tourist dollars.

Old Man, Havana

"Old fashions please me best."
– William Shakespeare

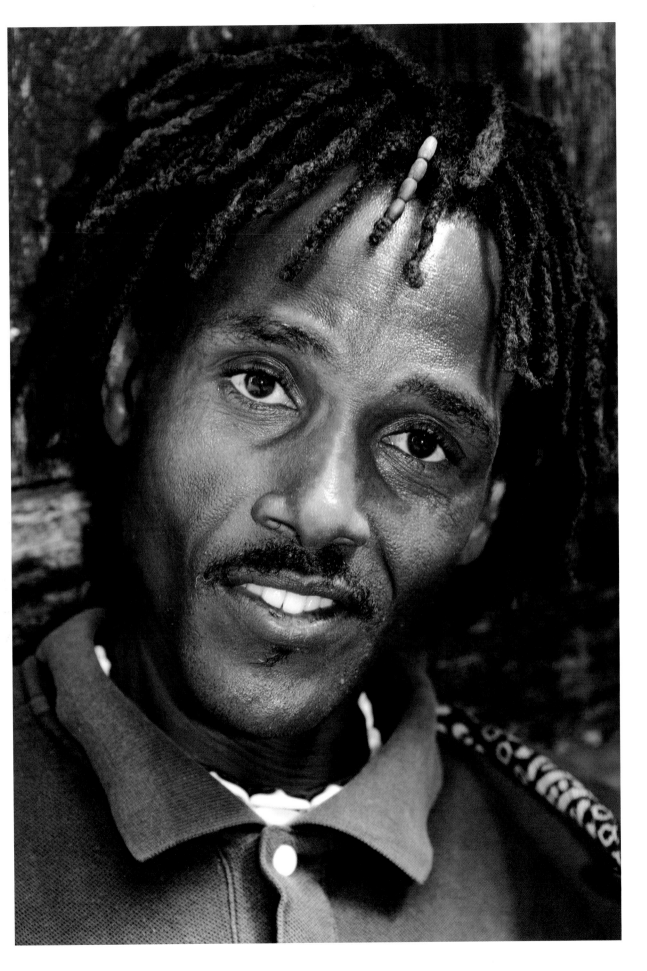

Young Man, Havana

"… time is a very precious gift of God; so precious that it's only given to us moment by moment."
– Amelia Barr

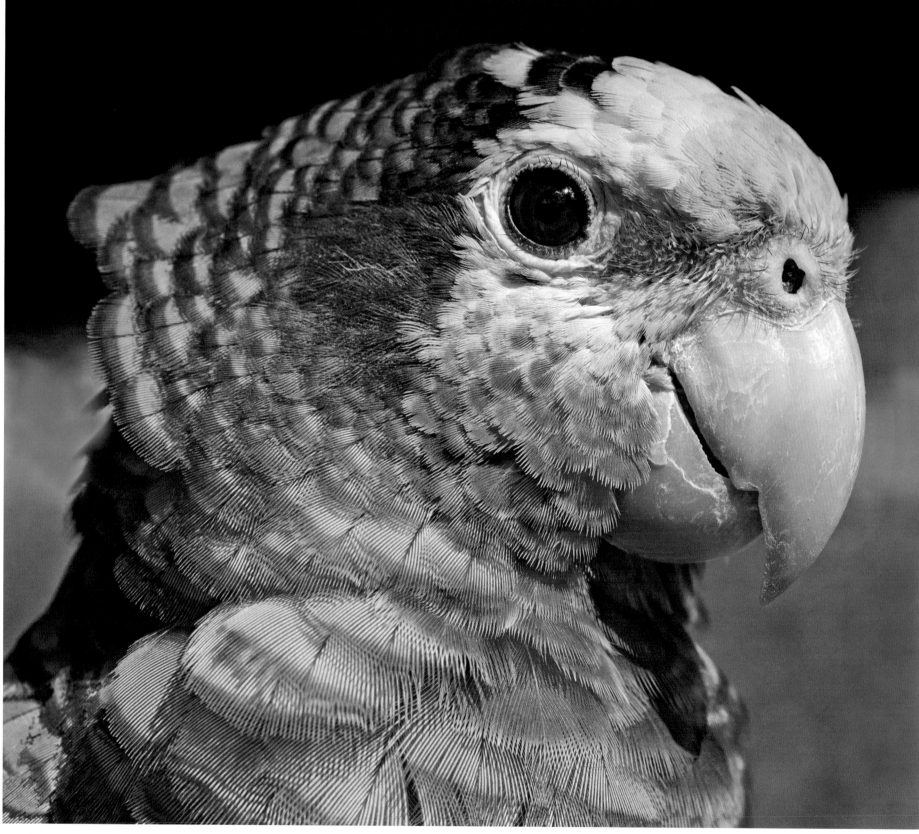

Cuban Parrot, Pinar Del Rio, Western Cuba
(previous page)

*"Mr Squeers' appearance was not prepossessing.
He had but one eye, and the popular prejudice runs
in favor of two."*
– Charles Dickens

The combination of rich colonial history, pristine
beaches, semitropical climate, welcoming people and
intoxicating live music everywhere is hard to resist,
making Cuba potentially a major tourist destination.
This parrot is found in the island's remote woodlands.

Woman with Cigar, Havana

*"It's not the men in my life that count, it's the life
in my men."*
– Mae West

This woman looks like a cover girl for a guidebook to
Cuba. Many tourists visit Cuba from all over the
world, except the United States, because of the opposi-
tion of the U.S. government. The only way for U.S.
citizens to go to Cuba legally is on a humanitarian mis-
sion. Our group took school supplies, medications
and clothes into the country.

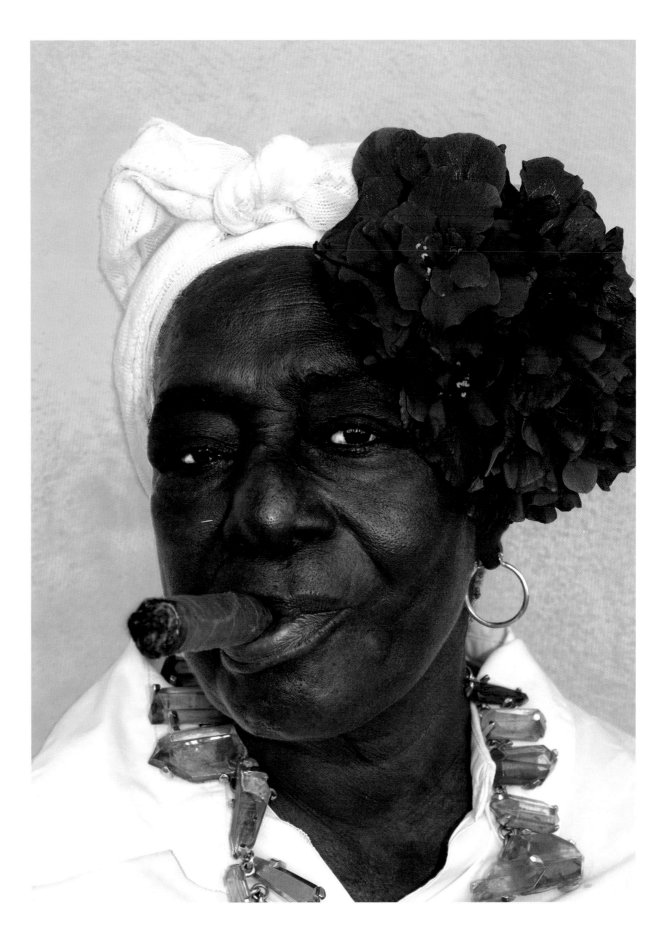

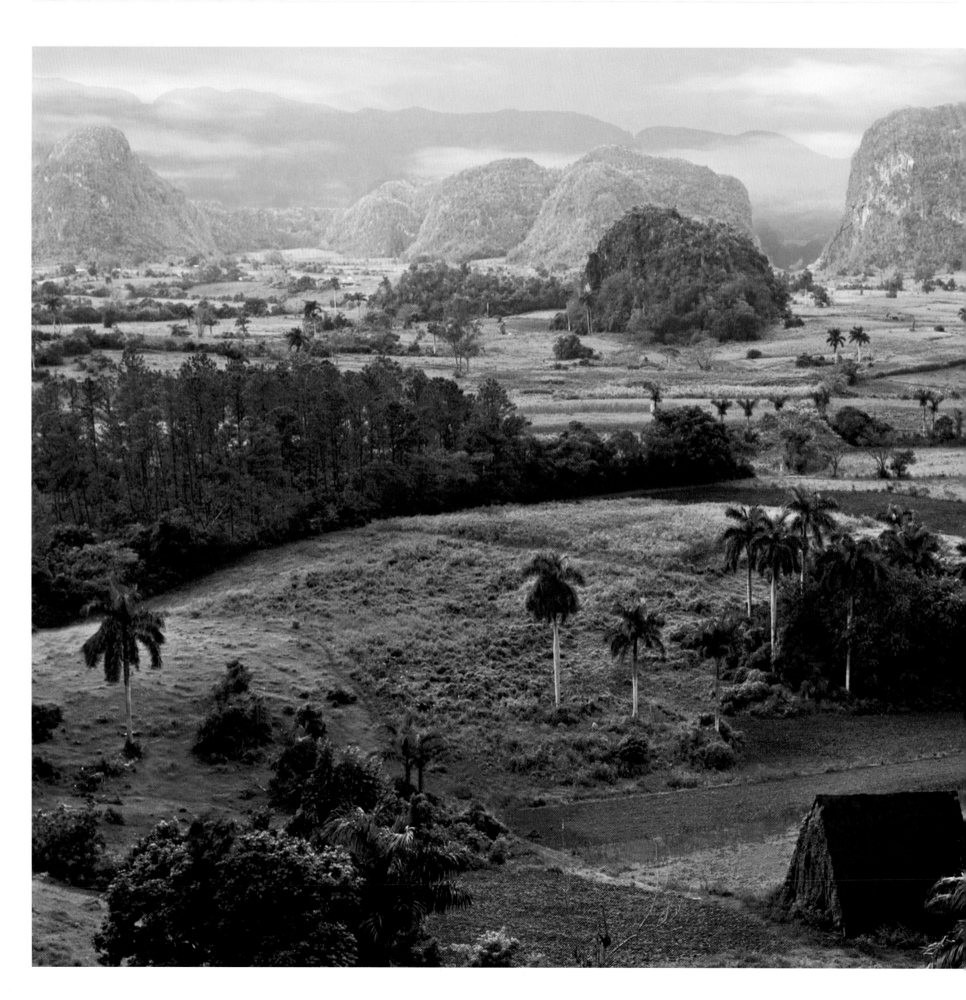

Tobacco Fields, Pinar Del Rio, Western Cuba

"Is it not pleasanter to be a farmer than to be shut up within four walls and delving eternally with the pen?"
– Thomas Jefferson

When Christopher Columbus arrived in Cuba he is reported to have seen the indigenous people smoking tobacco. The rich soil on the western side of the island, combined with the tropical climate, still produces the world's finest tobacco leaves. Cuba produces three hundred million cigars a year, all rolled by hand. A factory worker can roll up to one hundred fifty cigars a day. Seen here along the horizon are unique rounded limestone formations called magotes.

Beach, Grand Cayman (previous page)

"The springtime sea;
All day long up-and-down,
Up-and-down, gently."
– Buson

Every year, a group of my college friends rendezvous for a few days on Grand Cayman Island. This photograph illustrates how intense the activity is.

Snowy Egret

"The best part of our lives we pass in counting on what is to come."
– William Hazlitt

The snowy egret's characteristic black bill and bright yellow feet are clearly visible here. To feed, it walks delicately in shallow water, sometimes stirring the mud to activate the fish. When I visited our daughter while she was studying Spanish in Costa Rica, we saw some remarkable sights. In a cloud forest, we watched a long-tailed hermit hummingbird feeding its young in their nest on the tip of a leaf. Our guide pointed out a tree that he estimated was covered with one ton of epiphytes. When we had the rare good fortune to see a puma, our experienced guide said that it was the first time he himself had seen one.

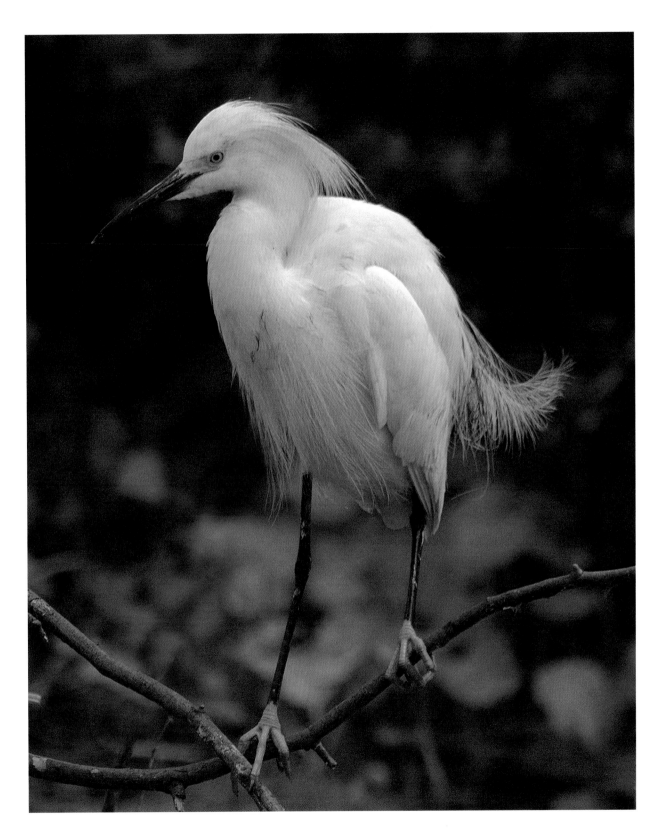

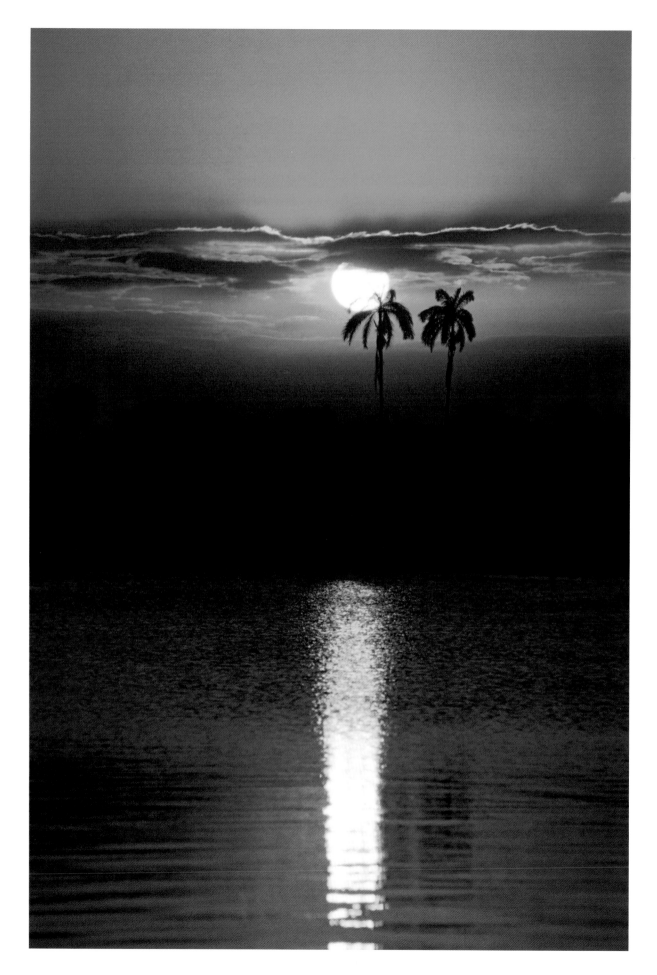

Sunset

"A huge red drop of sun lingered on the horizon and then dripped over and was gone."
– John Steinbeck

Mennonites Fishing

"The gods did not deduct from man's allotted span the hours spent in fishing."
– Babylonian Proverb

Three thousand members of this Protestant sect, similar to the Amish, arrived in Belize in 1959, hoping for a life free of religious persecution and of the trappings of modern society. They signed an agreement with the Belize government exempting them from military service and certain taxes in return for opening up the land. Renowned for their work ethic, they have become extraordinarily successful farmers and an economic force in the country.

North America

Wedding, Santa Clara del Cobre

*"When two people are under the influence of the most
violent, most insane, most delusive, and most transient
of passions, they are required to swear that they will
remain in that excited, abnormal, and exhausting con-
dition continuously until death do them part."*
– George Bernard Shaw

Father of the Bride, Santa Clara Del Cobre

"Strong men can always afford to be gentle."
– Elbert Hubbard

Accordion Player, San Miguel de Allende

"Ilsa: Play it once, Sam, for old times' sake.
Sam: I don't know what you mean, Miss Ilsa.
Ilsa: Play it, Sam. Play 'As time goes by'."
– Julius Epstein, Philip Epstein and Howard Koch

Balcony, Guanajuato (previous page)

"Why shouldn't art be pretty? There are enough unpleasant things in the world."
– Pierre Auguste Renoir

From the sixteenth to the eighteenth century the mines near Guanajuato produced twenty percent of the silver in the world and the town became fabulously rich. Its colonial architecture is very well preserved.

Miner, Guanajuato

"It's been a hard day's night, and I've been working like a dog."
– John Lennon and Paul McCartney

Today, although not as productive as in centuries past, the mines are still producing silver as well as tin, gold, and copper. This miner was on the way home from work.

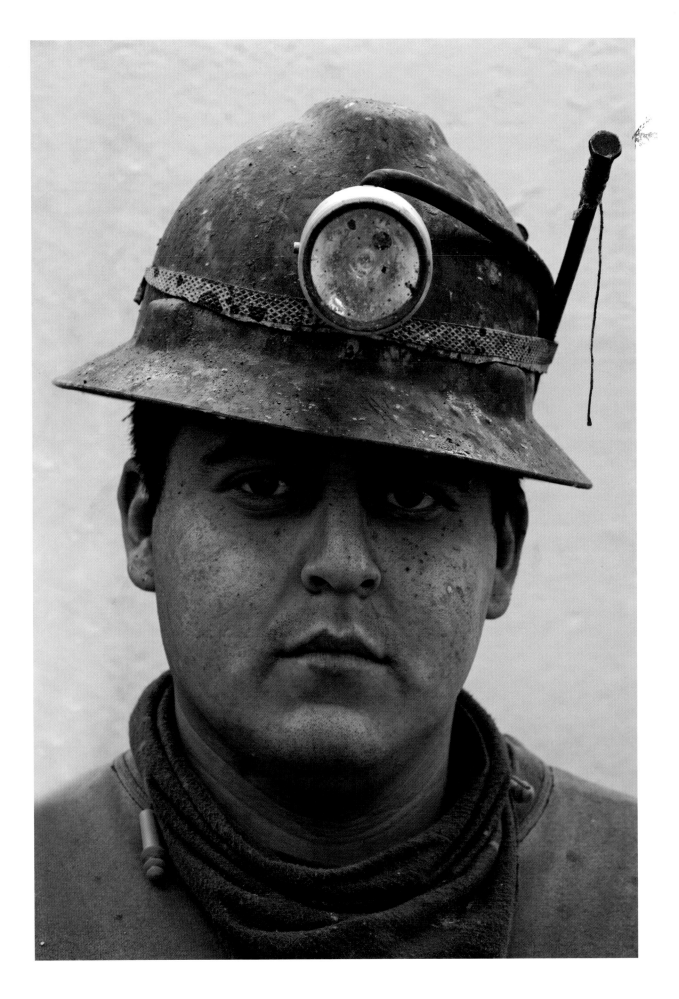

"How beautiful is youth! How bright it gleams, with its illusions, aspirations, dreams!"
– Henry Wadsworth Longfellow

Coincidentally, in one day I saw a 'fiesta de quince anos,' a wedding and a funeral. The fiesta is a coming out party for a girl (the 'quinceanera') on her fifteenth birthday. This one took place in the Basilica of Patzcuaro, which dates from 1554. A ten-piece orchestra helped to celebrate the occasion.

Purepecha Indian Woman, Village near
Lake Patzcuaro (facing page)

"As we grow old, the beauty steals inward."
– Bronson Alcott

When Hernando Cortez arrived in 1521, the population of indigenous peoples in Mexico was estimated at twenty-five million. Hundreds of thousands were then killed during the bloody Spanish conquest. Many more died of disease, or were worked to death on farms, in building projects and in the mines, with the result that, a mere century later, only about one million Indians remained. Today, Mexico has a population of over one hundred million people; a significant percentage live at or below poverty level, and many of those are Indians. As in the United States, discrimination is a factor that has impeded them from integrating well into mainstream society.

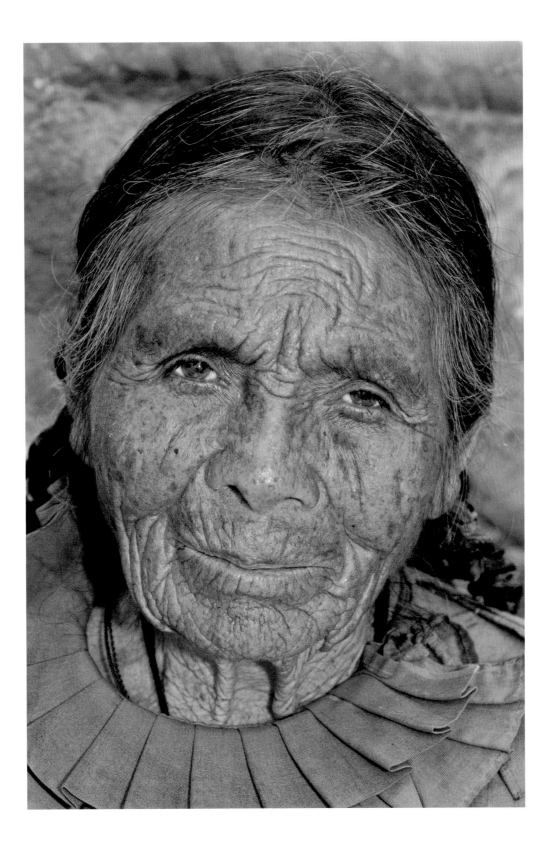

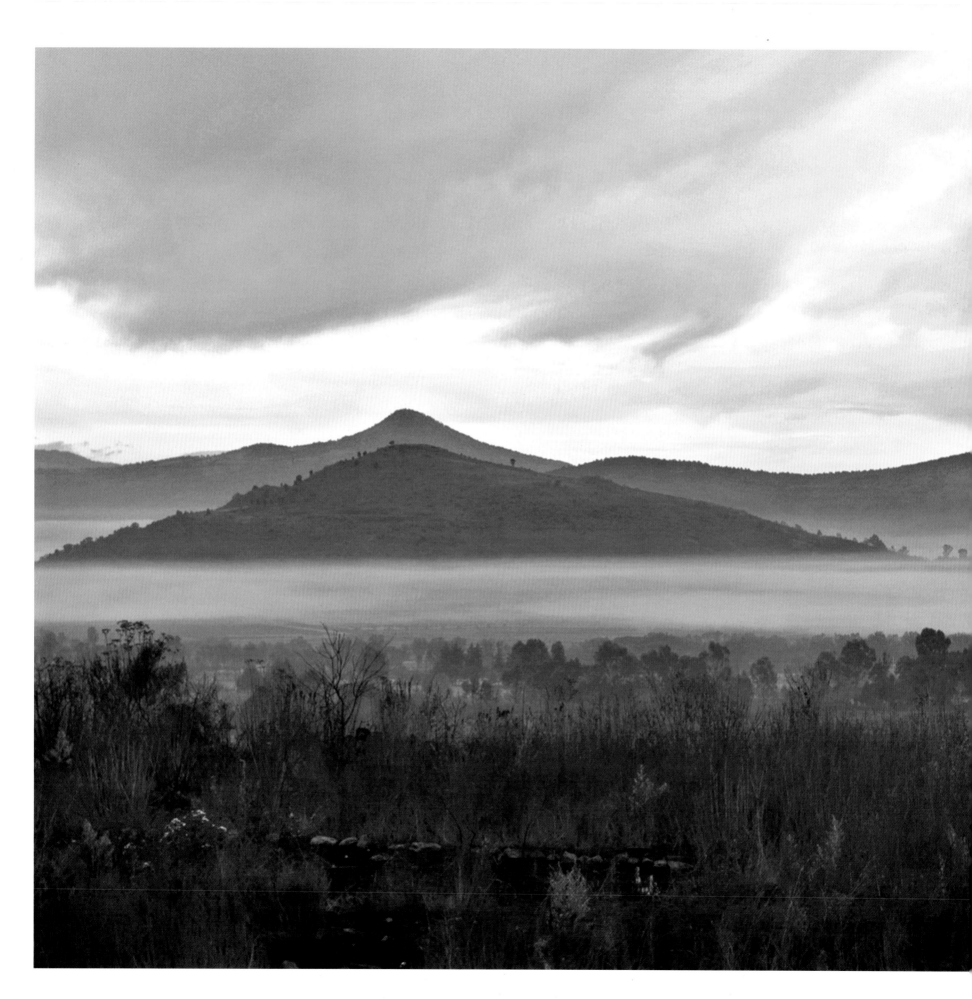

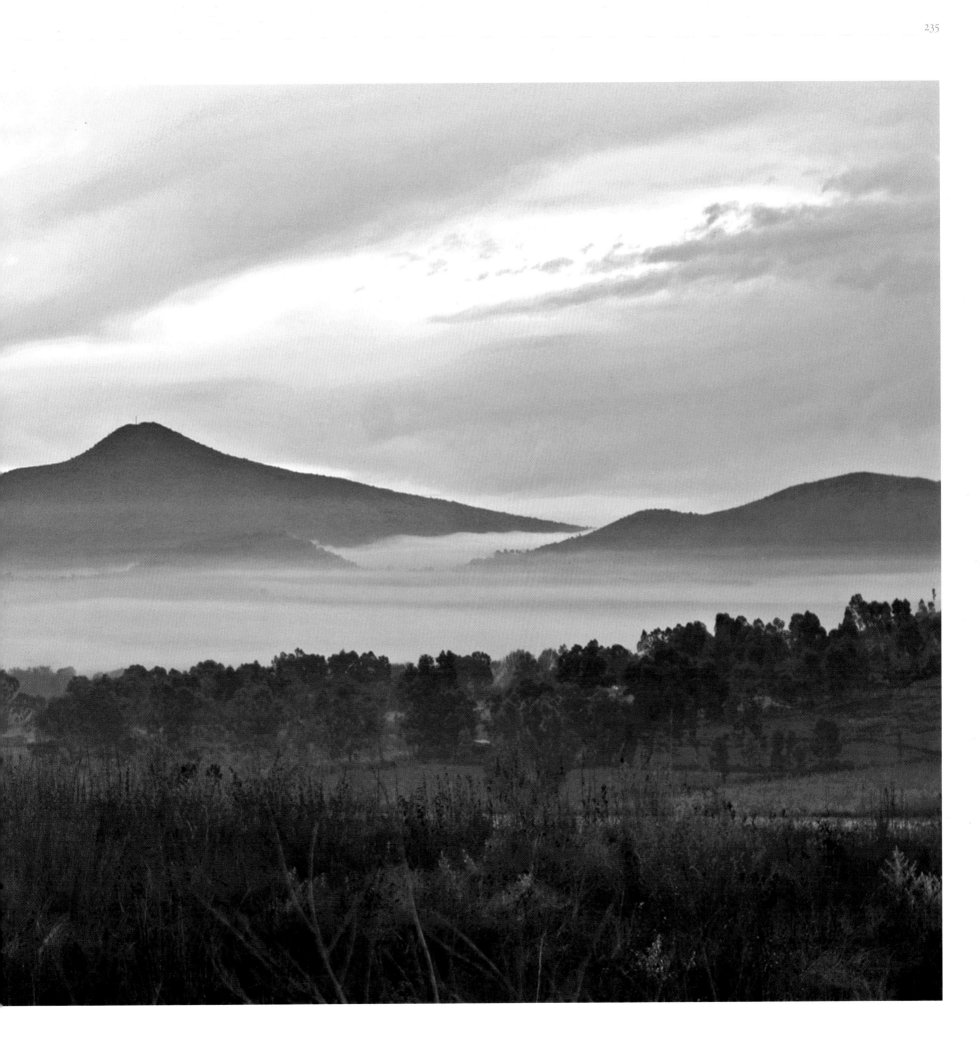

Early Morning Mist, Lake Patzcuaro (previous page)

*"Climb the mountains and get their good tidings.
Nature's peace will flow into you as sunshine flows into
trees. The winds will blow their own freshness into
you, the storms their energy, while cares will drop off
like autumn leaves."*
– John Muir

Fishermen, Lake Patzcuaro

*"A man seldom thinks with more earnestness of any-
thing than he does of his dinner."*
– Samuel Johnson

This lake is famous for its fishermen and their unique
style of fishing nets.

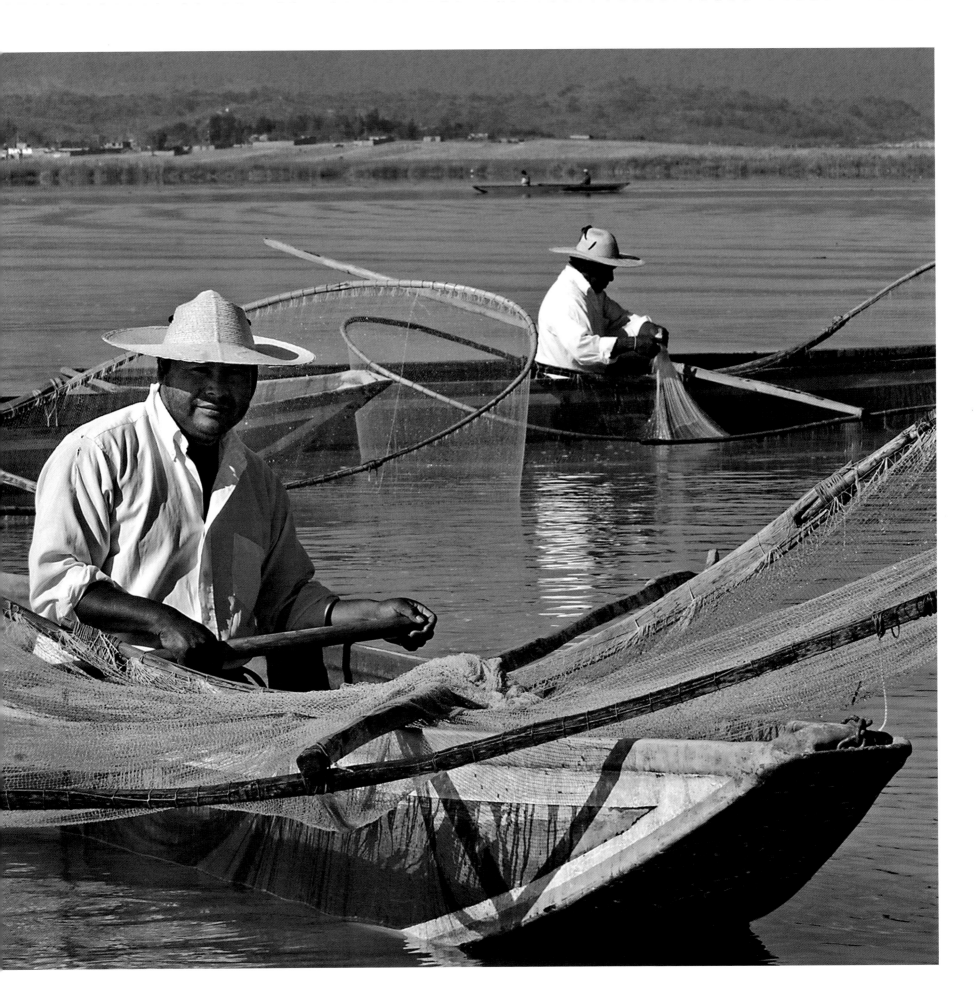

Easter Lily, Angangueo

"*To gild refined gold, to paint the lily, to throw
a perfume on the violet... is wasteful and ridiculous
excess.*"
–William Shakespeare

I saw this flower on my way to see monarch butterflies
wintering in Mexico. Vast numbers of them
migrate from the United States and Canada to a small
area in the mountains near the town of Morelia.
It is estimated that there are one hundred fifty million
in a few acres of evergreen forest. The branches
of the fir trees sag under the weight of so many butter-
flies hanging together for warmth. Although each
weighs less than one gram, they may travel fifty miles
each day during their migration, which can take
two months.

Aspen Trees, Canadian Rockies (facing page)

"*I did not find the world desolate when I entered it. As
my fathers planted for me before I was born, I now
plant for those who will come after me.*"
– The Talmud

Mountains in Clouds, Canadian Rockies

"There are moments in our lives, there are moments in a day, when we seem to see beyond the usual. Such are the moments of our greatest happiness; such are the moments of our greatest wisdom."
– Robert Henri

Bog, Cape Breton Island, Nova Scotia

"This summer I saw more colors than before."
– Vincent Van Gogh

The rugged weatherworn scenery of Cape Breton
Island offers striking vistas along the Cabot Trail. There
are picturesque fishing villages, peaceful valleys
with moose and bald eagles, and natural treasures such
as this bog.

Hamoa Beach, Maui, Hawaii

"Now my soul hath elbow room."
– William Shakespeare

Hawaii is for many people, including my daughter who
lives there, a paradise. The tropical climate, lush
vegetation, flowers, beaches and mountains are irre-
sistible, especially when combined with listening
to whales while swimming in the Pacific, and receiving
the warm spirit of Aloha from the islands' inhabitants.
James Michener, the writer, described this beach
as the most beautiful in the Pacific.

Wrigley Field, Chicago, Illinois

"All I remember about my wedding day in 1967 is that the Cubs lost a double-header."
– George Will

"Why not? I had a better year than he did."
– Babe Ruth, on being told that, in 1931, he had made more money than President Herbert Hoover.

It was Bill Veeck's idea to cover these fences in Wrigley Field, home of the Chicago Cubs baseball team, with ivy. Veeck, the owner of the Chicago White Sox in the late 1970s when I was a consultant for the team, had a remarkable ability to relate to everyone: owners, players, reporters, doctors, or baseball fans. Once, when he owned the St. Louis Browns baseball team and attendance was low, a man called the stadium to ask what time the game would start the following Saturday. Bill Veeck asked, "How many in your party?" "Six," the man answered. "What time would be convenient for you?" Bill responded.

Harley Davidson One Hundredth Anniversary,
Milwaukee, Wisconsin

*"The Buddha, the godhead, resides quite as comfort-
ably in the gears of a cycle transmission as he does at
the top of a mountain or in the petals of a flower."*
– Robert Pirsig

Several hundred thousand Harley motorcycle
owners came from all over the world to celebrate
the one hundredth anniversary in 2003.

Milwaukee Art Museum, Milwaukee, Wisconsin

"Architecture is inhabited sculpture."
– Constantin Brancusi

Opened in 2001, the museum is the first building in the
United States designed by Santiago Calatrava. A
world-renowned Spanish architect, his designs elimi-
nate the borders separating art, architecture and
engineering. The wing-like sunshade on top of the
museum is wider than a Boeing 747 and weighs
ninety tons.

Quincy Market, Boston, Massachusetts

"And this is good old Boston, the home of the bean and the cod,
Where the Lowells talk to the Cabots and the Cabots talk only to God."
– John Collins Bossidy

Funk, Nebraska

"My heart is a lonely hunter that hunts on a lonely hill."
– Fiona McLeod

Peru, Illinois

"Breathes there a man with soul so dead,
Who never to himself hath said,
This is my own, my native land."
– Sir Walter Scott

Polish Girl, Polish-American Parade, Chicago, Illinois

"*I hear America singing, the varied carols I hear.*"
– Walt Whitman

In Chicago, a city of numerous and very diverse ethnic neighborhoods, the largest ethnic group is the estimated one million people of Polish descent. Every year, thousands participate in the parade.

African Tulip Tree, Maui, Hawaii (facing page)

"*I was not looking at an unusual flower. I was seeing what Adam had seen on the morning of his creation— the miracle, moment by moment, of naked existence.*"
– Aldous Huxley

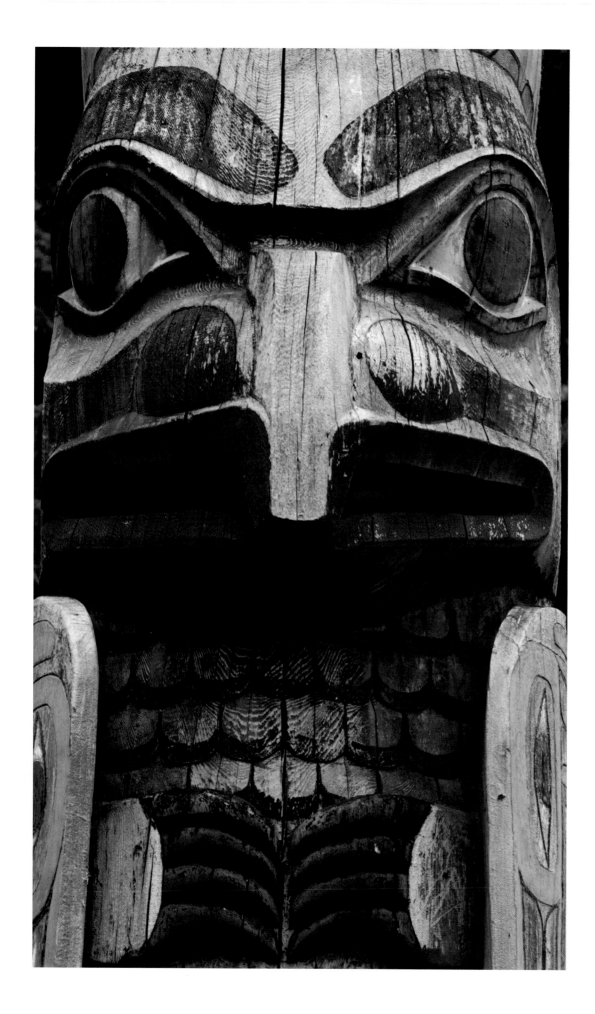

Tlingit Totem Pole, Ketchikan, Alaska

"Mankind are earthen jugs with spirit in them."
– Nathaniel Hawthorne

The Tlingit Indians, who settled in villages along the southeast coast of Alaska, were expert seamen, fishermen and carvers of totem poles. On this totem pole, which represents an eagle, the bird's beak, wings, feathers and claws are visible. An interesting custom in Tlingit society was the potlatch. A clan chief would save for years to hold a huge feast and give away almost everything he owned. The esteem in which the chief was held would be measured by how much of his wealth he gave away at the potlatch.

Bald Eagles, Ketchikan, Alaska

"A good marriage is that in which each appoints the other the guardian of his solitude."
– Rainer Maria Rilke

Bald eagles are found only in North America, the great majority in Alaska. They dive feet first for fish, their primary food source. When they extend their legs, their talons lock around the fish and cannot release it. The eagles are able to carry fish up to twice their weight back to the nest, but a heavier fish can drag them under water and drown them. Bald eagles mate for life.

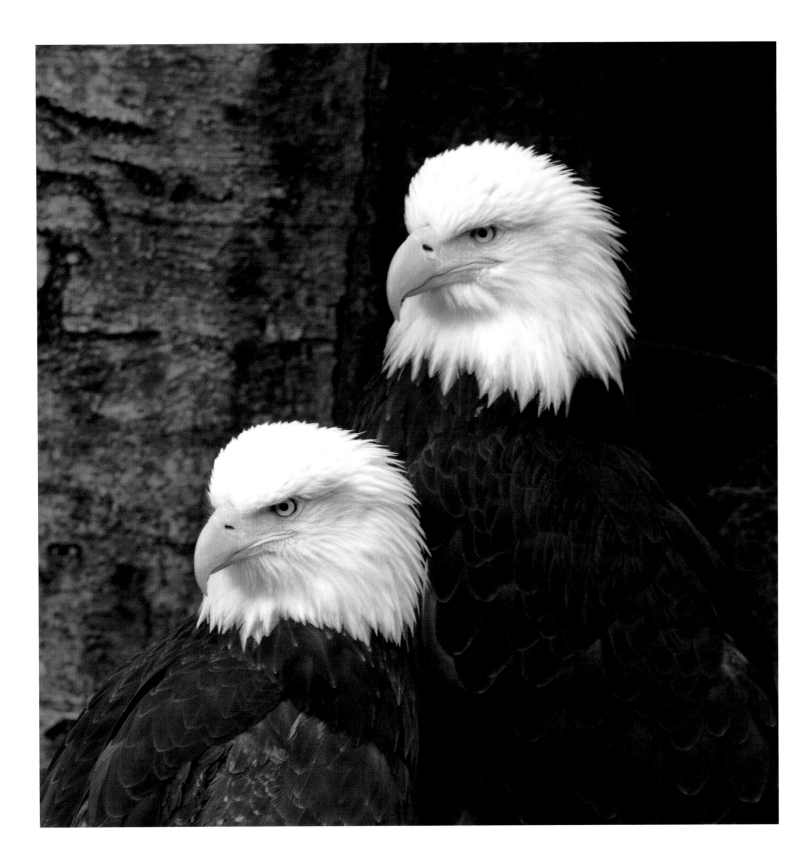

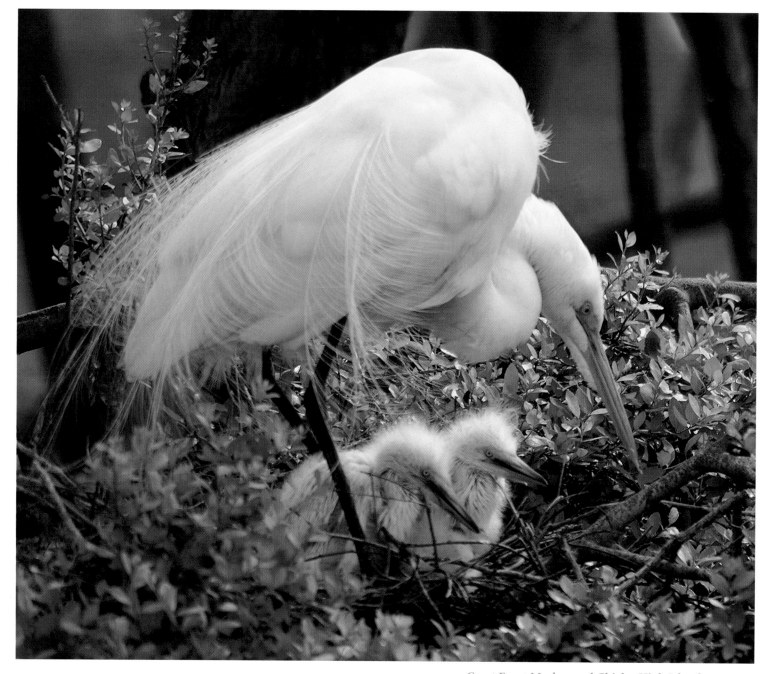

Great Egret Mother and Chicks, High Island Rookery, Texas

"We never know the love of the parent until we become parents ourselves."
– Henry Ward Beecher

Great egrets have beautiful breeding plumage. In the late nineteenth and early twentieth centuries, great egrets (and snowy egrets) were hunted almost to extinction because it was fashionable for ladies to wear egret feathers in their hats. In the United States, this situation was a catalyst for the formation of the conservation movement, including the National Audubon Society.

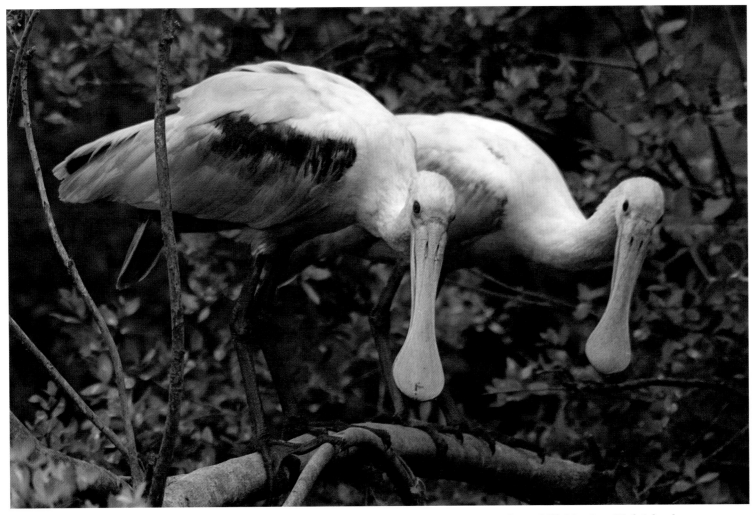

Roseate Spoonbills Nesting, High Island
Rookery, Texas

*"Experience shows us that love does not consist
in gazing at each other but in looking together in the
same direction."*
– Antoine de Saint-Exupery

Spoonbills feed in small groups. They sift the shallow
water with sweeping motions of their bills, eating crus-
taceans and insects. They are monogamous for one
breeding season. I have often seen flocks of them while
fishing with my family in the Louisiana marsh.

Fuchsia, Haines, Alaska

*"Never lose an opportunity of seeing anything that is
beautiful. Welcome it in every face, in every sky, in
every flower, and thank God for it."*
– Ralph Waldo Emerson

Sandhill Cranes, Platte River, Nebraska

"Angels can fly because they take themselves lightly."
– G.K. Chesterton

Half a million sandhill cranes use the Platte River as a rest area for three to four weeks during their migration. During that time, they feed all day to increase their fat, which will provide the energy necessary to complete their journey.

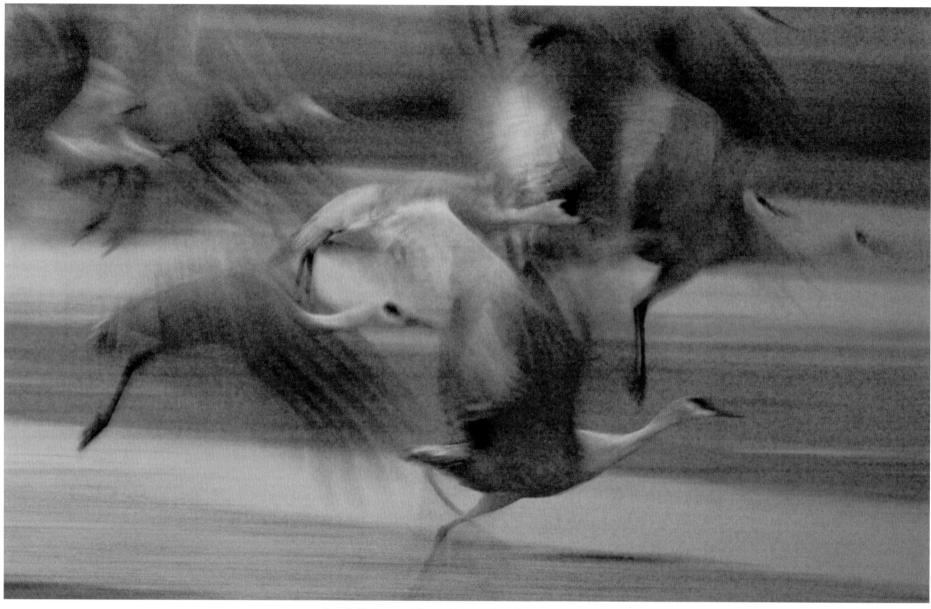

Sandhill Cranes, Platte River, Nebraska

*"The bird of time has but a little way to fly – and lo!
The bird is on the wing."*
– Edward Fitzgerald

Trumpet Flower, Kauai, Hawaii (facing page)

*"People from a planet without flowers would think
we must be mad with joy the whole time to have such
things about us."*
– Iris Murdoch

Trumpet flowers are found in several parts of the world, including Hawaii, and have been used by medicine men for their hallucinogenic and curative powers. The Hawaiian Islands are actually the peaks of volcanoes, which emerged through cracks in the earth's crust twenty-five to forty million years ago. Captain James Cook, the British explorer who landed in Hawaii in 1778, was the first documented European to arrive there. A most enlightened man, he was concerned about the effects of European contact with the Pacific Islanders. Worried about disease and destruction of the native culture, he warned his men not to consort with the Hawaiian women, but was ignored. Tragically, Captain Cook was killed in Hawaii.

Young Woman, Santa Fe, New Mexico

*"In olden days a glimpse of stocking was looked
on as something shocking, but now, heaven knows,
anything goes."*
– Cole Porter

Puffin, Acadia National Park, Maine

"Life has few pleasanter prospects than a neatly arranged and well provisioned breakfast table."
– Nathaniel Hawthorne

Puffins live in burrows and chase fish under water by beating their wings rather than moving their feet. While catching fish they are able to hold several simultaneously in their bills, all crosswise and alternately head to tail.

Phish Concert, Indianapolis, Indiana

"Come mothers and fathers throughout the land,
And don't criticize what you don't understand.
Your sons and your daughters are beyond
your command.
For the times they are a-changin'."
– Bob Dylan

I was greatly honored by my daughter who allowed me to be seen with her at a Phish concert. Out of seventy thousand people, only a handful was over forty years old.

HIV Positive, Phish Concert, Indianapolis, Indiana
(facing page)

"Midway in life's journey I awoke to find myself alone in a dark wood."
– Dante

Tibetan Prayer Flags, Tibet Refugee Center, Santa Fe, New Mexico (previous page)

"Outside the open window the morning air is all awash with angels."
– Richard Wilbur

The flags are designed to shred in the wind, sending their silent prayers up to the heavens.

Autumn Leaves in my Pond, Bannockburn, Illinois

"It's a long, long while from May to December,
But the days grow short when we reach September ...
Oh, the days dwindle down to a precious few ...
And these few precious days, I'll spend with you."
– Maxwell Anderson

Autumn, Upper Peninsula, Michigan

"These are the days when birds come back – a very few
– a bird or two – to take a backward look."
– Emily Dickinson

Starved Rock State Park, Illinois

*"In all things of nature, there is something of
the marvelous."*
– Aristotle

Known today for its forested bluffs, canyons and
waterfalls along the Illinois River, Starved Rock was
inhabited by American Indians for thousands
of years.

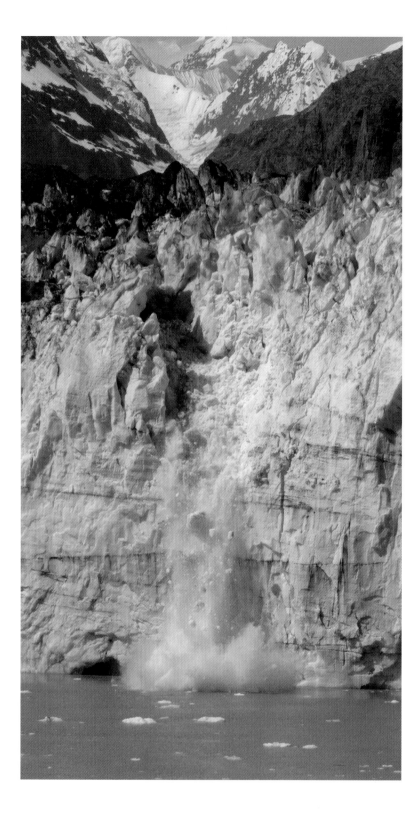

Calving Glacier, Inside Passage, Alaska

*"The ice was here, the ice was there, the ice was
all around:
It cracked and growled and roared and howled,
Like noises in a swound."*
– Samuel Taylor Coleridge

A glacier is an accumulation of compacted snow
and ice that slowly moves from mountain ice fields
toward sea level. If it eventually reaches the sea, it
breaks off, or calves, as seen here. Glaciers are in a
constant state of flux because of increases or decreases
in precipitation and temperature. Al Gore recently
stated, "Almost all of the mountain glaciers in the
world are melting, many of them quite rapidly. There
is a message in this." Nearly all scientists agree that
the greenhouse effect resulting from increased emis-
sions of carbon dioxide and other gases contributes
to global warming.

Hot Springs and Geyser, Yellowstone National Park
(facing page)

"Nature is the art of God."
– Dante

Hot springs and geysers, like these, occur because
surface water seeps steadily downward to meet the heat
of the earth's molten interior, which at Yellowstone is
closer to the surface than at anywhere else on the plan-
et. These hot springs are delicately colored by minerals
and by algae and bacteria that thrive in temperatures
over 120 degrees F. Geysers occur when the heat under
the earth's surface creates pockets of steam under
great pressure.

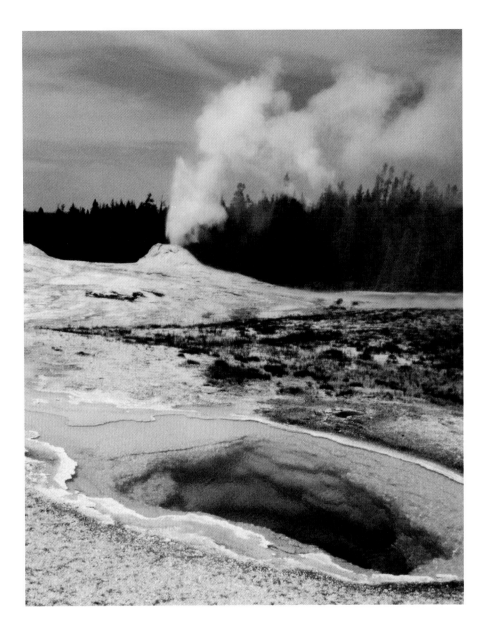

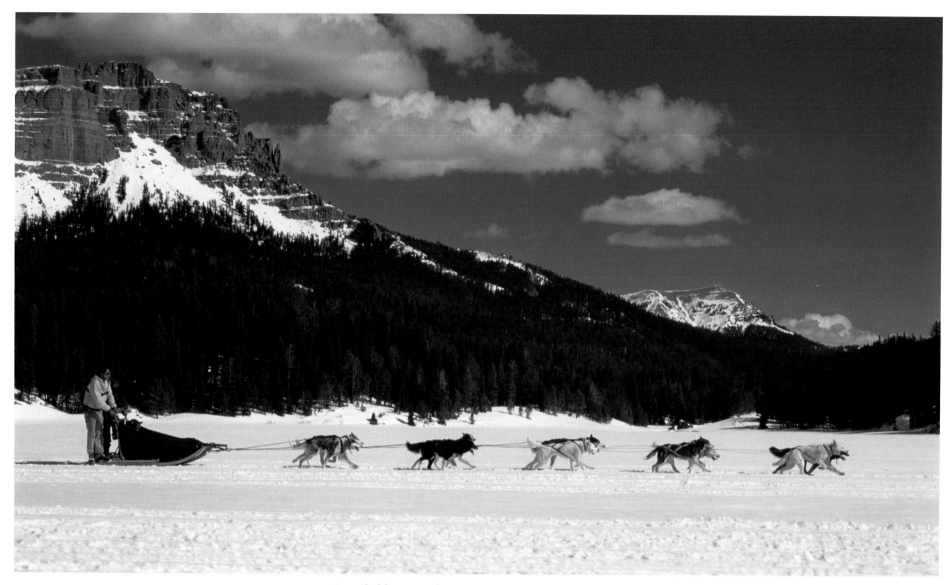

Dog Sledding, Wind River Mountain Range, Wyoming

Lucy, Lead Sled Dog, Wind River Mountain Range, Wyoming (facing page)

"Neither snow, nor rain ... nor gloom of night stays them from the swift completion of their appointed rounds."
– Herodotus

"Forget not that the earth delights to feel your bare feet and the winds long to play with your hair."
– Kahlil Gibran

During four days in Wyoming, near the Continental Divide, I traveled across breath-taking landscapes and learned some of the finer points of mushing. Each dog's character became very clear and appealing, while their interrelationships were most entertaining.

United States Marine Veteran, High Island, Texas

*"This will remain the land of the free only so long as it
is the home of the brave."*
– Elmer Davis

Cajun Musician, Breaux Bridge, Louisiana

"Strange when you come to think of it that of all of the countless folk who have lived on this planet, not one is known in history or legend as having died of laughter."
– Sir Max Beerbohm

No one knows how to party better than a Cajun.

Eldee Young, Chicago, Illinois

"He could fiddle all the bugs off a sweet potato vine."
– Stephen Vincent Benet

Here, Eldee Young, a good friend of mine, is playing the bass at his own fiftieth wedding anniversary. He was a member of the original Ramsey Lewis Trio. The saying, "You are the music while the music lasts," certainly fits Eldee.

Birthday Surprise, Houston, Texas

"Let the heavens dance for joy and let the earth reverberate with glee."
– Psalms

My daughters surprise their grandmother on her birthday.

Children, Washington, Louisiana

"The future belongs to those who believe in the beauty
of their dreams."
– Eleanor Roosevelt

"We are the world,
We are the children,
We are the ones
To make a better day."
– Michael Jackson and Lionel Ritchie

Addendum

Rainbow, Achill Island, Ireland

*"When Irish eyes are smiling, sure, it's like the
morn in spring. In the lilt of Irish laughter, you
can hear the angels sing."*
– Chauncy Olcott

Achill Island is in the far west of Ireland, just off the
coast of County Mayo. I was on a bus when I saw
this double rainbow. When the bus stopped, I started
jumping over hedges, so that greenery instead of
a road would be in front of the rainbow in the image.
A wide angle, fisheye lens was necessary to capture
the entire magical scene.

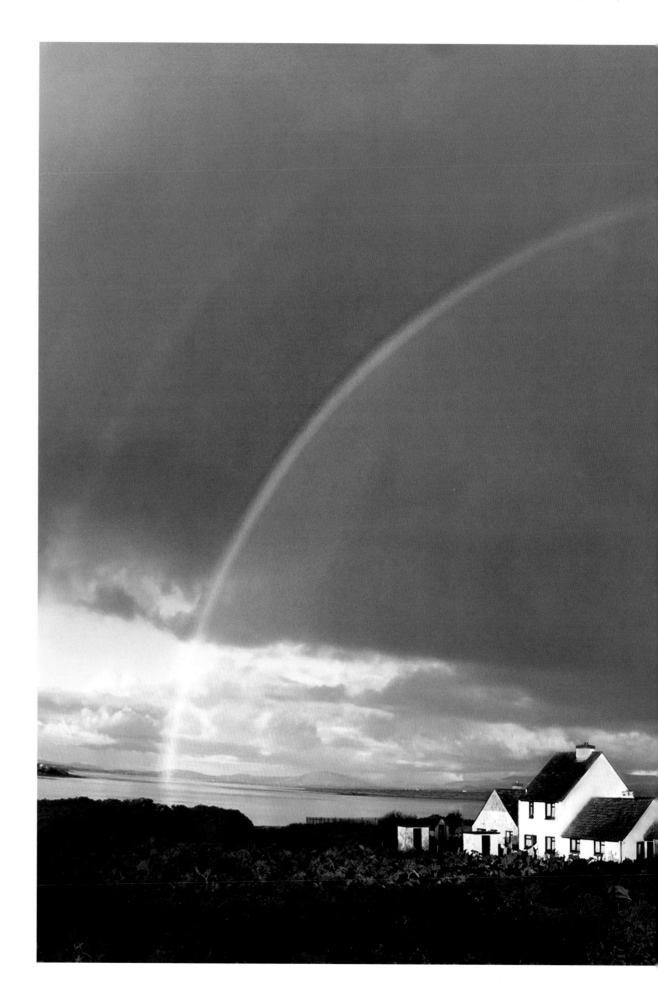

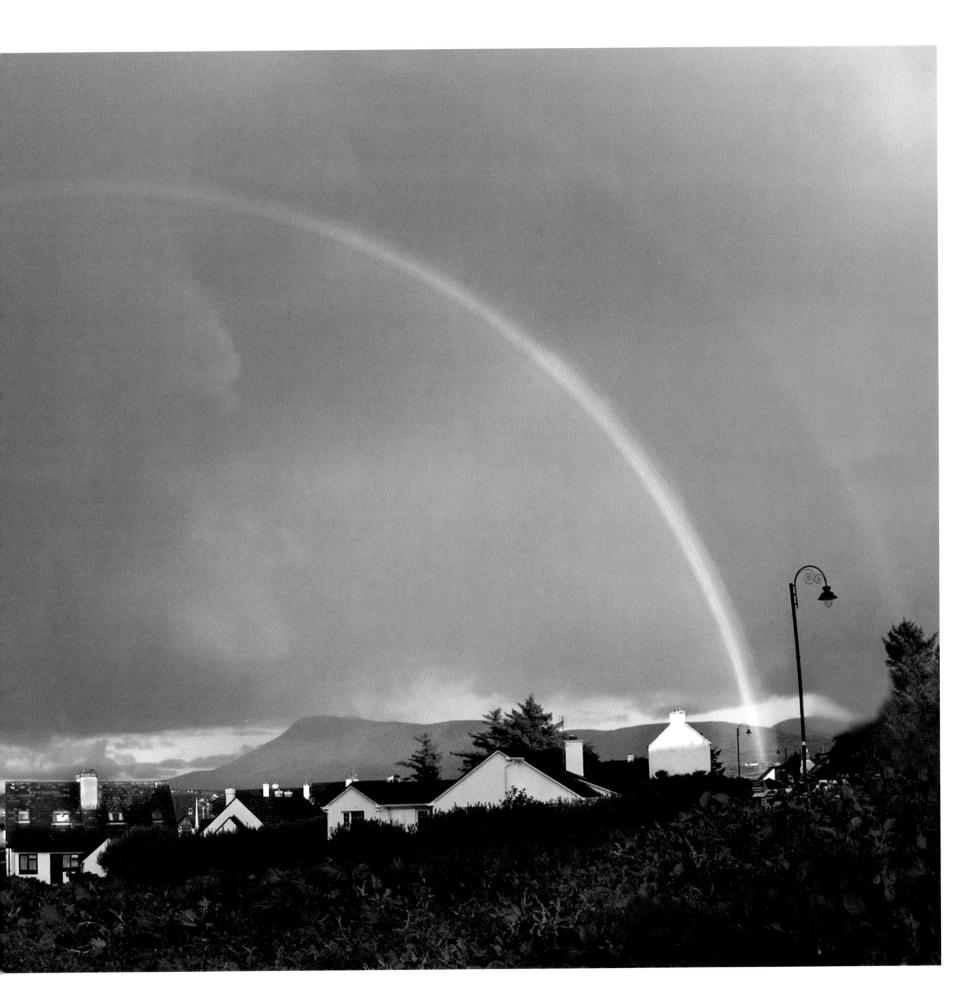

Polar Bears Sleeping in the Snow,
Churchill, Manitoba, Canada

"*Whatever souls are made of, his and mine*
are the same."
– Emily Bronte

In November every year, polar bears gather on
a peninsula jutting into Hudson Bay near the town
of Churchill, Manitoba, Canada. They have been
on the mainland since the spring. They are waiting
for sufficient ice to form so that they can live
on the Arctic ice flows and feed on seals.

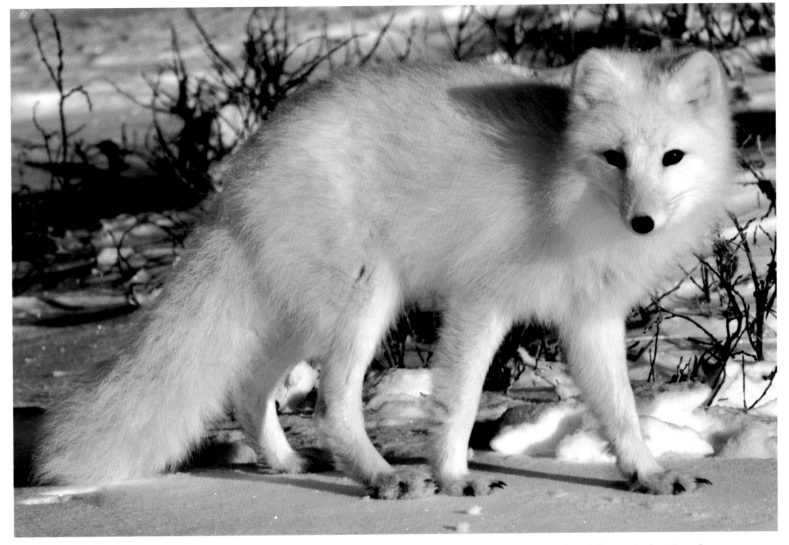

Arctic Fox, Churchill, Manitoba, Canada

"Down to Gehenna and up to the throne,
He travels fastest who travels alone."
– Rudyard Kipling

Found throughout the Arctic region, the arctic fox
has the thickest fur of any mammal, enabling it
to live in one of the most frigid areas of the planet.
Its beautiful white coat also serves as a very effective
winter camouflage so that its prey does not see
it until it is too late. Its diet consists primarily of
small animals, such as lemmings.

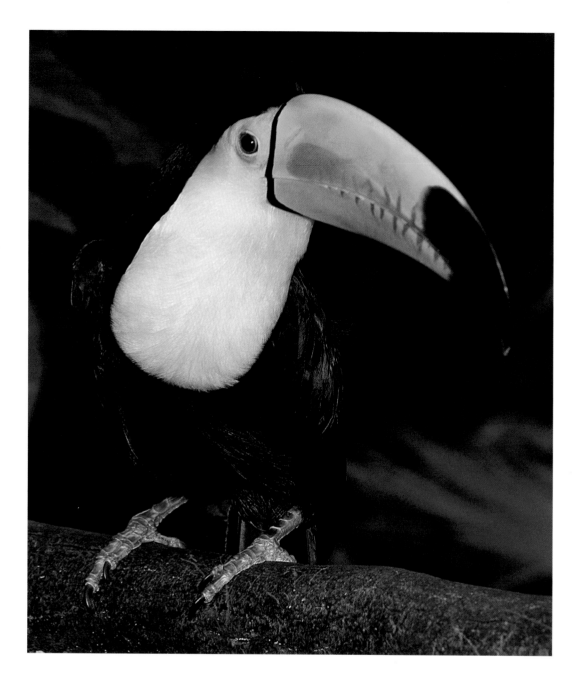

Keel Billed Toucan, Honduras

"I'd love to kiss you but I just washed my hair."
– Bette Davis, in the movie, 'The Cabin in the Cotton.'
Screenplay by Paul Green.

Toucans, with their large, colorful yet lightweight bills, are found in the rainforests of Central and South America. They are primarily fruit-eating and often can be seen throwing fruit into each other's mouths.

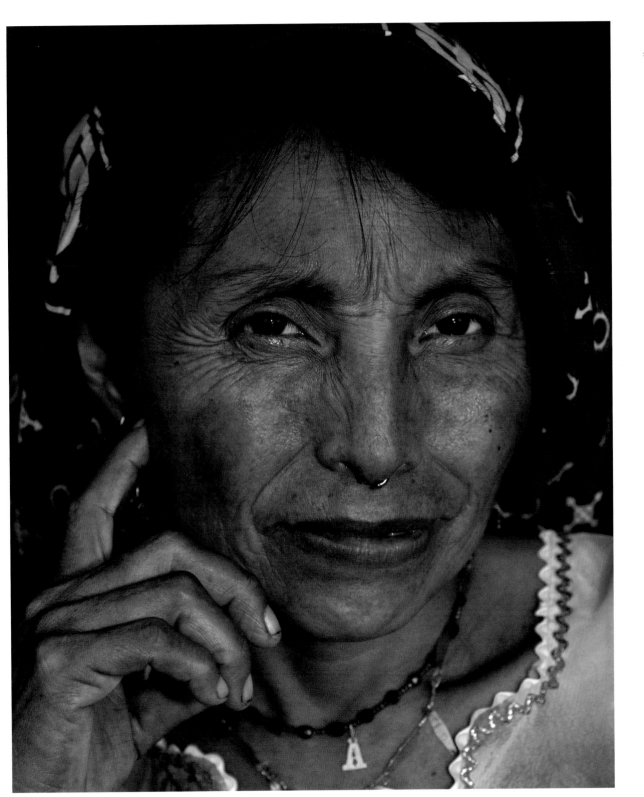

Kuna Indian, Panama

"*Come into my garden. I would love my roses
to see you.*"
– Richard Brindley Sheridan

The Kuna are one of the indigenous peoples of
Panama. In the early 20th century, during the
construction of the Panama Canal, doctors made
the connection between the mosquitoes infesting
the rainforest and the high rate of deaths from
both malaria and yellow fever. As a result, the Kuna
moved from their traditional forest villages to
the San Blas archipelago, where they now control
a politically autonomous area of 365 islands as
well as a strip of the Caribbean coast. The Kuna
women wear beautiful handmade blouses
known as "molas."

Young Ghanian Girls, Jamestown, Accra, Ghana

"Do you believe in magic, in a young girl's heart?"
– John Sebastian

These young girls are from Jamestown, a vibrant fishing community and a suburb of Accra, the capital of Ghana. In 1957 Ghana became the first European colony in Africa to be granted independence.

Grandmother and Grandchild, Cape Coast, Ghana

"There is only one happiness in life, to love and be loved."
– George Sand

This woman and her grandchild live next to Cape Coast Castle in the town of Cape Coast. Built in the 1600s, the castle was originally a trading post where gold, ivory and spices were stored. From the late 17th century to the 19th century it served as a portal through which millions of Africans were sent as slaves to the Americas and the Caribbean. Ominously, a sign near the exit to the sea reads, "Door of No Return."

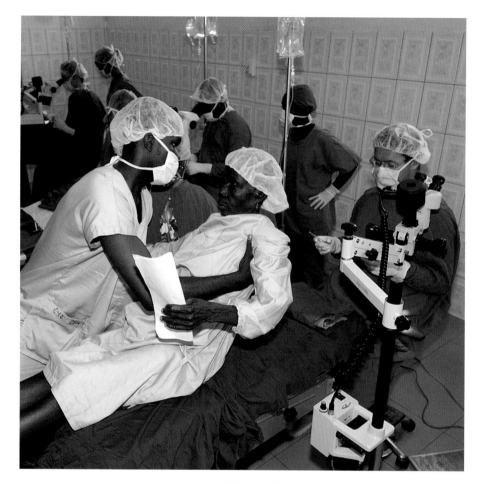

Geoffrey Tabin M.D. and his Team Performing
Cataract Surgery, Ghana

"*I expect to pass through this world but once. Any good
thing therefore that I can do, or any kindness that
I can show to any fellow creature, let me do it now for
I shall not pass this way again.*"
– Stephen Grellet

I was most fortunate to accompany Geoffrey Tabin
M.D., cofounder of the Himalayan Cataract Project,
and his team to Ghana, where over 400 cataract
surgeries were performed. After the surgery, people
who had been blind or who had minimal vision
were able to walk away unaided, excited at the prospect
of seeing their children and grandchildren—
sometimes for the first time.

Cataract Patient, Before and After Surgery, Ghana

"I have sometimes seen what other men have only
dreamed of seeing."
– Arthur Rimbaud

This man has been blind for years due to cataracts.
The photograph on the right is his first moment
of sight following surgery.

Muslim Woman, Tamale, Ghana

"I have spread my dreams under your feet. Tread softly
because you tread on my dreams."
– W. B. Yeats

Whereas the southern part of Ghana is overwhelmingly
Christian, the north is primarily Muslim. This Muslim
woman comes from the northern city of Tamale, which
is 70% Muslim and 30% Christian. I spoke to several
people from there, and they confirmed that the two
religions live in harmony – a fine example for the rest
of the world.

Muslim Woman, Essaouira, Morocco

"Clothed in white samite, mystic, wonderful."
– Alfred Lord Tennyson

This woman represents one half of the two major cultural traditions Morocco has managed to combine for centuries: the Islamic east and the European west. Her full-length white robe, or haik, combined with her facial veil, or nigeb, lends her an air of mystery.

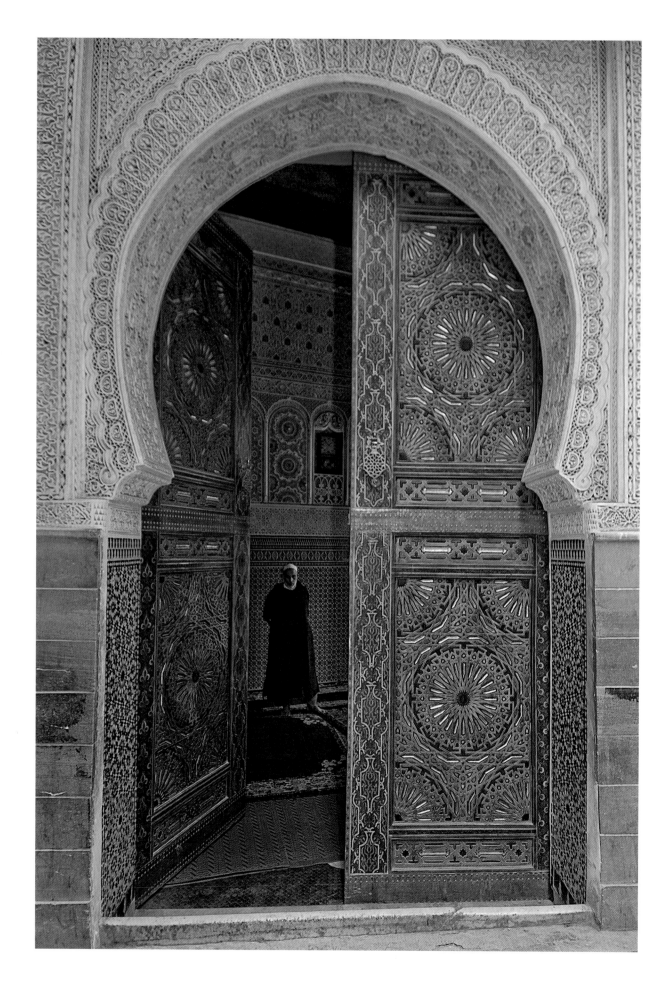

Man Behind Door of Mosque, Fez

*"Not knowing when the dawn will come,
I open every door."*
– Emily Dickinson

The city of Fez is the largest and most enduring medieval Islamic settlement in the world. The old medina is a labyrinth of narrow streets and souks, scarcely changed over hundreds of years. This doorway, a masterpiece of Moroccan architecture, is the entrance to the Tijania Zaouri, which serves as a community center for the Sufi brotherhood. It contains a mosque, a clinic, and accomodations for pilgrims. Non-Muslims are not permitted to enter.

Sardine Boats in Harbor, Essaouira, Morocco (facing page)

"A ship in harbor is safe, but that is not what ships are built for."
– John A. Shedd

The Moroccan coastline faces both the Atlantic Ocean and the Mediterranean Sea. It gives the country access to one of the richest fishing grounds in the world, and the largest catches of fish in the whole of Africa. These boats, found in the town of Essouira, are used for sardine fishing. Morocco is the largest exporter of sardines in the world.

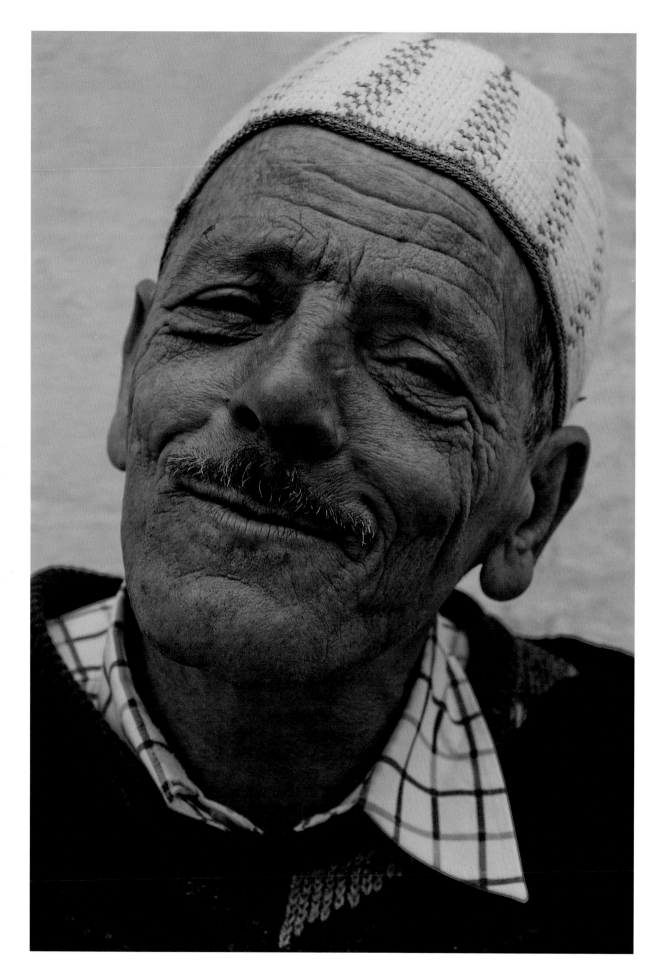

Man Smiling, Marrakesh

"The life that I have chosen gives me my full hours of enjoyment. The sun will not rise or set without my notice, and thanks."
– Winslow Homer

The souk, or market, is in the narrow alleys of the medina, or old city. There is always a colorful array of merchandise, such as foods, spices, and clothing of all kinds, as well as carpets, metalwork, and musical instruments. One is constantly dodging donkeys laden with large sacks, carts piled high with boxes, and hundreds of people. In the midst of all of this activity, this man maintains a serene smile.

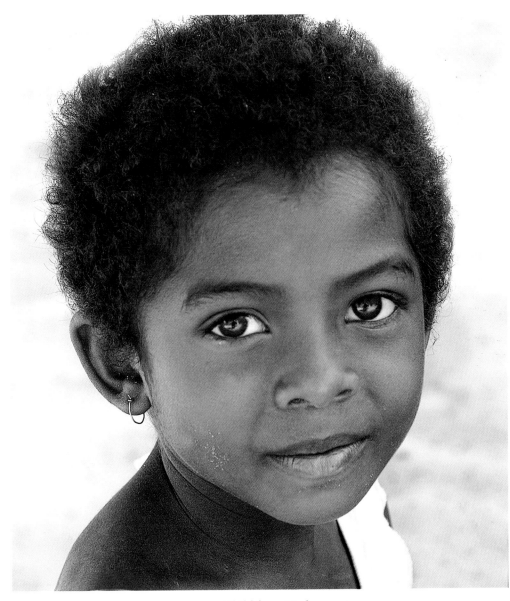

Child from Madagascar

"We find such delight in the beauty and happiness of children that it makes the heart too big for the body"
– Ralph Waldo Emerson

The people of Madagascar are a mix of Indonesians, Malaysians and Africans. The eighteen culturally distinct tribes are united by the Malagasy language. The country became an independent state in 1960, after being a French colony for over 60 years. Today, French is still the second language.

Ringtailed Lemurs

"The only rock I know that stays steady, the only institution I know that works, is the family."
– Lee Iacocca

Lemurs are primates, like us. Their ancestors drifted away from Africa on floating vegetation approximately sixty million years ago. More than fifty species have been identified, all endemic to Madagascar. Ringtailed lemurs always travel in groups, each one dominated by an alpha female.

Black and White Ruffed Lemur (facing page)

"Contemplation is the highest form of activity."
– Aristotle

The black and white ruffed lemur, unfortunately, is sometimes illegally hunted for food or captured alive for the pet trade. Here, he appears to be posing for a formal portrait.

Buddhist Monks Playing, Wangdue Phodrang Dzong, Bhutan

"To the art of working well, a civilized race would add the art of playing well."
– George Santayana

Wangdue Phodrang dzong is a traditional Buddhist monastery in Bhutan. Inside a courtyard in the dzong, young novices are playing makeshift volleyball with a small sponge ball which they bat with their shoes. They attend prayers for ninety minutes in the morning and evening and study for many additional hours each day.

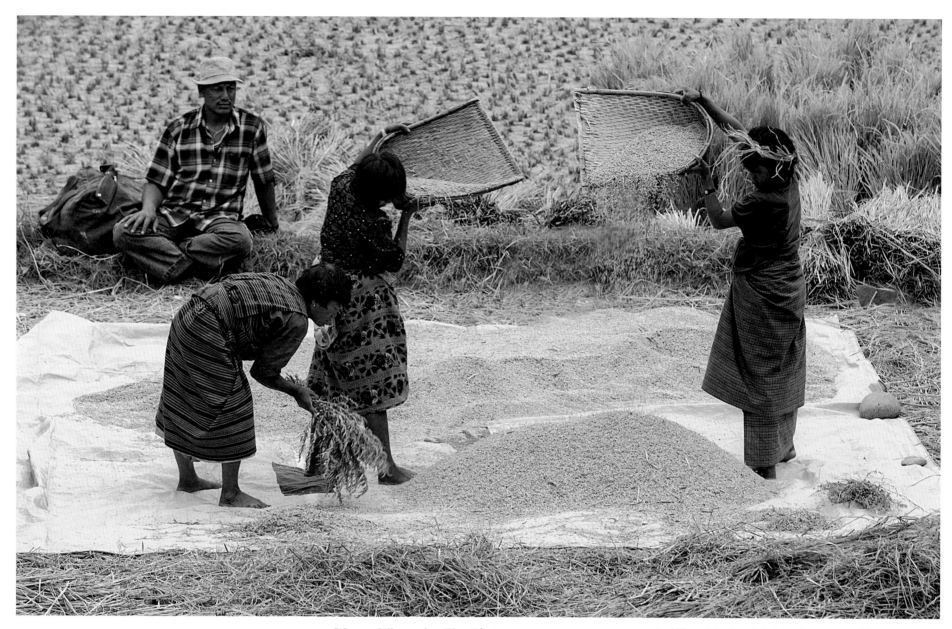

Women Winnowing Rice, Bhutan

*"To everything there is a season, and a time to every
purpose under the heaven. A time to be born, and
a time to die, a time to plant and a time to pluck up
that which is planted."*
– Ecclesiastes, Bible

Driving past golden fields of ripe rice and picturesque
three-story farmhouses I saw these women
winnowing rice. It is arduous work, but this moment
reminded me of a ballet.

**Buddhist Monks with Cellphone, Punakha Dzong,
Bhutan** (facing page)

*"For children, childhood is timeless. Everything is in the
present tense."*
– Ian McEwan

Bhutan, a Himalayan Buddhist kingdom, was
completely closed off to the outside world until the
1960s. Foreign visitors and the press came for
the first time in 1974, and TV and the internet were
not allowed to enter the country until 1999. These
young monks, who are being educated in a tradition
which goes back several thousand years, are engrossed
in a computer game and their cell phone.

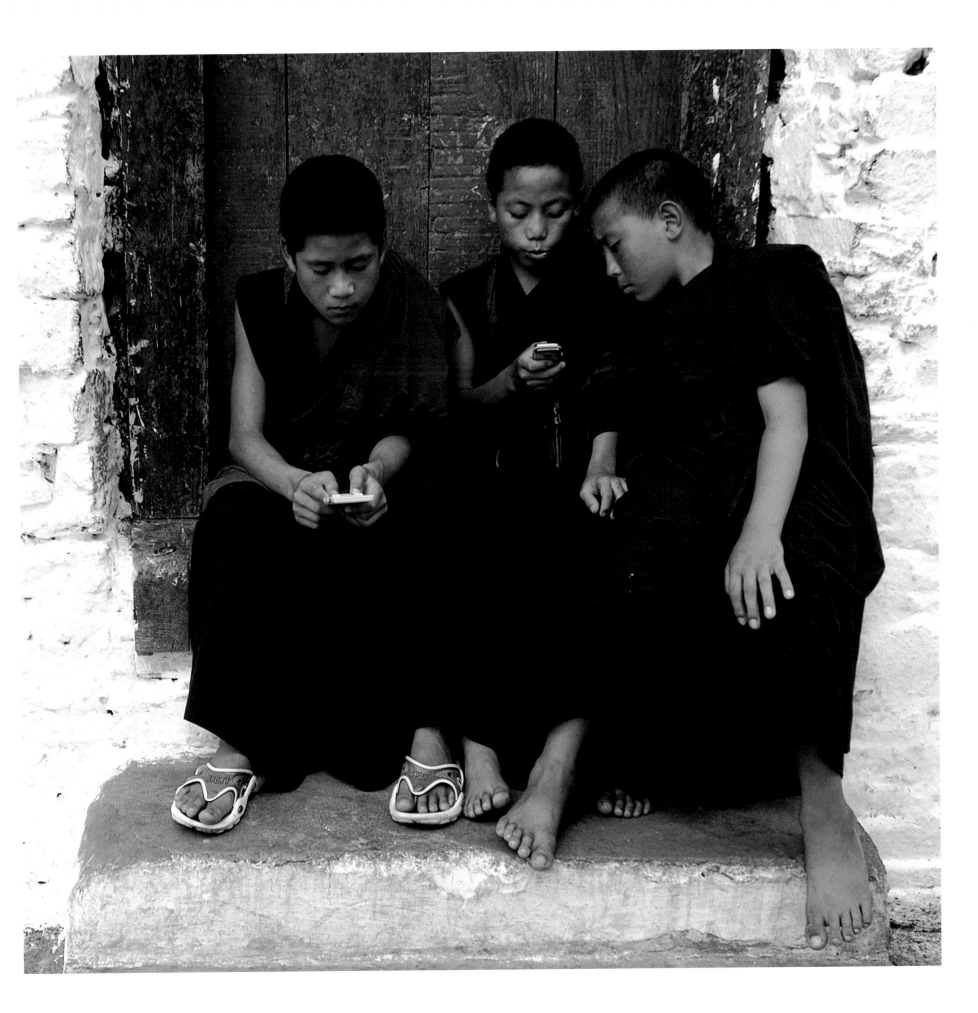

King Penguins, South Georgia Island

"*I was a child and she was a child in the kingdom by the sea. But we loved with a love that was more than a love, I and my Anabelle Lee.*"
– Edgar Allen Poe

One hundred thousand pairs of king penguins breed on South Georgia Island. They are deep divers. Their dives can last up to eight minutes and take them to a depth of 165 feet, where they feed on lantern fish and squid. The parents take turns incubating the egg and raising the chick. King penguins are very gregarious and can be found in colonies year round.

Magellanic Penguins, Falkland Islands (facing page)

"*Hey good lookin'. What you got cookin'. How 'bout cookin' somethin' up with me.*"
– Hank Williams

One of the joys of traveling to the Antarctic region is observing penguin behavior. Showing no fear, they walked right up to me, seeming to accept me as another quaint kind of penguin. A British possession, the Falkland Islands lie three hundred miles to the east of southern Argentina. The streets of Port Stanley, the capital, are lined with British-style pubs and shops, together with large numbers of land rovers.

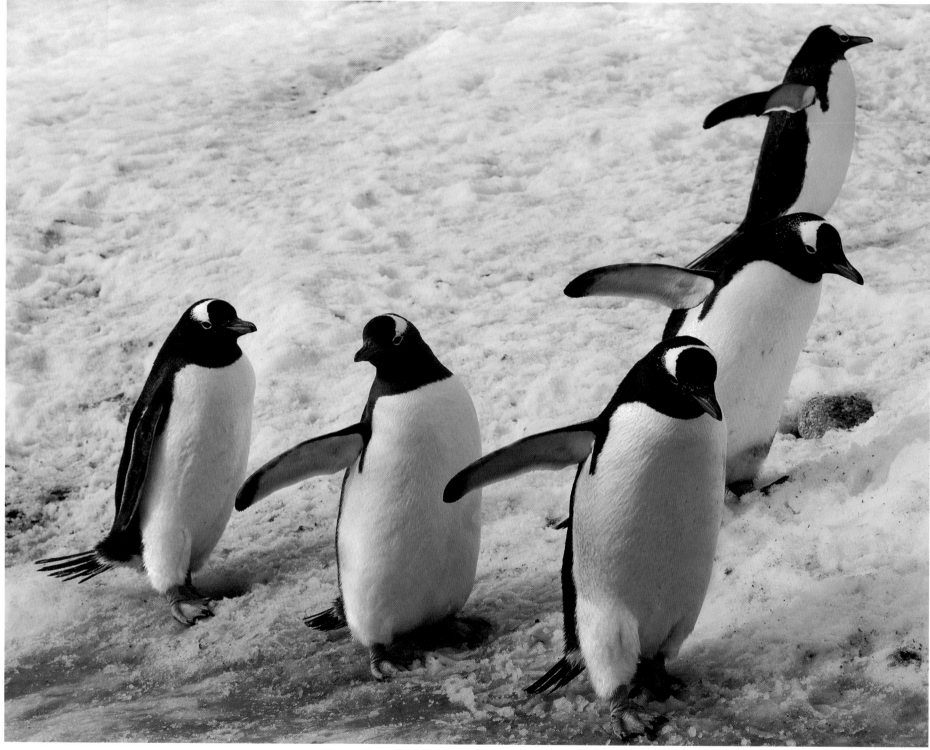

Gentoo Penguins Marching, South Georgia Island

"Never doubt that a small group of committed people can change the world. Indeed, it is the only thing that ever has."
– Margaret Mead

Gentoo penguins are seen here marching to the sea to enjoy a meal of fish and crustaceans. Their dives generally are shallow, lasting only half a minute. The majority of the world's 200,000 gentoos live on South Georgia Island.

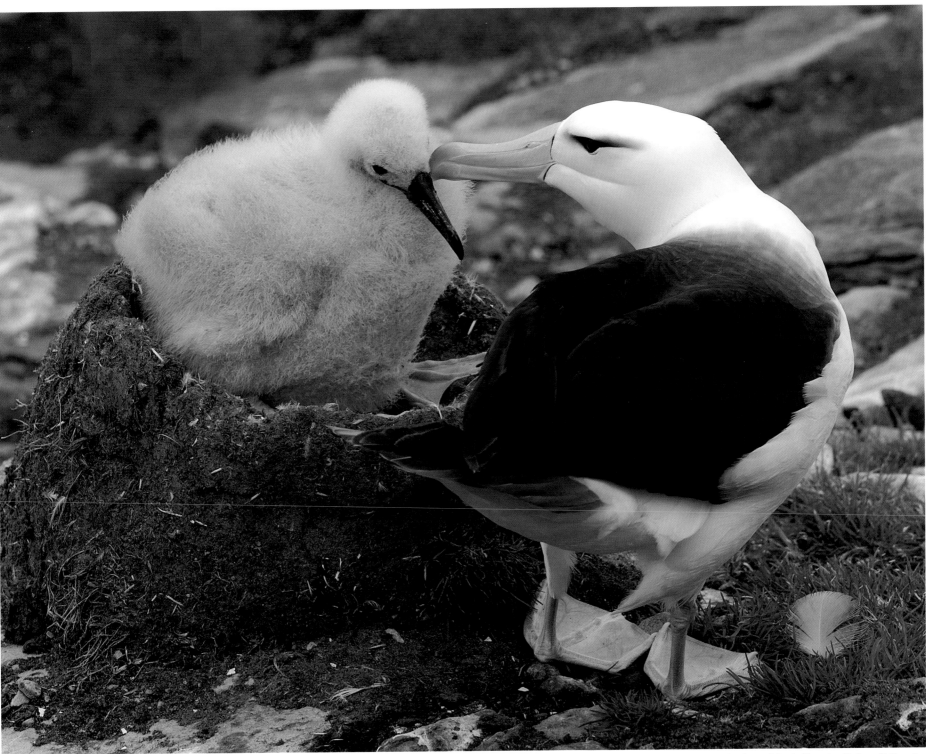

Black Browed Albatross and Chick, Falkland Islands

"A baby is God's opinion that life should go on."
– Carl Sandburg

Albatrosses spend a lot of their lives in flight, gliding in an extremely energy efficient manner along the major wind systems of the southern oceans. Black browed albatrosses are the most abundant and widespread of the species. They eat fish and krill and may fly over a thousand miles to collect enough food for a nestling. Every year long-line fishing vessels unwittingly drown tens of thousands of albatrosses when the birds seize bated hooks intended for fish.

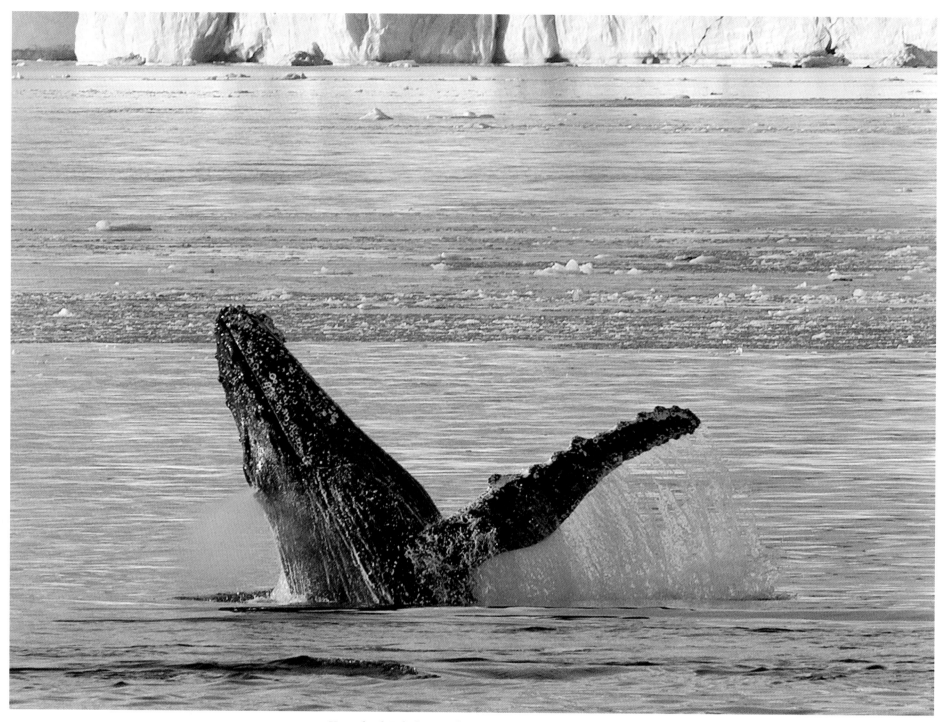

Humpback Whale Breaching

"Come my friends, it's not too late to seek a newer world. My purpose holds to sail beyond the sunset – to strive, to seek, to find and not to yield."
– Alfred, Lord Tennyson

Humpback whales average fifty feet in length and thirty-five tons in weight. Their pectoral fins are nearly a third of their body length. Typically, their heads are covered with the fleshy tuberosities and barnacles seen here, and their blow holes exhale misty breaths. Being amazingly acrobatic and energetic, they are powerful enough to leap completely out of the water. They feed on krill, consuming as much as a ton a day. Since the krill are mostly just below the surface, humpbacks, unlike other whales, seldom dive to more than three hundred feet.

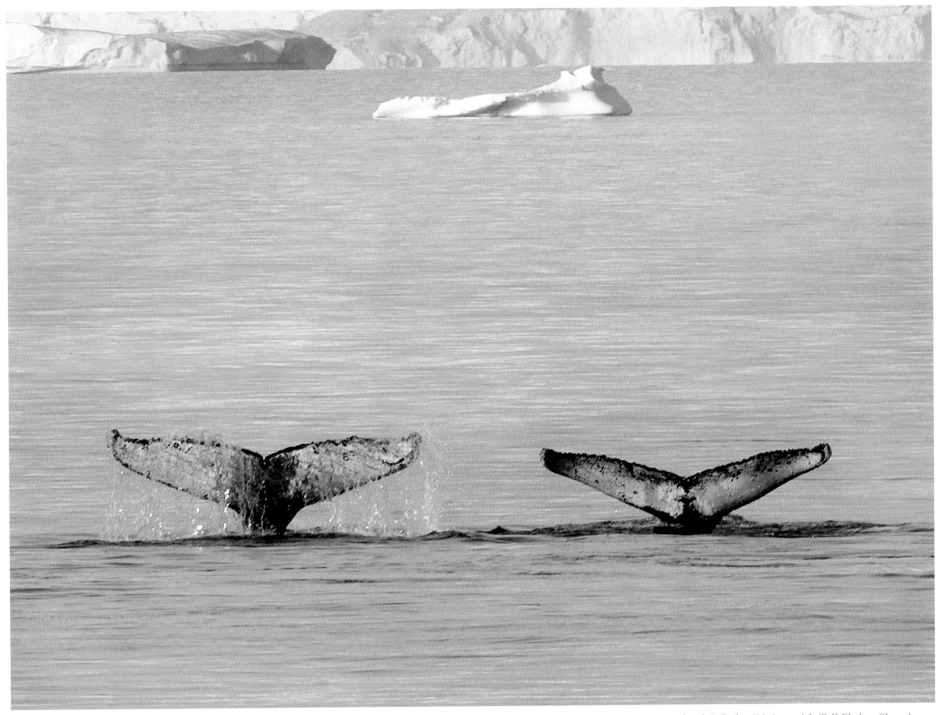

Humpback Whales Diving with Tail Flukes Showing

*"For you see, each day I love you more – today more
than yesterday and less than tomorrow."*
– Rosemonde Gerard

Humpback whales typically raise their tail flukes above
the water before diving. Each has a unique pattern
of pigmentation, which allows individual whales to
be recognized.

Iceberg, South Georgia Island

"There was a time when the earth to me did seem apparelled in celestial light. The glory and freshness of a dream."
– William Wordsworth

South Georgia Island, like the Falklands, is a United Kingdom dependency. A three-day journey by boat east of the tip of South America, it is not accessible by air and is one of the most remote places on earth. Between 1786 and 1965, it was a center for sealing, and in 1904 became a headquarters for whaling. Between 1904 and 1965 a total of 175,000 whales were caught around South Georgia Island. Shockingly this was only ten percent of the whales caught in the entire Antarctic area during this time. Whaling ended simply because they were fished out.

Since glaciers cover fifty-seven percent of the island, icebergs which have calved from the glaciers are common. The compaction of snow over thousands of years produces ice which is blue. Icebergs can also be blue because they contain organic material reflecting blue light.

Antarctica Peninsula

*"Every now and then, a man's mind is stretched
by a new idea or sensation and never shrinks back
to its former dimensions."*
– Oliver Wendell Holmes

Antarctica, composed of massive mountains covered
in an ice sheet, is the highest of the continents. In many
places, this ice sheet is more than 2.5 miles thick.
Eventually, the greenhouse effect will have a serious
impact. If all of the ice in Antarctica were to melt,
sea levels would rise by 200 feet aand coastal cities,
including New York, Shanghai and Tokyo, would
be wiped out. The unspoiled grandeur of Antarctica is
breathtaking. In every direction one sees majestic
mountain peaks, immense glaciers, vast expanses of
glistening snow, and towering icebergs.